# The Life and Opinions of
# WALTER RICHARD SICKERT

# The Life and Opinions of Walter Richard SICKERT

## ROBERT EMMONS

**Lund Humphries**
London

This edition of *The Life and Opinions of Walter Richard Sickert*
published 1992 by Lund Humphries Publishers
Park House, 1 Russell Gardens, London NW11 9NN

*British Library Cataloguing-in-Publication Data*
A catalogue record for this book is available
from the British Library

ISBN 0 85331 635 X

*Publishing History*

*The Life and Opinions of Walter Richard Sickert*
by Robert Emmons was first published by
Faber and Faber Limited in 1941.

Printed in Great Britain by
Biddles Ltd, Guildford, Surrey

*Ce qui fait la force d'une œuvre, c'est la visée, comme on dit vulgaire-
ment ; c'est-à-dire une longue énergie, qui court d'un bout à l'autre et
ne faiblit pas.*—FLAUBERT.

# CONTENTS

༄

## Part I: 1860–1905

## Part II: 1905–1921

## Part III: 1922–1940

# CONTENTS

# PART I

1860–1905

# CHAPTER I

# A PORTRAIT OUTLINED

❧

The photograph at the beginning of this book was taken in 1911, when Sickert was fifty-one years old. When you look at it you must imagine a man nearly six feet tall: a big man, built to his height: a broad forehead: blue-grey eyes, having often a look of hidden fun, as if the owner were enjoying a very private joke: a straight nose with flared nostrils, a very inquisitive nose: a broad mouth with sensitive corners, down-slanting when serious, but quick to come up for a grin and square open for a guffaw (for smile and laugh are words too thin for Sickert's mirth): a round chin, just small enough to be left out in caricature. Indeed the caricaturists, from Max downwards, have given a foxy sharpness to his face, which is certainly in keeping with one side of his character. His voice has an amazing range of expression, now high and thin, now deep, loud and guttural, as when he declaims or breaks into an old music-hall chorus, or to give point to the culmination of a story.

Sickert's wit is proverbial; words spoken and words written come as easily to him as lines and tones. But his is not the superficial wit of fashion; behind it is a wide culture which has made him intimate with many peoples and many literatures. He has known the classics, not as mind-trainers, but as poetry. He can make himself at home not only with languages but dialects. Goldoni is his favourite dramatist. His mind is inquisitive, searching, experimenting, but under the control of a sturdy common

3

sense. It is altogether self-reliant, though receptive to the best tradition.

It is true that with this common sense he has managed to combine an apparent inconsistence, a waywardness, a flippancy, that has been both the despair and delight of his friends. It was impossible to tell what he would say next, wear next or paint next. Sickert himself has always been critical of the habit of labelling artists by groups or theories. Every painter is an individual. His own name is his sufficient trademark. 'Let us leave the labels', he says, 'to those who have little else wherewith to cover their nakedness.'[1]* Least of any can he himself be docketed and pigeon-holed under this heading or that. Label him to Calcutta and he will turn up at Pekin. Like a well-travelled suit-case he has had many pretty stamps affixed to him: pupil of Whistler, Impressionist, Neo-realist, Academician, etc. Not one of them has stuck. Either the glue is not good enough or he is too slippery to be held. Like a boy after a butterfly, just when you have thrown your cap and think you have him pinned, he is away again, coquetting with a flower in your neighbour's garden. No wonder his friend Tonks found him 'exasperating', yet, 'he has become a character the like of which has never been on earth.'

Is there then no fixed point, no common denominator, that we may take hold of and say 'this is the real man?' Surely there is, and that the simplest and most obvious—his work. It is true that he has not always painted in the same style, so that it is possible to speak of a Venetian period, a Camden Town period, a Bath period, etc.: and that even within these periods there is more of variation than of uniformity. But this variety, while typical of the inquisitive and experimenting nature of the man, is not haphazard or fashionable in its origin: but is based on a solid foundation which remains constant beneath every change. Thus it is very important to determine the qualities which are common to all his work, as it is only then that it can be seen as a rational

* See Notes beginning on p. 315.

SALLY

W.R.S.

whole, or that the man himself can be understood. For the work is the mirror of the man.

First then Sickert is before all else a craftsman. From the beginning he has had a true workman's respect for the tools and materials of his trade. To know all their qualities, all their possibilities, as well as all their incompatibilities: to follow with loving admiration the practice of the greatest masters of the profession: to be able to use them with such confidence and sureness that in the end the hand might be forgotten and the mind set free; this was to him much more than an interesting research, it was the very foundation of the painter's art. 'Half the artist is his knowledge of what is properly the raw material of art.'[2] Without it nothing durable can be made. As well entrust the building of a bridge to an engineer who knows nothing of the strengths and weights of his materials.

The hall-mark of this ingrained craftsmanship may be seen in the least as in the greatest of Sickert's pictures, and in all his periods. In an age which puts the highest premium on aesthetic and none whatever on the technical skill of the artist, the quality of his paint-work as such stands out with an added significance. But probably there have been few painters at any time with greater knowledge of the oil medium, or skill in using it.

Besides this care for method, there is a quality of robustness which is common to all his work. It is the exact opposite of the aesthetic refinement of the 90's. Sickert is always near to the earth. He is never in the clouds. He shirks nothing, flatters nothing, denies nothing. A spade in his hand may sometimes resemble a plough: never a gentlewoman's trowel. He has had no predilection for the ugly or sordid in life: but the refined, the genteel and the tasteful are even more repugnant to him. Sickert is at home with the common man, and out of him, his wife, his pleasures and even his boredoms, he has created his art. 'The more our art is serious,' he says, 'the more will it tend to avoid the drawing-room and stick to the kitchen. The plastic arts are gross arts, dealing joyously with gross material facts. They call,

in their servants, for a robust stomach and a great power of endurance: and while they will flourish in the scullery or on the dunghill, they fade at a breath from the drawing-room. Stay! I had forgotten. We have a use for the drawing-room—to caricature it!'[3]

There is a special firmness even in the way in which he puts the paint on the canvas; scrubbing in the larger areas 'as a man would scrub butter from the soles of his boots on a granite slab', and laying on the final touches in clear discrete strokes. There is nothing weak or indecisive about Sickert's paint. 'Decision is the fence before which our poor humanity will eternally jib. . . . Education is the training to face these decisions, to take them, and their consequences. . . . Whistler often said to me from the depths of his soul, ''We have only one enemy, and that is funk.'' '[4]

A third characteristic of his pictures is that of movement. Something is happening or is about to happen. It may be only a mood or the passing of a day. But it is felt and meant to be felt, as essential to our pleasure as the design and the quality of the paint. More often there is a whole story, which unfolds to our imagination. 'It is just about a quarter of a century ago,' he wrote in 1912, 'since I ranged myself, to my own satisfaction, definitely against the Whistlerian anti-literary theory of drawing. All the greatest draughtsmen tell a story. When people, who care about art, criticise the anecdotic ''picture of the year'', the essence of our criticism is that the story is a poor one, poor in structure or poor as drama, poor as psychology. . . . A painter may tell his story like Balzac, or like Mr. H——s. He may tell it with relentless impartiality, he may pack it tight with suggestion and refreshment, or his dilute stream may trickle to its appointed crisis of adultery, sown thick with deprecating and extenuating generalisations about ''sweet women''.'[5]

The last of these common denominators to be mentioned is a negative one, but no less important. In all Sickert's work there is an absence of deep emotional feeling. He has not that wide

human sympathy, that awe in the face of nature's power and man's littleness, or that *saeva indignatio* before cruelty and injustice, which give such weight to the works of Rembrandt, Turner or Goya. There is sometimes irony and even bitterness in his pictures, which he is too big a man to degrade into cynicism, but not big enough to raise to tragedy. If there is no sugar of sentiment, there is equally no wine of passion; unless it be the pure passion of paint. The chief drama of his pictured world is the drama of light and shade. The relations between his men and women remain elusive, mysterious, even when most intimate. They seem to feel neither tenderness nor lust: but often indifference, which is perhaps how Sickert himself regarded them.

His friend Jacques Blanche says of him: 'As in the case of Degas, there is cruelty, disgust, and sadness in the scenes and characters of his *genre* paintings, a pathos which never degenerates into sentimentality; and principally a disdainful discretion, a sort of self-defence, in his attitude towards human contacts—*noli me tangere*. He needs but a commonplace object well set in an uninteresting interior in order to evoke a dramatic quality, to suggest situations guessed rather than seen. All relations with Sickert have an extraordinary, a mysterious character.'

It would be easy to continue the argument and in greater detail; but I have wished, in this introduction, only to brush in the main lights and shades of a portrait, and above all to make clear that it is in his works that the man may be found and recognised. The chief reason, more, the only justification, for writing about a painter is that others may be led to LOOK AT his pictures and delight in them. But if their delight is not spontaneous and true, no book can help them, though it be written with the pens of angels. The only proper reaction to a beautiful picture is an inward shout of pleasure: and the only proper function of the critic is to give body to that shout in print—or to note its absence, for nothing can take its place. Too often the approach to pictures is made through the turnstile of the written word. Half

our culture is but review-deep. We are taught to look for authority, not to look for ourselves. But the only authority is the eye of the spectator. Let us abolish the call of 'he that hath ears to hear, let him hear', and substitute, at least in our picture galleries, 'he that hath eyes to see, let him see.' This dependence on advertisement, for it is nothing else, has been the *fons et origo* of the cult of Cézanne and the school of Paris, and of the blindness to our own great master in England. 'Some hold,' he says himself, 'that art is a cryptic matter, about which doctrines must be laid down as from the initiated to the profane. Others that drawings, statues and paintings are themselves the doctrines, which he who runs may read. The great reputations have been made by silent and unanimous acclamation.'[6]

# CHAPTER II

# FAVOURABLE AUSPICES

The works of an artist are the resultant of many forces. First there is BREED: all the inherited traits of the individual man. Then ENVIRONMENT: family life, education, the social characteristics of the time and place in which he lives. Lastly the ART, which itself has had an evolution of its own, whereby each stage is fore-moulded by that preceding, and holds within its womb the fashion of the next. Not, of course, that art is an independent regency, promulgating its own laws of progress; rather is it a single thread in the warp of man's condition, colouring but not defining the pattern, which is shaped and bounded by the whole of his experience. Art indeed is a mirror in which the generations see themselves. What is the modern craze for originality but the reflection of an age which, with all the outer aspects of vitality, is in reality living on its nerves, unable to accommodate itself to new conditions and new inventions too rapidly accumulated, restlessly searching for it knows not what?

So then in the life of a painter the individuality of the man is impacted on the circumstance of the art. The paintings which are the product of this mating take their place in the history of art: but there is a tendency to divorce too widely the works from the men, to generalise over schools, emphasising their affinities and antipathies, and to forget the unique living beings who created them. Thus, even within their own life-time, the

11

conspirators of the Café Guerbois were in danger of losing their identities under the trade-name of Impressionism. Yet, of the two, the finished work owes more to the personality of the artist, which is concrete and individual, than to the 'state of art' in his day, which is an arbitrary generalisation.

<p style="text-align:center">*   *   *</p>

Walter Richard Sickert came of a line of painters. Of his grandfather he wrote: 'Johann Jürgen Sickert was born 1803 in Flensborg. He was at the same time a painter of easel pictures and head of a firm of decorators, who were employed in the royal palaces by Christian VIII of Denmark. He lived and carried on his business in Altona. He was a great dandy and wrote *vers de société*. He drew up a long and elaborate report at the request of the municipality of Altona, containing his scheme for teaching drawing to the pupils of the new Sunday continuation classes. "It will be of more use," he wrote, "to a carpenter, a turner, or a smith, if his lessons enable him to draw a vase or an ornament correctly, than if his schooling results in nothing more than the adornment of his bedroom with a few trophies, which it is clear to him that he did not then understand, and which he cannot now use." When his son Oswald was studying in Paris, the letters of Johann Jürgen generally contained as their *Carthago delenda est*, the words, "*Male gut und schnell*," which, being interpreted means, "Paint well and quickly." My grandfather Sickert was one of the earliest lithographers.'

And of his father: 'Oswald Adalbert Sickert, son of the above, was born in Altona in 1828. The astonishing portrait of himself at the age of sixteen certainly justified the gracious interest that was taken in him by H.M. King Christian VIII of Denmark, who conferred on him a travelling purse to Copenhagen. I remember my father saying to me, when I was about sixteen, and saturated with the National Gallery and Charles Keene, "When I was your age, I had never even seen a good picture." He studied in Paris under Couture. From 1859, the year of his marriage at Harrow, to 1868, he was a regular draughtsman on wood for

MUSHROOMS

the *Fliegende Blätter*. In 1868 he settled in England, where he was a frequent exhibitor at the Royal Academy. He acquired his wife's nationality by naturalisation during the minority of his six children. He died 1885, and his grave is in Brompton Cemetery. My father was an extremely taciturn man with a wide critical comprehension. He read music like a book. He judged himself as coldly as he did everything else. He was not at all pleased when one of his sons, in the absence of their father, entertained Sir Frederick Burton by pointing out the parental woodcuts in bound copies of the *Fliegende Blätter*. I have never forgotten anything he said to me.'[1]

He continued to paint up to the time of his death, shortly before which he had been honoured and delighted by the praise of Degas, whom he greatly admired, for some of his pastels. Painting and music were the absorbing interests of his life. He was of a quiet and retiring nature, though joyful of company, especially musical company, and of musical entertainments such as singing and dancing. He was nervous and apt to find his large family an irritating distraction in a small house. He kept a strict discipline with sons and daughter, but was content to be guided in most things by his more practical wife. He did not talk freely with his children, but they remembered what he said the more. His determination that none of his sons should follow his *chien de métier* did not carry the strength of its accomplishment. He had no strong views on politics or even on nationality. The conquest of Schleswig in 1864 made him a German, and he lived many happy years in Munich of Bavaria. He was equally contented later to adopt his wife's nationality, which he did to save his sons from conscription in the German army. Though still a comparatively young man when he came to England, he lacked the energy, rather than the talent, to make a name for himself in the art world of his new country. But he brought up five sons and one daughter and that stands him in place of many pictures.

In all this there is little resemblance to his eldest son. When, however, we turn to the mother's side we find more revealing

evidence. Of his mother herself we know that she was beautiful, strong, energetic, full of gaiety and life: musical by instinct: singing much both to herself, her husband and her children for the pure joy of song. The cares of a small income and a large family did not lessen her zest for life or spoil her even temper. She, too, was forced by circumstances to keep strict discipline in the crowded home; but it must have been a very quick and easy discipline, accepted as a just necessity and soon forgotten in the fun and liberty that followed. She also painted, though only as part of the expected accomplishments of young ladies. She was fond of society, loved parties, and was the central figure of a household which attracted people of all stations, characters and professions to its circle. Her own mother had been an Irish dancer, and her father a well-known astronomer at Cambridge, a man of wide culture, ready wit and devoted to polemical discussions on a large variety of subjects. He was also a great letter-writer; in short a man whose tongue and pen were always on tiptoe to serve a brilliant and enquiring mind.

Here at last there is a real foretaste of his eldest grandson. Inherited characteristics are known often to skip a generation, and in this case it seems that the mingling of races which followed was the right formula to bring out the astronomer's peculiar genius in a more marked and more productive shape.

The fact that both father and paternal grandfather were painters has no genetic significance by itself. The art and craft of painting is an acquired characteristic which is not inherited, though a tendency towards artistic expression in some form or other may be so. It is much more probable that an upbringing in a household, where drawing and painting were a paramount interest both in practice and talk, should direct towards that particular form an attention which might have borne different, though equally significant, fruit in other surroundings.

At any rate this flint of Denmark and this steel of England came together and emitted six sparks of which the first and brightest is the subject of this history. Before we leave the vexed

question of heredity altogether, however, we may turn for a moment to those other five sparks which came from the same source. Although none received quite the same impetus which carried the eldest brother so far, none started life without some share in it. The two brothers who succeeded Walter Richard were both drawn to the profession of painting, but the tide of circumstance was against them, and neither had the strength, mental or physical, to make headway against the current.

Robert Oswald was a handsome and cheerful boy, with a gift for comic writing and drawing. He was for a time employed as secretary to the Carfax Gallery under Arthur Clifton.

Bernard was a painter, with a light intimate quality in his work, which was chiefly landscape. He was essentially a 'prima' painter, working on a limited scale, quick to capture a fleeting mood of nature, but unable to improve on the first impression by subsequent work. His health, which was never strong, was not improved by misunderstandings at home and at school, or by a succession of uncongenial and sedentary occupations, before, with Walter's help, he succeeded in breaking free and devoting himself entirely to painting. He was an omnivorous reader. He exhibited for several years with the New English Art Club, but he had not the energy or stamina for success, and later became depressed by a sense of failure in life. Nevertheless he lived to be seventy.

In the fourth child, Nelly, we find again the fire and independence of the astronomer grandfather. After a rather stormy childhood, marred by ill-health, she developed a strong and ambitious personality. The path of a woman toward an active part in the world's affairs was even less easy at the end of the last century than now, and the fact that Miss Nelly succeeded in overcoming first the opposition of her parents and then the prejudices and obstacles to a public career, tells clearly of the determination and vitality of her character. She was early forward in the movement for women's suffrage, and later was a prominent figure in the British Empire Delegation to the Assembly of

the League of Nations at Geneva: though these are by no means the full tally of her activities. She had numerous and devoted friends throughout her life. In 1935 she published the memoirs of her long and active life under the title of *I Have Been Young*, from which I have gratefully taken much of the material for this chapter.

Oswald had the particular charm, which was so characteristic of the family, in full measure. He made friends wherever he went, which, at one time or another, included the greater part of the habitable globe. He was considerate of others, and particularly of his mother, whose favourite he was. He had a keen critical intelligence, especially in music and literature. After leaving Trinity, he was very interested in journalism, but later joined the firm of Hooper and Jackson, advertisement agents for *The Times*, for whom he travelled all over the world. He was not a creator, but apparently he was a very good salesman.

The youngest, Leonard, was the most musical of the family. He was trained as a singer, and has given many successful concerts.

\*　　　　\*　　　　\*

Samuel Butler in his *Note Books* says that, after every experience in life, we become a cross between that experience and our former selves, and that therefore is it so necessary that we cross ourselves only with good and beautiful things. The jargon of modern science would put the same thought into other words, namely that living is a process of 'conditioning' the few elementary faculties with which we are born. At any rate the early surroundings of Walter Richard Sickert, or just Sickert, as a painter may be known by his signature—a signature which Walter justified to his brother by pointing out to him that, 'If we had been girls, I should have been Miss Sickert, but you would have been Miss Bernard Sickert'—provided many good crosses for the growing body and mind, and relatively few bad ones. Certainly no one can altogether escape the latter in this world of mingled blessings, but the young boy was happily free from

any of the major misfortunes of childhood; except only that, before the family left Munich, he had two unsuccessful operations for fistula, before being brought to England and cured by Sir Alfred Duff Cooper. His great-aunt, the sister of the astronomer and the fairy godmother of the young family, took rooms for them in Duncan Terrace, Islington, so as to be near the City Road Hospital, where Sir Alfred worked. Thus early did Walter begin his life-long association with North London. Apart from this, and the minor ailments of childhood, bodily ill-health never stood sentinel, as it all too often does, against the sane development of the whole boy and man.

Sickert's father and mother had met and courted at Altona, whither the young English girl had been sent by her father to the house of one of his Danish colleagues for the study of music and languages. They were married at Harrow in 1859, and for the following nine years they lived at Munich where the father was on the staff of the well-known comic paper, *Die Fliegende Blätter*. They stayed in the town only for the winter months, passing the summers in the lovely country near at hand, walking in the forest, and staying at small inns or peasant cottages. Though they were poor, they had a large circle of friends, both German and English, and, apart from painting, music and musical entertainments formed their main and sufficient interest. The first son, Walter Richard, was born on May 31st, 1860, and in the three succeeding years three more children, Robert Oswald, Bernard, and the daughter Nelly were added to them. If they cannot be said to have been born with silver spoons in their mouths, at least they found a precious heritage in the friendly and cultured atmosphere which surrounded their earliest years. There is the picture (not a real one) of the small Walter sitting up in his high chair, waiting with father and mother for the arrival of *Die Fliegende Blätter*, in order to claim the envelope thereof for a hat. There is a picture (afterwards a real one) of him at the age of two, one night, when thought to be safely asleep, suddenly appearing before company completely naked. The painter Füssli,

a connection of the English Fuseli and a friend of the family's, was present on the occasion, and so delighted, that he insisted on painting *der prächtiger junge* just as he was: a picture which Sickert later called, 'first appearance on any stage as Hamlet.'

From the beginning the eldest of the children dominated the others, partly no doubt by the larger experience of age, partly by guile, but mainly from a superiority of wits, energy and charm, which he held throughout the whole of family life. He was a great reader, but his chief pleasure, from the earliest years, was in scribbling with a pencil or modelling in wax. He was very sociable and made friends everywhere: but he had a habit of dropping his playmates when least expected, leaving his mother to comfort them as best she might for his loss. Then, besides the play and mischief of childhood, there must be lessons, at this period chiefly from the father and mother: and it is significant that Walter is said to have learnt to read and write by himself, while the others, less inquisitive or less agile, underwent the ordinary discipline of schooling.

In 1868 they moved to England, after spending some months in Dieppe, where Walter began to learn French. After a short and rather painful residence at Bedford, where they nearly all took the typhoid and were generally miserable, they settled into a small house at Notting Hill. There the family was increased by the birth of two more sons, Oswald Valentine (1871) and Leonard (1873); and in 1878 another move, this time to Kensington, was necessitated by lack of space.

His first school was at Reading where the great-aunt lived. He went to lunch with her on Sundays, when she would give him his favourite dish of jugged hare. But he was very unhappy there and was soon brought back to London and sent to University College School. This did not last much longer, as he was expelled, because, he used to say, he sold doughnuts to the other boys at a profit! He denies this now, but it certainly seems a remarkable story to have made up.

About this time he used to walk with his father through Hyde

Park to his studio in Soho Square every morning. One day as they passed a memorial (near the little church decorated by Shields), his father stopped and said, 'There's a name you will never remember.' Walter asked him to walk on a little way while he learnt it: then called him back and repeated it perfectly. Not only that: but the other day, at his home at Bath, at the age of eighty, he wrote down the following words:

MAHARAJA MEERZARAM

GUAHAHAPAJE RAZ

PAREA MANERAMAPAM

MUCHER

K.C.S.I.

He was now sent to the Bayswater Collegiate School, which Mr. Hunt had opened at the corner of Pembridge Villas and Chepstow Place. They used to read Shakespeare in the gardens: and when the Tichborne trial started he followed it eagerly, thus beginning his life-long interest in the case.

Summer holidays were spent first at Lowestoft, then Morthoe, and later St. Ives. The great attraction at Lowestoft was the beautiful Mrs. Swears, whom he afterwards immortalised in one of the Echoes. After her morning bathe she drove up and down the front with her long hair floating in the wind to dry. The children used to run after her carriage in the hope of a bow or a smile.

But Morthoe was the real favourite. Many of their friends joined them there. Walter helped on the farm, learning to cut and bind the wheat, how to drive a waggon through a gate, and even getting up at four in the morning to milk the cows. One day he found an octopus on the shore, and, putting it on a slate, he carried it up the hill to show to Professor Huxley, who was staying there; after which they became great friends.

From Mr. Hunt's he went to King's College (in 1875), where, besides the Greek and Latin languages, he found out for himself the real delight of the classics as literature. More important than

W.R.S.

mere learning, however, was the development during all this time of that eager inquisitiveness which had marked him from the beginning. In 1870 he took a great interest in the Franco-Prussian war, following the siege of Paris, the Commune, etc., from the drawings in the *Illustrated London News*. At that time they were very keen on chess, and Walter invented a modification of it, which he called 'Sedan', in which the king could be taken. And, of course, both acting and drawing had already become absorbing interests. Both of these he took with him to King's College, where he was once caught drawing during class, but received no worse a punishment than the public exhibition of his caricatures. There, too, gregarious as always, he began to collect around him that large circle of friends which, expanding in one direction as it contracted in another, he was to carry with him through life. At home he not merely retained but increased his ascendancy over brothers and sister. His mother complained that they never seemed able to resist him, but she probably found it almost as difficult as they. This leadership was acquired not only through his cleverness and energy, but principally through the charm and interest which he managed to infuse into all their pursuits. In fact, throughout all these early years we get a cumulative impression of prodigious vitality which is the keynote to his future success. Who does not know the mighty oak in the midst of the forest, spreading and towering above all its fellows: and the feeling of delight, almost of awe, which its sudden-found majesty inspires? In the year of its birth, out of all the myriad acorns scattered broadcast over the earth, only that one had within its secret heart the vital power of pre-eminence. All is not luck in this rub-shoulder world of ours. The young sapling must have its chance, to be sure, but not all have the same energy of growth, the same *élan vital*, to carry them on and above their fellows. There are some that shoot up in youth with promise of great things, but lank and spindly, as if they knew that the first adversity would overwhelm them. But the true titans are made of a closer fibre. They develop more slowly, but sturdily, and,

once their roots are firm in earth, nor drought nor wind can stop their skyward growth. Something of this energy of spirit, this vital force, above the common measure of mankind, was given to Walter Sickert and formed him to be the great painter we know.

The value to Sickert of his early family life can hardly be exaggerated. There was a unity and, complementing that, a discipline, which is sadly lacking in many homes to-day. In a large household not everyone can always have their wishes; and it was not the way in those days for the children to be out so early on the business of their own pleasures, without regard for parents or brothers. Discipline may be likened to the dykes of a river. The constraint is irksome and the river seeks ever to burst its bounds. But we know that that restraint makes for the concentration of its power and that overflow is dissipation of power: which in a man without discipline means idleness and inertia. The Sickert family was a large one, and, while the children could be given good education, good surroundings and good friends, they would have to make their own way in the world. There was no chance of their being spoilt or made 'precious' or amateurish. Sickert was saved by circumstances as much as by his own character from the fate of the man with '£300 a year and a campstool' and 'nothing of Vandyke about him but the beard.'[2]

# CHAPTER III

# THE STAGE

❧

It has already been hinted that Sickert had become interested in acting at an early age. Indeed even as a boy he was stage-struck, and especially Shakespeare-struck. His first theatrical enthusiasm had been for Samuel Phelps, whom his parents had often taken him to see. When Phelps died, in 1877, Walter walked all the way from Kensington to Highgate in order to attend the funeral.

The favourite game of the four older children, directed of course by the eldest, was acting 'specially' exciting scenes from *Macbeth*, etc. In a disused quarry near Newquay Walter staged his first production, the Three Witches. Nelly, thin and with hair a-flame, was made to take off her dress and shoes and stockings, to brood over the cauldron, or circle round it, regardless of thorns and stones and the acrid smoke of scorching seaweed. On the cauldron itself Walter had carved 'Finger of birth-strangled babe, etc.' The company was drilled with the greatest severity (the witches were apt to miss their cue while hunting for blackberries). Rehearsals continued till they were all word-perfect. When the day came for the first full performance, Walter, dashing down the scree side of the quarry with a shout of 'How now, you secret, black, and midnight hags!' lost his footing and came down the rest of the way on his seat. The witches giggled irreverently, and the actor-manager stalked off with lofty scorn, turning at the end of the path for a Parthian shot: 'You've got no respect for Art!'

24

IN MEMORIAM

Later he organized a group of amateurs, called the 'Hyps' (Hypocrites), who rehearsed a great deal, but never arrived at a production. One summer he was invited to stay with Count Bozenta Chlaposki, and his wife Modjeska, the famous *prima donna*, at Cadgwith in Devonshire. Johnstone and Ian Forbes-Robertson were among the other guests. Modjeska had arranged to produce *La Dame aux Camélias* in a barn belonging to the Rector in aid of the church-repair fund. Johnstone was the *jeune premier* and Walter the *père noble*. He had ordered an imperial from Clarkson's for the part, but unfortunately it did not arrive in time for the performance. Seeing a white donkey in a field, he borrowed a pair of scissors from one of the ladies and snipped off some of the hairs from its tail. When the *père noble* came to kiss Modjeska on the brow, a very pathetic scene, he felt her shaking with suppressed laughter. 'I have never been kissed by a donkey's tail before,' she whispered to him.

At King's College speech day one year he gave a recitation from *L'Avocat Patelin*. He was able to recite French so well that even Frenchmen were deceived into thinking him a compatriot, and would launch out into conversation to which he could not reply. Another year he played the tent scene from *Richard III*, giving a remarkable imitation of Irving's mannerisms. Not content with this, he obtained permission, for the next, to give the same scene with his own interpretation of the part.

At this time the stage became a passion, having its focus in Sir Henry Irving. Walter, joining forces with others of his companions under the same spell, used to besiege the pit of the Lyceum, and afterwards form a guard of honour at the stage door. Through Irving he came to know many of the actors and actresses of the day, a particular friend being Ellen Terry, then a rising star in the theatrical firmament. He was also intimate with Forbes-Robertson, who had been a pupil at the Slade, and who painted a picture of Walter in the part of Romeo.

After matriculating from King's College in 1877 he wished to be a painter, but his father advised him to take up a profession in

which he would be certain of earning a living. So he decided on the stage. His first part, 'Jasper', was in a play at a theatre in Holborn, which was afterwards used by Carter to sell his tested seeds. He had only one cue, and never knew the rest of the story. The cue was, 'That man Jasper creeping among the laurels,' and then he knew he had to appear. One day he met a friend of the family, a Scotsman, who asked him what he was playing in. On being told he said, 'Take care, Walter, don't let it affect your true character!'

He then joined Irving's company, and tells how kind Irving was, making many allowances for his lack of experience. Make-up was one of his strong points, and he defied his mother to pick him out from the crowd as a shrunken, toothless old man. One of the company was called Tom Mead. He was an old and experienced actor, but when he had once got a word wrong, he was unable to correct it. For instance he always said, 'Dip it in *dragoon's* blood.' Irving tried to correct him, 'No, Tom, *dragon's* blood. You know, mythical animal.' Tom: 'Dip it in dragoon's blood—said it again, be-gum!' He played the part of the ghost to Irving's Hamlet. One night he found he could not get to the other side of the stage, where he should have appeared. So he came on behind Irving, saying, 'Here. Here.' Hamlet had to turn round. 'Quite a new effect, that,' said Tom afterwards.

While on tour in the provinces with George Rignould's company in *Henry V*, Sickert doubled five parts, and in 1929 could still repeat the part of the French soldier who is captured by Pistol, with all the old gusto. When Rignould came on to the stage at Manchester, mounted and wearing his heavy armour, the floor cracked ominously. Rignould jumped off and told Walter to sit on the horse's head. This he did, until it had nearly kicked its way through the stage, jumping off just as it went through. It took them all night to get it up again.

He played for a short time with Mrs. Kendal; and then with Miss Isabel Bateman's Company at Sadler's Wells. Of his part

in *A Midsummer Night's Dream*, when he had to rest upon the mossy bank, he remembers only the rattling of the boards under the weight of the fairies, 'so lightly, lightly do they pass!'

But beyond minor parts he never reached, and in 1881 he gave up the footlights for ever and devoted his whole time and his whole power to painting. The truth is that he himself had never had any doubt about what he wanted to do and what he could do; and it was only that the parental face was set against the profession of art, that he had for a while put it aside as a life work. But he had scribbled with increasing interest, since a child: and he was of too independent a character to be permanently directed by however well-meaning a father.

The theatrical connection, however, both at this time and later, was no mere accident in Sickert's life. It corresponded with—and fulfilled—the deepest needs of his character. His early *début* on the stage, and the long series of drawings, etchings, and paintings of music halls tell only half the story. Although he left the footlights for the studio so early, Sickert has been an actor all his life, the world his theatre, the gallery his stage, and the whole picture-going public his audience. His seeming eccentricities are merely the property of the actor. To accuse him of posing would be to miss the essential nature of the man; as well impute pose to the actor, clad in antique garb, mouthing his deep iambics on the stage. Even off-stage the actor must play a part continually. It is born in him. He cannot escape it. And so it has been with Sickert. Not only in talk does his mind continually revert to theatrical imagery and theatrical gossip: not only in company will he suddenly strike an attitude and declaim some favourite strophe, or bawl out the lines of an old music-hall song with all the savour and gusto of the original: not only has he remained to the last in touch with the profession, *persona grata* to the successors of Ada Lundberg and T. W. Barrett: but all his life has been the life of an actor, from such details as those of dress to that old-fashioned courtesy offered equally to titles or taxi drivers. He is a natural-born citi-

zen of that true Bohemia, where the relation of money to goods and services remains always on the plane of the fairy tale. In his emotional life no other and greater devotion is allowed to interfere with the one *grande passion*.

The art of painting itself is allied to that of the actor in that both are but a mimicry and a simplification of nature; but Sickert has carried the attitude of the actor into his painting life to an outstanding degree. Faithful first and last to the Art itself, submissive to tradition and the proper limitations of the medium, firm against the least intrusion of society or self-seeking into the privacy of his artistic convictions, the actor-artist is still naturally avid of applause. His delight is not, as some may have thought, in the limelight—but in the spotlight. For what other purpose is the actor there? The art is sacred, but the art is none the less for the use and delectation of the audience. The roar of applause is the natural response to a great performance. It is highly probable that there would be no great performances without it. To the artist it is the meat and drink which infuse new blood into the productive circulation. When the gods roar their loudest, Sickert too will give his encore: but, like the greatest masters of the profession, it will not be merely a repetition, but will have a new turn, an unexpected twist of line or character, which will bring the house down louder than ever. Sickert has never set out to *épater le bourgeois*. The god is stern and the true prophet obeys, if necessary crying out against the people uncomfortable things. But if the people hail him, even the prophet may be forgiven some satisfaction—and if the *bourgeois* is *épaté*, that also is not without its ironic savour.

# CHAPTER IV

# WHISTLER

At this time Sickert was lodging in Claremont Square, the green hill he could remember from Duncan Terrace days. Among those who went frequently to tea with him were the Misses Cobden. It was not long afterwards that he became engaged to Ellen Cobden; and his father, seeing that she had a fortune of her own, then agreed to his son's giving up the stage and studying painting. In 1881 he entered the Slade under Legros, but did not remain there long. His real preparation came from other sources. 'For the understanding of Whistler's painting, I had the good fortune to be prepared, in the '70's, by the fact that I had received my earliest artistic education from two painters, both also affiliated to the French school. The one was my father, who had studied at Couture's and was to some extent influenced by Courbet and Troyon, and the other was Otto Scholderer.'¹ Thus the elder Sickert had not been so far set against his son's adoption of his own calling, as to withhold all counsel on the subject from him. Indeed during the '70's father and son were frequent visitors together at the National Gallery and the winter exhibitions at Burlington House. His father must also have been responsible for his early enthusiasm for the drawings of Charles Keene and other black-and-white artists such as Wilhelm Busch and Adolf Oberlander, with whom his own profession had brought him in contact. With Scholderer he worked, contemporaneously with the Slade, at the painter's studio in Putney.

One day he met Whistler at a party; and the next, seeing him in the street, he followed him into a tobacconist's shop and asked if he might come to his studio. As a result, he was persuaded to leave the Slade ('You've wasted your money, Walter: there's no use wasting your time too!'), and go to help Whistler print his etchings.

James McNeill Whistler was already a lion of the artistic society of the day. Perhaps it would be going too far to describe him, in theatrical language, as a *lion comique*, but there was a theatrical air about his social fireworks, which probably added to his fascination for the young student. Like Sickert himself, Whistler was an actor on the stage of life. He became indeed the greatest one-man show in Europe. But again there was no pose about the man. The part he played was no figment, but himself. It was a good part and he knew it. All he asked was that the audience should be appreciative. Whistler's personality, his wit, his court-like entourage, his familiarity with France and French painting, together with a certain flattery, which the special attention of THE Master implied, would all have their part in the hero-worship, which Sickert now concentrated on his new idol. But these influences alone, strong as they were, would not have sufficed, if Whistler had not had at the same time great gifts to impart. In France he had been the pupil of Gleyre and of Lecocq de Boibaudran, who had been the master also of Fantin, Boudin, Cazin, Lhermitte and Lepine, and who taught his pupils to pay attention to values out of doors and to develop their visual memories. Sickert no doubt overrated these gifts during the early years of their association, but gifts there were, certainly greater than any others he could have found in England at that time. The very closeness of the association, which resembled the older, but never-bettered, system of apprenticeship was of inestimable value to him.

Sickert now became, for better or worse, the 'pupil of Whistler'. He went every day to the latter's studio in Tite Street, watching him at work 'on the Sarasate, the Duret, the

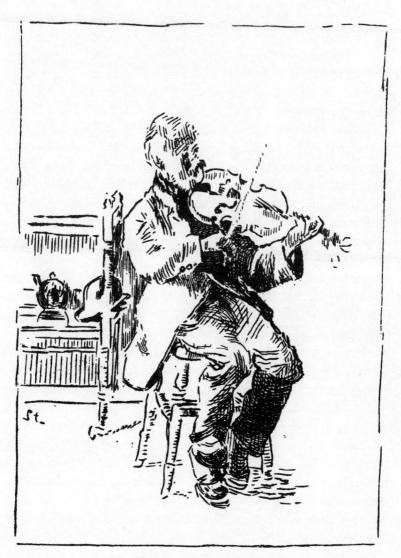

THE OLD FIDDLER

Lady Archibald Campbell, several of the Mauds, the Mrs. Cassatt, the blue girl, his own portraits, Lady Meux's, Stephen Manuel's, my wife's, Eldon's, the lost, stolen or strayed one of Miss Barr, Robert Barr's, my own, Mrs. Forster's, Miss Waller's';[2] and often working by him from the same sitter—'I painted a small panel of Duret, while W. painted his large portrait. The panel was exhibited at Suffolk St. . . . I painted a sketch of the blue girl, actually taking the mixtures off Whistler's palette. . . . I etched a plate of Stephen Manuel while he was sitting to Whistler.'[3] They were at St. Ives together for part of the winter '83–'84, going out before breakfast or at twilight to make those beautiful swift colour-sketches, which Sickert so much admired. He, and one or two other pupils were called 'the followers', and the Pennells give a rather ludicrous account of their subjection to the whims and caprices of their master. No doubt Whistler was exacting and capricious, but no mere tyrant could have inspired such admiration and loyalty in anyone as independent as Sickert. There was patronage in Whistler's attitude to his pupil, but there was affection too. Loyalty, however, always came first in his demands. He could not bear that his adherents should look beyond him, or even have opinions that were not reflections of his own. When Sickert ventured to praise in print Leighton's *Harvest Moon*, Whistler, hearing of it, telegraphed, 'The harvest moon rises over Hampstead' (where Sickert then lived) 'and the cocks of Chelsea crow.' The critics should limit themselves to his praises. 'Once, when I wished to introduce McColl to him, and thinking to prepare the way and to tinder, as they say in France, the spirit of the master, I said "You know, the author of that article in the *Saturday*, 'Hail, Master!"—"Humph,'" said Whistler, "that's all very well, 'Hail, Master!' But he writes about OTHER PEOPLE, OTHER PEOPLE, Walter!" Of course, with Whistler there was always a twinkle.'[4]

Of Sickert at least there could be no complaint on the score of infidelity. 'It was in 1892 that I may be said to have wound up

in these columns, a defence of Whistler begun in 1882 by a very *convaincu* paragraph to the *Pall Mall Gazette*. It was a defence that was carried on with some obstinacy in whatever papers would put up with it. In *Truth*, in the *Pall Mall Gazette*, the *Whirlwind*, the London edition of the *New York Herald*, the *Speaker*, and the *Saturday Review*, I insisted in season and out of season on the excellence and importance of Whistler's work. "See here, Mr. Sickert," said the sub-editor of the *New York Herald* to me one day when I met him in Regent St., "people are asking whether the *New York Herald* is a Whistler organ." . . . In 1889 Miss Goold allowed me to arrange a Whistler exhibition in the rooms of the working women's college, in the beautiful old house in Queen's Square.'⁵

To no avail. As the years passed, the pupil passed out from his tutelage. He had been to France himself, and there learnt other lessons than Whistler could teach. The latter, unfortunately for himself, could not brook a divided loyalty, and the rift, so small at first, gradually widened to a gulf of separation. As a matter of fact Sickert's admiration for his first master's work long survived the French influence. He met Degas for the first time in 1883, and again in 1885 they were together at Dieppe. Yet the *Whirlwind* articles were published in '90, and in the same year he opened an *atelier* at 1 The Vale, Chelsea, 'with Whistler's approbation'. In 1893 Whistler worked for a time in Sickert's studio in Robert Street. However, in '97 a suit was brought by Pennell against the author (W. R. S.) and publisher (Frank Harris) of an article, in which the word lithography was held not properly to cover the process of transfer lithography, in which sense it had been used by Pennell. It was a storm in a tea-cup. But Whistler in his evidence could refer to his once favourite pupil as an 'insignificant and irresponsible person'.

Whistler died in 1903. And in 1908 Sickert, whose own loyalty never wavered, but who had meanwhile come to measure his art by the scale of Degas, Millet and Pissarro and so could see his first master's work in truer perspective, wrote his summing-

up of the latter's achievements and non-achievements in one of his best critical reviews.

'It was Whistler's incessant preoccupation,' he says in part, 'to present himself as having sprung completely armed from nowhere. And it certainly was a flaw in his philosophy that he did not understand that it is no shame to be born. In matters of trade it is doubtless necessary to defend the originality and the copy-right of your trade-mark with vigilance. But pretensions of that kind are useless and confusing to the serious study of art. Pissarro is in no way lessened if a student is told, as a point of departure: "You may consider him as a kind of Courbet grafted on to a Corot." We are only by this means inducted into a sympathetic comprehension, which is likely to take us quicker and further along the path of Pissarro's life-work, and make us appreciate more intensely the great resultant, of which his very self remains, naturally, by far the preponderant factor. . . .

'If Whistler has himself left, in an interesting and passionately felt lifework, a contribution to our better understanding of the traditions of painting, he has also done another thing. He has sent the more intelligent of the generation that succeeds him to the springs whence he drew his own art—to French soil. He had the great good fortune to learn painting in Paris, while the traditions of David and Ingres and Delacroix were still vivid, and his talent had the extraordinary instinct of self-preservation through years of residence in England, never to let go again of what he had learnt from Gleyre, Lecocq de Boibaudran, Courbet and Fantin. That instinct of self-preservation in a talent is what constitutes genius. George Moore has quoted Degas: "*Tout le monde a du talent à vingt-cinq ans. La difficulté est d'en avoir à cinquante.. . .*" '

"*Il a du talent, le petit Whistler,*" Courbet used to say, "*mais il fait toujours le ciel trop bas, ou l'horizon trop haut.*" Japan was breaking up the admirable *bonne peinture* of Paris. Whistler's talent survived the internal conflict, the only real one for him, and evolved in his Nocturnes, his little streets, and seas, and

W.R.S.

shops, that something new, which justifies an artist for his existence.

'I see him settling in London towards 1860, at first puzzled, bewildered, and no wonder.

*Navire loin du vrai port assablé!*

'He had come from the wholesome rigid common sense of Paris . . . to the lilies and languors of the Chelsea amateurs. I had almost written "aesthetes", when I reflected that they were perhaps anything but perceivers. "Rossetti," said Whistler once in a burst of frankness, "Rossetti is not a painter, Rossetti is a ladies' maid!" . . . I see *la bonne peinture* breaking up; a confusion—how natural to a young man so isolated—creeping in upon him. Perhaps the aesthetes were right? Perhaps he could retain his good painting and yet satisfy the English thirst for sentimentality? Suppose we get the loveliest woman procurable, and put her in the finest robe imaginable! Suppose we even design the dress! Greco-crinoline, shall it be? No; Japanese, perhaps? Let us surround her with the most precious china! Let there be sprays of azalea, and so on! Perhaps we shall thus create a very paradise of art! Who knows? . . . Why should it not be able to contain *la bonne peinture* as well?

'Again I find it difficult to say why it cannot, but we all know that it cannot. . . . Taste is the death of a painter. He has all his work cut out for him, observing and recording. His poetry is in the interpretation of ready-made life.'[6]

In another place Sickert compares the different uses to which the stimulus of the Far East was put by the Impressionists and Whistler. The former, 'having their roots firmly embedded in the tradition of the school of their country, digested the East, took from it what they wanted for their nourishment, and rejected the rest. What they learnt was entirely assimilated. They went on with their own business, like a cobra who has swallowed a goat, goes quietly on with his own business of being a cobra with the goat inside him. Whistler, coming from a

country with no traditions, did not stay long enough in France to affiliate himself to the French school as he might have done. So when, among the Chelsea aesthetes, he came under the fascination of the Japanese imports, he did not digest what they had to teach. He painted pictures in which Japanese fans were pinned on to English walls, and English ladies were popped into kimonos on Chelsea balconies. . . . Instead of the cobra who had swallowed the goat, he was rather like a cobra who wondered whether he hadn't become a goat.'[7]

In no branch of his art was Sickert more indebted to Whistler than in etching. His interest in a medium, which never wholly suited him, was first aroused by the example of his master, an example which he followed both in spirit and letter. In his earliest plates, indeed, it is difficult to distinguish the chrysalis from the butterfly. They were drawn, bitten and printed in Whistler's studio. Once when Sickert dropped a plate that he was biting, Whistler said, 'How like you, Walter.' A little later, having dropped one himself, 'How UN-like me,' he drawled. Of Whistler's own etchings he wrote, in after years:

'I remember with delight a lesson in the art of controversy that Whistler gave me in the early '80's. He said: "You go to work in a ponderous German manner, answering objections, controverting statements of fact with tedious arrays of evidence. Now that's no use at all. People haven't time. When a tiresome person bears down on you with a stodgy array of learning and argumentation, what you've got to do is simply to say 'Stocking!' Don't you know? Ha! Ha! That's it! That's controversy! 'Stocking!' What can they say to that?" I don't suppose that this lesson has ever been published, and I am rather glad that I happen to remember it, as it embodies, in a concise and delightful form, a considerable part of Whistler's theory and practice in controversy. In spite of the fact that Whistler said "Stocking" to Mr. Hamerton several times, Hamerton's criticism of Whistler's etching, published in '68, remains unshaken, and amounts to this, that Whistler's Thames etchings were not FINISHED but

simply LEFT OFF, which is a different thing. They were left off because he had not the artistic training and experience needed to build up his plates from drawings, and because he had not yet tapped the well of free and inspired improvisation from nature, which he eventually reached in such plates as the *Rialto*. . . . I think that Poynter was mistaken, in deploring as he did to the horripilation of the more abject Whistlerians, Whistler's lack of a sound training in drawing. May not the very amateurishness of Whistler's equipment as a draughtsman have been to him a blessing in disguise? The homing instinct that guides the perilous flight of the lonely talent to its appointed end, like the way of a man with a maid, defies analysis. Was it not perhaps that very amateurishness that, refusing to him, over and over again, achievement on lines of ordered composition, threw him back, baffled and in despair, on the cultivation, to the pitch of ex-quisiteness, of his genius for swift improvisation from nature. His method was not suited, it is true, to bring out the topo-graphic interest of architectural subjects. I remember that it was not till I had brought a mirror that I could convince the owner of the Ca' d'Oro that one of Whistler's etchings ended next door to his own palace. But in scenes like *The Long Lagoon* or *The Rialto*, there is a flower-like charm, a magical breath of life and immediateness, that not only justifies itself, but confers dignity and importance on every step, however stray or halting, in the long road they had behind them.'[8]

'I imagine that, with time, it will be seen that Whistler ex-pressed the essence of his talent in his little panels, pochades it is true, in measurement, but masterpieces of classic painting in importance. While his maturer etching inclined to a superficial hinting, to a witty suggestion, of form, what our national critic has called "pirouetting on paper", the paintings have always weight. The relation and keeping of the tone is marvellous in its severe restriction. It is this that is strong painting. No sign of effort, with immense result. He will give you in a space nine inches by four an angry sea, piled up, and running in, as no

painter ever did before. The extraordinary beauty and truth of the relative colours, and the exquisite precision of the spaces, have compelled infinity and movement into an architectural formula of eternal beauty. Never was instrument better understood and more fully exploited than Whistler has understood and exploited oil paint in these panels. He has solved in them a problem that had hitherto seemed insoluble: to give a result of deliberateness to a work done in a few hours from nature. It was the admirable preliminary order in his mind, the perfect peace at which his art was with itself, that enabled him to aim at and bring down quarry, which, to anyone else, would have seemed intangible and altogether elusive.

'It was always a grief and annoyance to those who loved and admired these rare and precious qualities in Whistler that he would so constantly leave his easel for his writing desk. Sitters would wait for hours in the studio, while he polished a little squib for Mr. Edmund Yates. For the literary preparation of the collected quarrels, the studio fire was needs let out for months at a time, to the benefit, maybe, of the book-sellers, but at an irreparable loss to art. A painter must not quarrel. It makes his hand tremble, and destroys the serenity of his contemplation of nature, which is often the only thing the poor devil has got. Goethe's words to Eckermann cannot be too often quoted: "He, who wants to work in the right way, must never scold, must not concern himself at all with what is being done in the wrong way, but must simply continue to work in the right way himself."

'Among the cloud of witnesses called by Mr. and Mrs. Pennell we get delightful and touching glimpses of the light of far-away days. The diary of the painter's mother depicts the child the same as was the man I knew; sunny, courageous, handsome, *soigné*; entertaining, serviable, gracious, good-natured, easy-going. A *charmeur* and a dandy, with a passion for work. A heart that was ever lifted up by its courage and genius. A beacon of light and happiness to everyone who was privileged to come within its comforting and brightening rays. If, as it seems to me,

humanity is composed of but two categories, the invalids and the nurses, Whistler was certainly one of the nurses.'[9]

Could any man desire a better epitaph?

\*     \*     \*

Of Whistler's influence on Sickert's own painting we may say that he absorbed all that was best, and instinctively rejected the worst. He learnt to draw from the centre outwards, relating the radiating lines of the drawing to the 180° of a half-circle. He learnt to sketch rapidly from nature with the pencil, the etching-needle, and, with already mixed colours, on small panels in oil. He took over *tale quale* Whistler's dark tones and muffled colour, so that Degas complained, '*Oui! C'est bien!—mais tout ça a l'air de se passer la nuit!*' The dark tones by themselves, however, were nothing. Sickert well understood that it was the subtle relation of one to another throughout a very limited range, that made the strength of Whistler's painting, as it became also one of his own that he never relinquished. His early work, up to the end of the Venice period, contains much of the calligraphic element which Whistler took from the Japanese, though he avoided the 'slippery strip touch, which was the former's worst fault'.[10] And finally he adopted an extreme simplification, in which the interest is concentrated on a few main forms, with all extraneous detail subordinated or omitted.

But all these means he used to his own ends, completely different from those of his master. From the very beginning he rejected the artificial 'arrangements' of Tite Street and Cheyne Walk. He preferred to go straight to the life which surged around him, which laughed and wept and worked and went to bed, and in which his 'arrangements' were ready made. 'The truth is,' wrote Middleton Murry, 'that Sickert had in his whole composition scarcely a grain of the exotic. He came of a line of artists; the craft was in his bones. Like all hereditary craftsmen, he was naturally a coarse feeder. He was bound to react against the predigested nutriment, on which Whistler so elegantly, and at times so unsatisfyingly, supported the life of

his art.' It is important to remember, too, that other influences were at work very early in the moulding of his outlook on painting. His meetings with Degas in '83 and '85, and with others of the French Impressionists about the same time, pointed the way to a simpler and more realistic attitude to art.

Whistler's influence, however, was not only felt in relation to art. It was strongest at that most impressionable age, the early twenties. For the time Whistler was the ideal, not only in painting, but in life, in manners, in everything. Sickert's literary style, indeed his habit of writing for the press at all, owes much to the caustic author of *The Gentle Art*. Even his preference for telegrams as a means of communication may have originated in the '80's. The fact is that Whistler's and Sickert's natures swung together in that they were both actors at heart, declamatory, incisive and oracular. Whistler, with his independence, his wit, and also with that 'terrible, straight and ineluctable conscience of his'[11] was the pattern of what Sickert first formulated as an ideal, but knew also that he had it in him to realise. Sickert had already felt the word working within him. Whistler was the word made flesh.

# CHAPTER V

# THE MUSIC HALLS

ᒭᘺᒮ

The historian cannot afford to specialise. The painter cannot afford not to. He must be able to indicate a whole race in a head, a class by an attitude, a city by a single house. The life of a great metropolis may be mirrored in any one of its popular institutions, and in his search for London, Sickert chose the Music Halls as the scene for his first subjects. The choice could hardly have been better. The Halls, in the '80's and '90's were a microcosm of the town. As in the West End, so in Shoreditch and Camden Town, in Poplar and Hackney, they were the centres of their own particular night-life. They were of recent origin, having developed from the old sing-songs attached to public houses, where the performers could exchange pleasantries or otherwise with their patrons. Admission was gained by the purchase of a refreshment ticket, often as little as twopence, which entitled the holder to a drink as well as the entertainment; a custom which was still in force in the middle '80's, notably at Gatti's and the Shoreditch.

The audience sat at little tables. There were bars and waiters everywhere: and a chairman who announced the turns and kept a certain amount of order. There were eighteen or twenty turns and the performance started at 7.30, ending at midnight. At the Standard, where the Victoria Palace now stands, the stage jutted out into the room; it was here that George Leybourne sang 'Champagne Charlie'. The Eagle Tavern

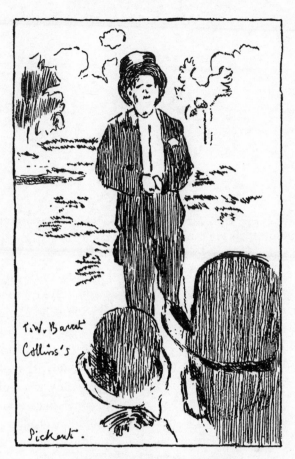

T. W. BARRETT, COLLINS'S

and Grecian Saloon, in the City Road, was immortalised in the couplet:

*Up and down the City Road : in and out the Eagle :*
*That's the way the money goes : pop goes the Weasel.*

the 'weasel' being a tailor's iron, which could be pawned.

The watchword in the early days of the Halls was, 'Hit 'em and hold 'em!' The patrons were a tough lot, and if the performance did not catch on, the wretched artist was lucky if over-ripe tomatoes were all he had thrown at him. Some owners of the first halls used to take the precaution of relieving their clients of any loose fruit they might have brought with them. In the '70's none of the big halls had yet come into existence; but they were in full swing when Sickert came on to the scene in the '80's. They were theatres in form and scope, though the bar was still one of the chief centres of attraction.

Those were the halcyon days of the Halls. The Stars shone their brightest on Ambrosian nights. Dan Leno, the Great McDermott, Vance of 'Slap Bang' fame, Vesta Tilley, Jennie Hill, Bessie Bellwood, Katie Lawrence, Lottie Collins, were at the summit of their glory. Marie Lloyd had given her first performance at the Old Bedford at the age of nine. She appeared at the Grecian in 1884 as Bella Delamere, afterwards changing her name to Lloyd (from *Lloyd's News*) when she appeared at the Star in Bermondsey. The songs these great artists sang were slight enough; the tune was nothing, if not catchy; personality, movement, expression—in a word, style—covered every defect, and brought down the house.

The West End Halls had each their special devotees. An air of intimacy and friendliness surrounded them. Saturday afternoon at the Tivoli was the favourite meeting place for the stage, the bar, the ring, and the 'fancy'. The authors and illustrators of the *Yellow Book* foregathered at the Empire or the Oxford. But, characteristically, Sickert chose rather the smaller outlying alls, where the relations between the audience and the stage

H
47

were closer and less formal. Here was more vulgarity, but greater ease. The stars were at their best in the warmer emotional atmosphere. Wedmore relates how Sickert had warned him that Bessie Bellwood, for instance, could not be seen at her most reckless and abandoned west of the Old Mo' in Drury Lane. The patrons were the people of London, the 'lads' of the district, the local bookie and his clients. To them the music hall was more than a light diversion. It was an enchanted palace, where they could forget their troubles in a warm world of magic and romance. The Bedford music hall, known as the Family Theatre, was preferred by Marie Lloyd to any other. The audience was said to be the most democratic to be found in London.

Here Sickert was at home. As always he preferred the company of publicans and sinners to that of the sadducees or philistines. He came, not as an outsider to spy out the land, but as an intimate of the company, a player on the stage. He hob-nobbed with the chairman, and drove the stars from hall to hall in hansoms for their successive engagements. One night he and Katie Lawrence had just got into one outside Collins's, when the horse began to prance. 'Oh!' said Katie, 'a song and dance horse!'

He came because he loved it, because it was moving with a colourful, romantic life of its own. He loved the garish lights, the gilt and the crimson, loved the absorbed faces of the audience with their hats and feathers, loved the twined shapes of the orchestra and their instruments, the attitudes of the singers, the spot-lights, the curtains. To many it seemed, and still seems, a fault in Sickert that he chose always vulgar and tawdry subjects. The truth is he looked first for life and movement in his scenes, and found them more often in the poorer and uncultured corners of the earth than in the swept and garnished ones.

After he was married, and they were living in Broadhurst Gardens, he used to go nightly to music halls and walk home from Hoxton, Shoreditch, Canning Town or Islington, across Primrose Hill, and so on to Hampstead. He wore a loud check coat, long to the ankles, and carried a little bag for his drawings.

One night in Copenhagen Street a party of young girls fled from him in terror, yelling, 'Jack the Ripper, Jack the Ripper!'

He and his wife often went out to dine at little restaurants in Soho, and on to a music hall afterwards. The top floor of the house in Broadhurst Gardens was the studio. Katie Lawrence used to come and sit to him there. He did a number of life-size paintings of her (afterwards destroyed), and asked if she would like to have one. 'No,' she answered, 'not even to keep the wind out at the scullery door!' One day, coming over the rough ground where the workmen were building, she stubbed her toe against one of the bricks that were lying around. 'Oh, b— the bricks!' she exclaimed. A workman, who was walking behind her said, 'Quite right, marm, quite right! B— the bricks!'

Bessie Bellwood was living at that time in Gower Street. She used to be 'at home' after the theatre and give her guests a feast of tripe and onions. One night, when Sickert was there, she said, 'I've got something in your line, Walter,' and sent her servant Hoppy to fetch an old oil painting, black with grime. She had taken it to a restorer, who told her that for £40 she would be able to see what the picture was. Sickert asked for a bowl of hot water and started to clean off the dirt very gently. This was altogether too slow for Bessie. She rolled up her sleeves and grabbed the sponge, saying, 'Here, let me have a go.' Pretty soon they saw that the subject of the picture was St. Lawrence on a grid-iron. At that moment Hoppy announced another visitor, 'Someone to see you, Miss Bellwood.' 'I can't see anyone,' she answered. 'I'm giving Lawrence a Turkish!'

One day, when a cabby began to argue about his fare at her door, Bessie shouted, 'Do you think I'm going to stand here to be insulted by a low-down, slab-sided cabman? I'm a public woman, I am!'

<p style="text-align:center">*  *  *</p>

The music hall series of paintings is the only one which Sickert has made of public life. With the exception of a number of café and casino scenes, practically the whole of the rest of his

work has been in portraiture, architecture, landscape and the human comedy. For this reason alone they have a particular interest and importance. And then with how true and witty a comment he has portrayed the rich meaty life of the halls! Listen to some of the titles: *Second turn of Katie Lawrence at Gatti's Hungerford Varieties*: *Tom Tinsley in the Chair*; *Joe Haynes and little Dot Hetherington singing 'The Boy I Love is up in the Gallery' at the old Bedford*; *Cupid in the Gallery*; *Bonnet et Claque*, or *Ada Lundberg at the Marylebone Music Hall* ('*It all comes from sticking to a Soldier*'); *Noctes Ambrosianae*. Do they not make the mouth water like some rich list at Voisin or Foyot?

These pictures were, necessarily, painted from drawings. Night after night the artist returned to the same seat, until he had a collection of documents, some, the slightest, giving the pose of a single figure, others, of the stage and the decor of box or circle, carried to the furthest limit of detail. On the margins of some are scribbled the words of the song which was being sung: or an *aide-mémoire* to it in the form of the first letters of each word.

These labours were not always carried out without opposition. When he was making studies for the picture *Noctes Ambrosianae*, he asked permission to go up into the gallery which he was drawing. 'I am an artist', he explained. 'An artist, are you?' was the reply. 'Don't try that on with me, young man! You're one o' these County Council inspectors pryin' round to see if the railin's are safe!'

In the paintings he remained faithful for a long time to the dark Whistlerian tones (a few years later Gore showed how the same subjects could be treated with light colours). In the earliest the paint is very thin and smooth—'*peints comme une porte*,' according to the recipe of Degas—and most of these were painted between 1885 and 1895. After the return to London in 1905 he took up the series again, and in these the paint is thicker, the strokes being laid on in dots and dashes according to the technique he was then using. *Noctes Ambrosianae* is inter-

mediate in date, and was probably painted in Dieppe. Having all the necessary documents by him, he could take them up at any time or place for a painting: so causing great difficulty in the dating of many of his pictures. Some of the Venice pictures, for instance, were painted in Dieppe; not a few of Dieppe, in London.

Sickert's connection with the Music Halls, though broken, was thus a long one. Nor did he confine his attention only to the English variety. In Paris he used to frequent the Gaieté Montparnasse, the Gaieté Rochechouart, the Bataclan, Bobinos, the Eldorado, etc. At Dieppe he drew, in the evenings, at whatever theatre, cabaret, or other place of entertainment (such as the circus) was available.

In London after 1905 he remained faithful to his old favourites. Both the Bedford and the Middlesex had been transformed meantime. The decorations of the New Bedford were magnificent, and were soon pressed into service. They were used in fact for the finest of all the music-hall pictures, the tall panel-shaped view of one of the boxes, the parterre below crowded with its Cockney audience in all their Edwardian finery. There are at least three versions of it on canvas, the largest and most important being in the Leeds Art Gallery, two etchings, and of course innumerable drawings. The Leeds picture was one of a series, never completed, of large panels of the New Bedford, designed for Miss Ethel Sands' dining-room and painted in tempera about 1916-17. It is noticeable that in the later series, Sickert's chief interest was in the audience and the auditorium, while in the earlier it was divided between them and the stage. Of the New Middlesex the principal record is a view of the orchestra and front rows of the stalls, seen from a box, the hand-rail of which cuts across the bottom of the picture. Of this, too, there are two etchings as well as paintings, drawings and a lithograph.

After the war he made a new series of studies, going every night with Thérèse Lessore to one hall or another; and again of

late years he has turned to the theatre as a subject, working principally at Sadler's Wells. The old music-hall days, however, are the dearest to his memory, and he never misses an opportunity to tell stories of the great figures he has known, or to declaim a deep-throated version of one of their songs. Seldom have painter and subject been so well matched. It is not surprising that some of his best work should be found among these pictures.

# CHAPTER VI

# IMPRESSIONISM

The 1880's, the moment of Sickert's introduction to the scene of painting, marked the end of a long period of equilibrium, and the beginning of controversy and experiment in art. Conformity was giving place to originality; and although the latter was at first kept within bounds, which seem to us academic enough, none the less fierce was the opposition of the former in retreat.

In England particularly a sort of *Pax Academica* had endured since its foundation in 1768, wielding a paternal authority over the profession, and supplying (punning apart) a stable product for a stable demand. The Pre-Raphaelites had made but a very small eddy on the even current of artistic thought: for, though they cleaned their palettes of bitumen and brown glazes, they remained faithful to the two chief tenets of academic painting, 'high' finish and a strictly moral theme. And did not their chief, Sir John Millais, become the 'head of the profession', holding that 'a baronetcy was an encouragement to the pursuit of art in its highest and noblest form'? Moreover, when it came to a real rebel, 'there was one person, whose name seems to have sent a shiver down the spine of Millais. Where Virgil said, "*Guarda e passa*," to Dante, where Ingres said to his students in passing by some paintings by Delacroix, "*Saluez, mais ne regardez pas*," Millais said to Archie Wortley in front of Whistler's pictures at the Grosvenor, "It's damned clever; it's a

53                                                    W.R.S.

damned sight *too* clever!'' ''And'', said Archie, ''he dragged me on!'' '[1]

In fact, it was left to the American Whistler to carry the first seeds of rebellion from France to England, where he settled in 1859, the year before Sickert's birth. Whistler was connected with the Impressionist group by personal sympathies and by their common enthusiasm for Japanese prints, but he was never one of them in the way that Sickert later became. His translation into English of their creed was 'Art for Art's sake', and round this nineteenth century slogan the war of brush and pen revolved. It ended indeed in a victory for the French influence; but nothing, it seems, can quench the moral thirst of the English. It is not quite so bad with us as it was in the days of Mr. Watts, who 'was interviewed and made to say that technique was not his aim (skilful though he was to a high degree); that his pictures were not paintings, but sermons; that he was warring against crimes and oppressions, and so on. If in the 80's anyone had so much as squeaked in presence of a Watts, he would have been apostrophised on all sides, somewhat thus: ''But, disgusting person, you are then in favour of rapine and oppression! Learn that on THIS side of the Channel'', etc.'[2]

I say, it is not as bad as that to-day. 'Even in the England that loves *Vertige* and *Enfin Seuls*, a new generation is learning that the visible world is infinite and interesting. That all has not been said, when we have popped the jujube of sentimentality into our mouths and cried ourselves to sleep. . . . ''The spiral staircase'', I had the pleasure of hearing a distinguished non-conformist divine assert the other day, ''bends under the weight of the ascending ideal.'' A spiral staircase that bends is already broken, and we have no use for an ideal that breaks down a staircase.'[3]

Nevertheless even to-day 'art for art's sake' has become a duty in its turn, and Mr. Roger Fry himself rather resembles a non-conformist divine in his preaching than the high priest of a pagan cult.

And yet painting is nothing if not sensuous. Its essential an-

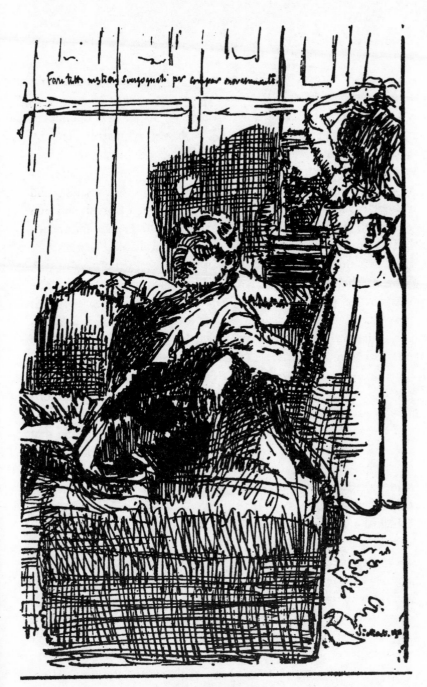

MR. JOHNSON

*Pen-and-ink drawing, 1911. In the collection of Maresco Pearce, Esq.*

tagonism to morality is proved by the puritan distrust of all things artistic. This is very well understood in France, where the dual aim has never existed in painting. On the other hand, as regards academic domination, the situation in France around the middle of the century paralleled quite closely that in England. Outside of the official salon there had been great painters, Courbet, Corot, Daumier, Millet; but their supporters were few and weak, and they themselves had made no effort to enter those doors, within which alone the honours and emoluments of the profession were to be found.

Such a renouncement, however, did not appeal to Edouard Manet. Besides being a great realistic painter, 'he was immensely preoccupied with exhibitions, with publicity, with the press. "*Alors, c'est entendu, M. Manet,*" a journalist once said to him, "*nous vous mettrons dans tous les enterrements.*" '[4] His personal elegance, his eminently Parisian personality, no less than the insults and abuse of press and public, marked him as the leader of the group of painters who met at the Café Guerbois, and who were later known as the Impressionists.

Of Manet's own painting Sickert wrote, 'He was the magnificent painter of the *morceau*. Give me a ham by Manet, a few oysters, a dish of figs, but an *Ecce Homo* is not for him. Give me by Manet a head with a bonnet, a figure in a crinoline with the delicious mixture of grace and *gaucherie* that touches the heart and clings to the memory, the eternal feminine that we can hold on canvas in the sunshine of art for years after the dear model has eluded our grasp. There is hardly any paint. No scaffolding. No groans. No cutting himself with a knife. But on to the canvas the artist spills a living being, with nothing, with a breath. In compositions like the *Ecce Homo* he goes off his own ground, where he stands firm and is supreme, on to a quaking morass. He becomes the critic, the appreciator. He says, "See how I admire Velasquez, Ribera, etc."; in fact, "see me tumble!"

'It is curious to see how this sort of insincere *tableau vivant* in a coal-hole dates. I can see it redrawn by Cham with appro-

priate legend, "*Le Christ ennuyé parce que les soldats Romains ne veulent plus manger des roseaux, mais demandent avec insistance des asperges.*" The little old gentleman on the left of the picture is Cham "all spat", as they say in France. And over the whole the touch of the born painter, doubled with that of the man who knows, almost too well, what painters like in painting. It is almost matinée painting, painting to a house filled with professionals, all paper. I can see a ceremony. Grasso should be there, and should come forward and embrace Mr. Peploe. Not a dry eye in the house!'[5]

Apart from their opposition to the Salon and the powers-that-were, the Impressionists had in common a realism which they inherited from Courbet and Corot. In place of the Classics they took their inspiration from the contemporary scene. They looked for beauty as it passed by. Instead of the ancient Romans or of models dressed up as such, they painted the Parisians in the mode of the day: and for landscape they preferred the open fields and rivers of France to the 'picturesque' ruins of an older civilisation.

'We may perhaps say that the addition made to the wealth of ideas by the Impressionists was twofold. They have shown us that composition has infinite possibilities, infinite permutations and combinations, other than those already found by the old masters. In this discovery their chief guide was nature. But their research was greatly stimulated by the importation of certain work from the Far East. . . . Their second gift has been an enlargement, equally extensive and important, of the understanding of colour, especially in the shadows. In this the essential fact was that they reacted from the abuse of glazes, which had completed the decadence of the art of oil painting. They returned to the practice of the great primitives, and secured their effects by the juxtaposition of definitely intentional colours, rejecting entirely the softening and dirtying veil of brown, which made, of a mechanical process, a substitute for the accumulation of touches of precise thought and observation.'[6]

# IMPRESSIONISM

Although sharing certain fundamental principles, each member of the group followed a separate and personal road. Each had an individual contribution to make to the common treasury. The landscapists were more closely associated than the others with the purely technical innovations. 'What is it', asks Sickert, 'that Pissarro, Sisley and Monet have had to remind us? They have had to repurge painting of the hollow brown shadows. They have had to point to the Venetians, and recite again this law: if you use colour at all, it is written in the immutable and mysterious laws of harmony that the colour in the shadow must be the sister of the colour in the light. . . . What is the sum of the teaching of the Impressionists in the matter of execution? Reacting from the tendency of much admirable work to become too set, they suggested forcibly that it were better to keep the execution of studies from nature in a state of greater tentativeness, or looseness: to sacrifice much of decision and authority, in order to remain a passive conduit for the fluidity of the shifting impressions received from nature.'[7]

Again, 'I will take as examples of pure Impressionism a Sisley or a Pissarro. In these, though exquisite places, or exquisite groups, are sometimes the excuse for the painting, the principal personage is the light. It was found by a pleiad of the keenest and ablest talents in history, that certain laws imposed themselves, if this protagonist was to remain paramount. It was found that direct painting in broken colour imposes a limit to the size of the canvas. The immense majority of Monets, of Pissarros, of Sisleys, are on a small scale, and, we may be certain, not for nothing are they so. Theirs is an art closely conditioned by an incessant readjustment and restatement of the message sent from the eye to the hand. I doubt if you are free to alter the sizes of the stitches in this tapestry of sensibility as you please. Certain relations in nature are stable. A general would be ill-advised, it seems to me, who ordered the step, in marching, to be henceforth lengthened. A cup must always retain a certain proportion to the hand that lifts it, and the mouth that is to drink from it.

So I am inclined to think that when we have been tempted to do Impressionism on the scale of the exhibition picture, we have run considerable risk of being losers of the essence of what we had learnt from the French Impressionists.'[8]

Of Renoir, Sickert had always the highest admiration. 'Renoir', he writes, 'is a classic example of the great painter who has achieved a series of masterpieces by the methods of the sketcher. . . . He had the good luck to enter upon the painting of easel-pictures after the finest apprenticeship conceivable, that of a painter on *biscuit*. . . . Instead of being demoralised in his youth by the "*gran' commodità*" of oil-painting, he earned his living at the age of thirteen in a medium which imposes, with every touch, decisions that are irrevocable. Painting on *biscuit* imposes also a certain order on the operations, which happens to be the ideal order for the formation of a painter. You are obliged to paint first and draw afterwards. The china-painter, therefore, instead of beginning by staining drawings with paint, enters his world, as he should, head foremost, literally a "born painter". I have named two forms of discipline that are imposed on the potter's servant, but there is a third. The painter on *biscuit* knows that the lamp behind his purple jar is the white ground of the *biscuit* itself. Thus triply armed, not in theory only, but in training, Renoir passed, by way of the fan and the painted blind, on to canvas.

'And so this perfect painter proceeds, for the rest of his brilliant life, to improvise from nature, subject to immediate revision at home, his astounding array of impeccable masterpieces in terms of the flowers of the vetch. As much, and no more, of drawing as was needed for his feast of colour. In a dry-point by Renoir you may see the arms and hands of his little girls hardly carried much further than to what they have in common with the paws of a rabbit, and the eyes, out of tone, like little twinkling cherries off a Staffordshire teapot. . . . Renoir was a great intellect, in nothing greater than in this, that his august critical faculty retained him from all digression. His comprehension was

universal. He understood himself, as he understood everything, with the complete detachment that belongs to the highest intelligence. So he stuck to his last.'[9]

These four painters achieved their aims 'by the methods of the sketcher'. When we turn to Degas, Sickert's true precursor, for whom his greatest veneration and affection are reserved, we come to a BUILDER of pictures. Degas was less interested in light than in form, and not at all interested in landscape. His character, ardent yet detached, at the same time craftsman, aristocrat and *savant*, had much in common with Sickert's own. The story of their meeting and subsequent friendship was as follows:

'Paris was still, at the date of Manet's death, small, exquisite and provincial. People still knew what they liked. We loved Judic, and we adored Dupuis (whose son I recognised, without a programme, in 1922). We adored Chaumont. I drew from the stalls of the Eldorado what I could see of the face of Mdlle. Bloch, setting behind the curves of the embonpoint of the period. The ballet of the Bersaglieri at the Eden was the rage. Never shall I forget the meeting of pickaxes in the Mont Cenis tunnel. Science and Romance in each other's arms! . . .'[10]

'In 1883, the year in which the portrait of Whistler's mother was exhibited in the Salon, Whistler asked me to take charge of the picture, which I did, crossing by Dieppe. I have a clear recollection of the vision of the little deal case swinging from a crane against the star-lit night and the sleeping houses of the Pollet de Dieppe. Whistler had given me letters to Degas and Manet, and copies of the famous brown-paper catalogue of his etchings to present to them, and I was to say to them that Whistler was "amazing". I alighted in Paris at the Hotel du Quai Voltaire as the guest of Oscar Wilde, whence I paid my first visit to Degas, first at his flat in the rue Pigalle—"*mon rocher de Pigalle*" I have heard him call it—and then, as the reader will see, by appointment at his *atelier* in the rue Fontaine St. Georges.

'Degas, whose perpetual characteristic was a rollicking and somewhat bear-like sense of fun, half regarded, and half affected to regard me, erroneously I fear, as the typical and undiluted Englishman, much as Gavarni always addressed his friend Ward as "*l'Anglais*". I prefer to give the account of my first visit through two sufficiently piquant distorting media, to give Oscar Wilde's account of Degas's later story to him. Degas alleged himself to have been disturbed too early in the morning, by a terrific knocking and ringing. He had opened the door himself, his head tied up in a flannel comforter. "Here at last", he had said to himself, "is the Englishman who is going to buy all my pictures." "*Monsieur,*" he had said, "*je ne peux pas vous recevoir. J'ai une bronchite qui me mène au diable. Je regrette.*" "*Cela ne fait rien,*" the Englishman is here made to say. "*Je n'aime pas la conversation. Je viens voir vos tableaux. Je suis l'élève de Whistler. Je vous présente le catalogue de mon maître.*" Degas willingly special-ised in an imitation of the English method of pronouncing the letter R, making of it something like a soft ch, as *maitche*. The visitor had then entered, had proceeded silently, and with great deliberation ("*Il n'a pas desserré les dents*") to examine all the pictures in the flat, and the wax statuettes under their glass cases, keeping the invalid standing the while, and had ended by, "*Bien. Très bien. Je vous donne rendez-vous demain à votre atelier à dix heures.*"

'The facts are singularly exact. I have seldom known a game of "German scandal" in which less distortion had taken place. From that time until my last visit to him, Boulevard Clichy, shortly before the war, I had the privilege of seeing constantly, on terms of affectionate intimacy, this truly great man. "*J'ai beaucoup changé,*" he had said, and, whatever draught of grief was to be mine at his dissolution I drank to the dregs on that day, as I passed down the Rue Victor Massé, and saw the demolished walls of the apartment that had been, since my youth, the light-house of my existence. Never again was I to enter the little ante-room where Forain's last published drawing was lovingly laid on

its *soigné* pile. A polished mahogany table was affected solely to that use. Never again should I hear old Zoë say, "*Monsieur Degas est en courses: il ne va pas tarder de rentrer. Vous resterez à dîner, n'est-ce pas?*" Nor anticipate the feast of instruction and amusement of which I now held the grateful certainty. Fantin-Latour said to me once of Degas: "*C'est un personnage trop enseignant,*" thus noting a defect which was to me precisely the quality. . . .

'My second meeting with Degas was at Dieppe in the summer of 1885, when we learned with delight that he was staying with the Ludovic Halévys, next door to Dr. Blanche's *châlet* on the sea-front by the Casino. . . .

'We went out in a party one day with the vague intention of sketching, into a field behind the Castle, and it was here that Degas said to me a thing of sufficient importance never to be forgotten. "I always tried", he said, "to urge my colleagues to seek for new combinations along the path of draughtsmanship, which I consider a more fruitful field than that of colour. But they wouldn't listen to me, and have gone the other way." This, not at all as a grievance, but rather as a hint of advice to us, to Broutelles, to Helleu, Ochoa, Jacques Blanche and me. He came to see my sunlight pochades in the rue Sygogne and commended the fact that they were "*peints comme une porte*". "*La nature est lisse,*" he was fond of saying. He referred me to Boudin. I was expecting Whistler on a visit, and Degas, talking of him, said, "*Le rôle de papillon doit être bien fatiguant, allez! J'aime mieux, moi, être le vieux bœuf, quoi?*". . .

' "*Je veux*", he said, when he was showing us his pastels, "*regarder par le trou de la serrure.*" This expression, when promptly and duteously retailed by me in London, was received with raised hands by the English press. The somewhat excusable prurience of our Puritans could not conceive of anything being seen through a key-hole but indecencies, and on the strength of this subjective and mathematically erroneous opinion, Degas was promptly classified as a pornographer. "*Qu'est-ce qu'ils feraient à l'Académie Royale si je leur envoyais ça?*" he asked me. "*Ils vous*

*mettraient sûrement à la porte!" "Je m'en doutais. Ils n'admettent
pas le cynisme dans l'art."*

' *"Dans la peinture à l'huile il faut procéder comme avec le pastel."*
He meant by the juxtaposition of pastes considered in their
opacity. It must be remembered that I am only recording what
he said at a given date, and to a given person. It in no wise
follows that, by advising a certain course, he was stating that he
had himself refrained from ever taking another. And again, *"On
donne l'idée du vrai avec le faux,"* which I only understood a week
ago.

'He said that George Moore was very intelligent. He said that
the art of painting was so to surround a patch of, say, Venetian
red, that it appeared to be a patch of vermilion. He said that
painters too much made of women formal portraits, whereas
their hundred and one gestures, their *chatteries*, etc., should in-
spire an infinite variety of design: *"J'ai peut-être trop considéré la
femme comme un animal,"* he queried some years later.

' *"J'ai beaucoup de peine à me mettre au travail le matin,"* and as
much in leaving off was implied. Later, when his eyes were al-
ready troubling him—he was very much hindered by a blind
spot, the circumventing of which caused him endless fatigue—
he said his one joy was to *"grimper à l'atelier"*. He spoke of this
when he was in the 70's, in the gleeful tone which a young
man would use in speaking of an escapade. *"Travailler encore un
peu avant de mourir." "Une fois que j'ai une ligne, je la tiens. Je ne
la lâche plus."*

'I remember the last time I was in the studio, upstairs in the
Rue Victor Massé, he showed me a little statuette of a dancer
he had on the stocks, and—it was night—he held a candle up,
and turned the statuette to show me the succession of shadows
cast by its silhouettes on a white sheet.

'We were walking one morning down from Montmartre to
go to Durand-Ruel's. Degas was dressed in a grey flannel shirt,
a muffler and a suit that might almost have been ready-made.
*"Ce n'est pas,"* I said, stopping as one does on the Continent,

"*Sir John Millais qui se présenterait chez Monsieur Agnew fichu comme vous l'êtes.*" He pulled up with mock indignation: "*Monsieur! Quand un Anglais veut écrire une lettre, il se met dans un costume spécial, fait pour écrire une lettre, et après il se rechange. Etre foutu comme quatre sous, et être le grand Condé! Voilà l'affaire! Dites?*" ...

' "*Sacré Monet,*" he said to me once, in a burst of playful and admiring jealousy. "*Tout ce qu'il fait est toujours tout de suite d'aplomb, tandis que je me donne tant de mal, et ce n'est pas ça!*" Of Sisley he said that the *terrains* always remained somewhat fluttering and wanting in *assise*. Of the school of Vuillard he said he had only one reproach to make. Pointing to a drab, and pale, and rather dingy bottle of white wine on the table, he said: "*Ils feraient de ça un bouquet de pois de senteur.*" His whole-hearted adoration seemed, among the moderns, to be given to Millet, to Ingres and to the earlier Corot, and Keene, of course, he loved. He hated the "arty" and all exaggerated manifestations of aesthetic sensibility, real or affected. I said once, I couldn't see that So-and-so, who was at the time *le chouchou d'un cénacle*, was a genius. He said, drily, "*Monsieur, ce n'est pas un génie. C'est un peintre.*" I remember, at a private view of some landscapes with water, where two or three ladies were sitting on separate poufs in silent ecstasies of artistic *recueillement*, he said to me, "*Je n'éprouve pas le besoin de perdre connaissance devant un étang.*"

'He was an *enragé* collector. At the rue Victor Massé he had three suites of apartments, one to live in, the one above for his collection, and, at the top of the house, his studio. I have sometimes in the second apartment threaded my way with him, by the light of a candle, through the forest of easels standing so close to each other that we could hardly pass between them, each one groaning under a life-sized portrait by Ingres, or holding early Corots and other things I cannot remember. Among them was one picture, by himself, of a woman playing the piano, and he told me with glee that a musician had recognised the score of music in his picture as "*du Beethoven*".

'Upstairs I watched him with interest one day when he was glazing a painting with a flow of varnish by means of a big flat brush. It represented a lady drifting in a picture-gallery. He said that he wanted to give the idea of that bored, and respectfully crushed and impressed absence of all sensation that women experienced in front of paintings. As he brought out the background in a few undecided strokes, suggesting frames on the wall, he said with irrepressible merriment, "*Il faut que je donne avec ça un peu l'idée des Noces de Cana.*" There you have Degas. . . .

'I remember how Degas took the trouble to write down for me a phrase that particularly delighted him. "*Far tutti i mestieri svergognati per compar onoratamente.*" His delighted relish of a phrase like that paints the man as accurately as anything.

'Degas had the good-nature and the high spirits that attend a sense of great power exercised in the proper channel, and therefore profoundly satisfied. The sensation that seemed to me to be perpetual with him was comparable to the irrepressible laugh of a boxer who gets in blow after blow exactly as he intended. He earned his living largely. His intellectual vitality, assimilative and creative, was so intense and so absorbing that it seemed he could not be bothered with any of the expensive apparatus of vanity and pleasure which, to less generously endowed natures, seems a necessary compensation. There was his work, and, when his eyes were tired, there was conversation, there were endless rambles through the streets of Paris, and long rides in and on omnibuses. "*Je n'aime pas les fiacres, moi. On ne voit personne. C'est pour ça que j'aime l'omnibus. On peut regarder les gens. On est fait pour se regarder les uns les autres, quoi?*" And to what good effect he did so we all know.'[11]

Then 'there is the song and dance, for which the French is *rengaine*, about the secretive and terrible aloofness of Degas. If an artist does not, like Rodin, call the press in once a week, to take his temperature, and to show them his tongue, the press is apt to revenge itself by calling him grumpy and mysterious. "There must be something radically wrong with a man who

doesn't wish to see us." *Le maître grincheux*. Nobody was less grumpy than Degas. . . .

'I don't know whether the following *mot* of the master is remembered in this country. One of the enquiring ladies that we sometimes used to have the privilege of taking in to dinner (now we shamble down—pell-mell) asked him, *"Pourquoi, Monsieur Degas, est-ce que vous faites toujours des femmes laides?" "Parce que, Madame, la femme en général est laide."* But this was his fun, and said with the playful and affectionate courtesy we know. He had no need to defend himself. Look at the portrait in the Tate, of the woman with the tracing in the background. Or the exquisite tenderness of the *femme au bandeau*. Beauty for him was in the lover's eye. He loved nature and movement with the kind of love that strikes a child with dumbness, and makes it turn its head away from the beloved, in bliss intolerable.'[12]

Of all the Impressionists Degas was the closest in spirit to Sickert. He represented the necessary link between the new painting and the old, the central tradition carried down in direct line through Ingres from the great draughtsmen-painters of the past. Also he represented the craftsman, with that profound knowledge of the materials of his trade and respect for them, without which nothing durable can be made by men. Sickert learnt from Degas the solution to those impediments which he had felt in the technique of Whistler. Foremost of all he discovered the advantages of painting from drawings. The physical difficulty of covering a full-length portrait with oil-paint at one sitting, and the inconsistencies involved in reworking the whole surface later in a different light from a model never twice the same, must have weighed heavily on him. The practice of painting from drawings, the realisation that the methods of the old masters were still applicable to modern painting, and were in fact used consistently by the greatest of living painters, came to him as manna from heaven: the deliverance from a material tyranny which threatened to stunt the green blade of talent at its birth.

But it was not only in technique that the influence of Degas was felt. In the course of the long afternoons at the rue Victor Massé, Sickert imbibed much more than the mere 'shop' of painting. Degas' uncompromising realism both in art and life: his search for beauty in the unexpected and accidental: his delight in the shapes and lines of movement: his catholic taste in the art both of old and modern masters: his tolerance towards his contemporaries, and his intolerance of society and the nets which society seeks to cast over the artist; in a word, the whole human wisdom of the man, entered into the receptive mind of his English disciple and was never forgotten.

But while he absorbed the spirit, Sickert was under no debt to the body of Degas' art. He took to himself neither the mannerisms nor the subject-matter, which the latter had made his own. He had already formed an individual and characteristic idiom, and coveted no other man's. Time alone would give it strength and confidence. Its origin with Whistler was not suddenly denied. The first change came many years later, and when it came, reflected the practice of Pissarro rather than Degas.

\*       \*       \*

If I have insisted at such length on the importance of the Impressionists, collectively and individually, in the history of nineteenth century painting, it is because of the intimate connection between them and Sickert's own place in that history. To all intents and purposes, SICKERT IS ONE OF THE IMPRESSIONISTS. If not one of the original group, at least so closely allied to them both in method and sentiment, as to take his place, naturally and inevitably, within the innermost circle of the school. He learnt much from Degas: much from Pissarro. But his own contribution is as original as any. He was always faithful to the main traditions of European painting. 'There is only one way to draw and one way to paint,' he says. 'There is no new art. There are no new methods. There is no new theory. The old one is great. It prevails, it has prevailed, and it will prevail. There can no more be a new art, a new painting, a new

drawing, than there can be new arithmetic, new dynamics, or a new morality. When it seems that a new man or a new school have invented a new thing, it will only be found that the gifted among them have secured a firmer hold than usual on some old thing. Degas can only draw with the drawing of Mantegna and Holbein, if he applies that drawing to other subjects with other curiosities. . . . The error of the critical quidnunc is to suppose that the older things are SUPERSEDED. They are NOT superseded. They have been ADDED TO. That is all.'[13]

Sickert himself has certain affinities among the old masters, notably with Rembrandt on one side and Vermeer on the other; but if he painted with their painting, he applied it to his own subjects and his own curiosities. It is a question whether future generations will not perhaps recognise that it was left to Walter Sickert rather than to Cézanne 'to make of Impressionism something solid and durable like the old masters'.

# CHAPTER VII
# DIEPPE

Dieppe is one of the place-names most often associated with Sickert. Together with Venice, Camden Town, and Bath, it has become the label of one of his 'periods'. Dieppe and London, however, stood to him in a quite different relation from the other two. Of the former he was a citizen and a householder; to the others little more than a tourist.

Sickert was not a great traveller. He always preferred familiar scenes to new discoveries. Thus, in spite of a recurring restlessness, he remained faithful to certain localities. Even in London his migrations seldom took him outside of Camden Town and Islington. He was the explorer of a little world of his own. He had cravings for change, but change within limits: for movement, but movement within boundaries.

The early Dieppe 'period' extended from 1885 to 1905. Up to the end of the century, however, Sickert's home was in London. Dieppe remained a summer side-show, although, as we shall see, a very important one. He had married Miss Cobden in 1885. After a honeymoon which began at Scheveningen in Holland and afterwards took them across Europe to Munich, Vienna and Milan, they passed the rest of the summer at Dieppe, and then returned to the house which was being built in Broadhurst Gardens, Hampstead.

Nellie Sickert was a great favourite of Whistler, and used to go to his studio in Tite Street, where he painted several portraits

QUAI HENRI IV

of her. Through her father's connections, she was able to introduce her husband to many people in the political world: the Allandales, T. P. Potter, John Morley, Sir Ed. Watkins, etc. Walter was to paint a portrait of Potter. The Sickerts were invited to lunch: after which the ladies went for a drive, while the portrait was begun. On their return they found both gentlemen still at the table—fast asleep! When Potter came to his studio he used to pull up the cloth and look under the table: 'Any models about, Walter?'

They went often to see the William Morris's at Chiswick, Walter making a point of wearing a ready-made tie in the worst possible taste. They also visited Charles Keene, who had put Sickert up for the Arts Club. When he knew he was dying he sent for Sickert and Starr to choose any drawings of his that they liked. He used to say, 'Bad drawing somehow revolts me—much of it.' It was a great thing for Sickert to have known personally two such draughtsmen as Keene and Degas. Such contacts influence a painter more directly than any paintings or drawings by themselves.

<div align="center">*      *      *</div>

Summer holidays were spent regularly at Dieppe. The family connection with that place was of long standing. His mother had been to school there and had kept friendly contact with her old mistress Miss Slee. The children had been taken over several times to visit her at Neuville. In 1885, the year of Walter's marriage, they were all there together. It was the last time that the whole family was united, as later in the same year his father died suddenly, leaving the mother stricken by a grief from which she took many years to recover. Mr. and Mrs. Walter had rented a house in the rue Sygogne, which became the centre of a great coming-and-going of friends, both French and English. Degas was staying for a while with some near neighbours, and encouraged Sickert to continue the series of paintings he had commenced of the old town and harbour. They went out together, walking or sketching. That summer the foundation of

their friendship and of Sickert's discipleship was laid. In the course of their long talks the main lines of his future practice were determined, particularly those precepts which gave the first place in the painter's armoury to drawing rather than to colour. No action or saying of Degas' but was retained and remembered long afterwards. For instance:

'It was in 1885', he wrote in later years, 'that I received a lesson in criticism that I have not forgotten. M. Degas, then in the fifties, and at the height of an uncontested and world-wide reputation, was at work on a portrait group for which I was one of the models. Gervex, then a young man under thirty, was another. During a rest, I was somewhat surprised to see Degas, by a gesture, invite Gervex to look at the pastel on which he was working, and Gervex, in the most natural manner in the world, advance to the sacred easel, and, after a moment or two of plumbing and consideration, point out a suggestion. The greatest living draughtsman resumed his position at the easel, plumbed for himself, and, in the most natural manner in the world, accepted the correction. I understood on that day, once for all, the proper relation between youth and age. I understood that in art, as in science, youth and age are equal. I understood that they both stand equally corrected before a fact.'[1]

For this same pastel portrait group he was wearing a light overcoat: and, having put it on negligently, was about to turn down the collar, when Degas stopped him, calling out, 'Leave it, leave it! It's better like that.' Ludovic Halévy, who overheard, murmured, 'Degas prefers always the accidental!'

Although the most important, Degas was not the only contact with French painting and French culture which Sickert made at Dieppe. The Norman port had long been a favourite resort for the aristocracy of France. After the fall of the Empire in '71 an element of the *haute bourgeoisie* made its appearance beside the old families. The presence of M. Thiers in high frock and spectacles provoked violent palpitations in breasts still loyal to the princes of Orleans, one of whom, the future Ferdinand

of Bulgaria, was then catching his first fish off Le Pollet. Near-by, at Puys, Alexandre Dumas and Mme. Carvalho had formed a colony of artists, the painter Vollon and the sculptor Carpeaux among the number. And from the same quarter on Sundays in summer Lord Salisbury in silk hat, with his Lady and a train of Cecils, might be met walking to the English church in the rue de la Barre. As for music, within living memory Franz Liszt had played at the little Casino, and Saint-Saëns, Dieppois himself, found a warmer welcome from his *concitoyens* than in Paris itself.

But it was above all to the painters that Dieppe appealed. First Delacroix and Bonnington, then Corot and Daubigny, and later Vollon, Boudin and Gauguin were attracted by its clear skies and picturesque countryside. In the late '80's, besides Degas, Renoir, Monet and Pissarro were all in the neighbour-hood for a part of the summer, and Durand-Ruel had a villa in the town for the holidays. Thus Sickert was brought into close and personal touch with most of the original band of Impres-sionists. Not only that, Dieppe at this period was the chief summer resort for the society and especially for the intel-ligentsia of the day. Sickert met them there, writers for the most part, such as Hervieu, André Gide, Barrès, Henri de Regnier, Edouard Dujardin, Pierre Louys and Proust, some of whom later bought his pictures and helped to make his reputa-tion in France. Among his more intimate friends were Daniel Helévy, Paul Robert and Tavernier.

The importance to Sickert of his early years in Dieppe lay chiefly in these intimate contacts with French culture. Not only did they confirm him in his allegiance to Impressionism, and above all to Degas, but they fixed his whole mental outlook in the French mould which he retained for the rest of his life. This will appear clearly enough in the extracts which will be given from his writings. Both in them and in his painting there will be found the logic, the common sense and the absence of senti-ment which are typical of French thought.

One of the most popular *rendezvous* of the painters and writers

who came to Dieppe was the Bas Fort Blanc, the home of
Jacques-Emil Blanche and his mother: and it was chiefly there
that Sickert met them. He had known Blanche first in London
at the house of Mrs. Edwards, the friend and patron of Fantin,
but their lifelong friendship was ripened in Dieppe. They were
of about the same age, of the same profession, with the same
eagerness to know the world and conquer it. Blanche had been
to school in Paris. Sickert introduced him to Whistler and to
his methods. At Dieppe Blanche was useful to him in many ways,
introducing him to his countrymen, buying his pictures (he
afterwards presented fifty paintings and drawings to the Musée
de Rouen), and persuading others to do so; in particular induc-
ing Durand-Ruel to interest himself and take his paintings
wholesale at a time when Sickert badly needed support.

Those first years at Dieppe were among the happiest of
Sickert's life. He was 'on top of the world', young, newly
married, full of strength and enthusiasm, confident of his art,
surrounded by affection and regard. His gaiety radiated. His
good spirits were irrepressible. He was as resilient as a sapling,
as supple as a serpent. His wit was always ready, either for
attack or defence. Once, when reproached by a French col-
league for returning empty-handed at the end of the day, 'You
carry that box about all day for nothing, and call yourself a
painter?': 'Should I call myself a sportsman', he replied, 'if I
insisted on firing off my gun, when I had seen nothing to shoot
at?'

George Moore, who met him at this time, wrote of him,
'coming in at the moment of sunset, his paint-box slung over his
shoulders, his mouth full of words and laughter, his body at
exquisite poise, and himself as unconscious of himself as a bird
on a branch. No, I don't think that anybody was ever as young
as Sickert was that day at Dieppe. A few months afterwards he
shaved his moustache, a frizzle of gold—God only knows why!
—and ever since has sought new disfigurements: cropping his
hair, growing a beard. All you know of him to-day is that which

neither he nor time can undo, the beauty of the line of head and face, and what he cannot suppress or curtail, his wit.'

His wife was never at home in Dieppe. She kept aloof from Blanche's circle of young barbarians, though a link was found in their mutual friendship with the Lemoinnes and Ludovic Halévys. She was older than her husband and of a delicate constitution. They were well matched intellectually (she published a novel under the name of Emily Amber, in which Walter figured as hero), and each allowed the other perfect freedom. Nevertheless, or perhaps for that very reason, their life at Dieppe disclosed and sharpened the incompatibilities in their characters which later led to a divorce. What is more important to remember is the long and happy years they spent together and the great influence which Nellie had on her husband's career in London, and to begin with that it was she who first enabled him to leave the stage and take up painting as a profession.

The divorce took place in 1899, and this, combined with the fiasco of the Whistler law-suit, was the cause of his leaving London altogether for a while. For the next six years he lived on the Continent, for the most part at Dieppe, but with expeditions thence to Paris (frequently) and to Venice (twice).

He was now dependent on his brush and palette for his livelihood. The barometer of his fortunes oscillated. It was not always fair weather. This it was that brought him into closer contact with another section of Dieppe life, the fisher-folk of the port and the *petite bourgeoisie* of the town. The Polletais fishermen and their wives were a handsome and sturdy race, living hardily whether on land or sea. They were said to be descended from a colony sent out from Venice in the fifteenth century. These were a people that Sickert could understand, and who responded by giving him their friendship and the freedom of the port. It was not long before he spoke their *patois* as one of themselves.

To tell of hard times as well as good is not to be avoided:

but the history of the painter was not dependent on the financial crises of the man. If there were not evidence enough of Sickert's own indifference to money matters, there is his written commentary on the mistake of assuming too close a relationship between any artist's work and his bank balance.

'If we have to sum up in one word the obvious attitude suggested to a writer who is engaged to write on the life of an artist, the inevitable word is struggle, and struggle in the financial sense. It is rare that an artist—and artist is only Greek for joiner—has moving accidents by flood and field. If the artist is a wrestler, he is, as Degas said to Whistler in my hearing, a wrestler *in camera*. Most writers about artists forget that a professional man, who needs £2000 for his manner of material and social life, has, in the financial sense, a more arduous struggle than a man who requires £100 and makes it. Tight corners in the latter case differ only from tight corners in the former in that they are less perilous. In the case of the man who is earning more and spending more, nothing is heard of it, and it would occur to no biographer to explain such a life mainly in the light of tight corners.'[2]

The tight corners in Sickert's life were never so tight as to obstruct his chosen way. He was poor, but never too poor to buy paints and brushes, to keep several separate rooms for working at Dieppe, to emerge, during the summer season, immaculately clad, and mingle on equal terms with the aristocratic society on the Plage or at the Casino. He was not even forced to cohabit, to the extent he did, with the people of the port. He went among them by deliberate choice and because they served his needs. No doubt at first it was an advantage that he could live cheaply and so save money for other uses: but he stayed because he liked the people with whom this way of living brought him in contact. His real friends in Dieppe were among the professional and shop-keeper class, the true Dieppois, rather than the migrants of the summer villas. He was always

attracted to characters that reacted simply and directly to the pleasures and pinpricks of life, without the subtleties or complications of more civilised beings. It is a sign, not only of his adaptability, but also of his essential forthrightness of nature that he fell in with their manners and habits with the ease of a native. He worked hard like them, though at a different trade. He preferred their sing-songs, their cabarets, to starch-fronted opera. He liked their expressive back-chat and the ribaldry of the fish-market.

When the bathing season arrived, he would come out, sometimes with commissions for Vanity Fair cartoons, and take part in the festivities of the gay world. He became indeed one of the lions of the fashionable and intellectual society which gravitated between the Bas Fort Blanc and the restaurant of Titine Lefévre; charming everyone by his wit, his polished manners and his self-possession. He approached the denizens of both his worlds with the same gentle courtesy; but there was always a limit beyond which he never stepped nor would allow others to step. An underlying reserve prevented anyone who might have been inclined from taking liberties with his friendship. An unwarranted demand would be met by a flash of coldness, even of harshness. 'The serpent lay dormant in the basket of figs.' Sometimes, when a mood of depression or misanthropy caught him, he would remain invisible for weeks at a time, and then suddenly reappear as gay and debonair as ever: entertaining his friends at Lefévre's like a sea-captain home from a voyage, overflowing with cordiality, chanting his music-hall choruses, or reciting from Balzac, Rabelais and the Latin poets.

But with Society his stay was not for long. In the world in which Blanche moved so easily and gracefully he saw a snare both for the bodily freedom and peace of mind of a working painter. Blanche himself, entangled in a net of social duties and pleasures, confessed that he envied his friend's cap of invisibility. He thus contrasts Sickert's working hours with the gay parties at the Casino:

'Midnight! The trumpet is calling in the dancers. It is time for the little horses to rest. The Baccarat tables are given over to the highest punters. Between the triple line of bathing huts, fond parents have spotted a fugitive by the colour of a scarf. They hail her. *M. l'inspecteur* will unleash his hounds in pursuit. *Minuit!* Time to go home. The sickle of the moon is cutting the pepper-cones of the citadel. The baskets of petunias and heliotropes suck the salt wind, the oil-laden whiffs of the port. *Minuit quarante!* The hoot of the Newhaven packet. The sailors' taverns fill up. Sickert sharpens his pencils.'

Meanwhile Blanche's own style had been adapted to the social proclivities which were so important to him. It was based on that of Boldini and Helleu. There is an amusing passage on this school of painting in one of Sickert's essays, written, of course, many years later:

'Mr. Francis Howard is certainly a wonderful *impresario*. He manages to put in the field exhibition after exhibition of the greatest piquancy and variety. This time it must have amused him to demonstrate that Boldini is the non-pareil parent of the wriggle and chiffon school of portraiture. It is a pity that Helleu is not represented by a series of his brilliant dry-points. It would then be seen that the Franco-Italian master has three sturdy sons, Sargent, Blanche, and Helleu, and that none of them quite succeed in the bravura of the *décolleté* like their master. None of them has lifted the fashionable flic-flac to the nth with the same ring-master's flourish of the lash as has the wizard of Ferrara and the Boulevard Berthier. His virtuosity and vitality are astounding. An artist can only interpret what inspires him, and his sitters do not bore Boldini.'[3]

Thus the friends, who had commenced their life-work together under the aegis of Whistler, parted company, and Sickert, who cared for none of these things, went on his way alone.

Another newcomer to Dieppe, Fritz Thaulow, offered another contrast, and perhaps another object lesson. Thaulow

sprang himself on the amazed Dieppois fully armed with a large robust family, an all-embracing enthusiasm, good-nature and energy, and a European reputation. His optimism and industry were equally boundless. Cases full of pictures departed every month to the far corners of the earth. He painted, he invested, he exposed, he advised, he spent, he founded. He and his family lived on the fat of the land and kept open house for rich and poor. His villa, decorated by Conder, contained marbles of Rodin, *grisailles* by Carrière, a Stradivarius violin, and family portraits by Carolus Duran. Thaulow's critical heart was wide open to all comers—save only to Sickert, whose style he found 'boring' and wanting in 'colour'. The contrast between the two men was matched by that of their methods. Summer and winter Thaulow went out into the fields and valleys, followed by his wife and daughters carrying the paraphernalia of his trade— the camera. At the same moment Sickert was about the harbour, living with the fishermen, and drawing, drawing, drawing.

That he was on the whole contented with his new life, while regretting much that his self-imposed exile debarred from him, is shown by the following letter to D. S. MacColl, written towards the close of the century:

*9 Quai Henri IV*

MY DEAR MacCOLL

Your letter was most welcome, caught me at a moment when I had rushed from an outdoor sitting not only indoors but into bed in the only hope of thawing again. The papers are like rain on a thirsty land. I hanker after the cackle of my own town and kind, though I am very happy and well here. Such constant sun and daylight. Not only do I take coffee with *la belle rousse* but that angel in divine shape permits me to share the table of her children at cost price, gives me the use of her *bonne*, employs a seamstress *à la journée* to sew me strange shirts after my own designs, washes me at home, sits to me, teaches me the idiom of the Pollet, stands between my ignorance and all the greed of a *bain-de-mer* in face of an English visitor—and I—write her letters

for her. '*Madame, le turbot que j'ai eu l'honneur de vous envoyer en gare jeudi était tout ce qu'il y a de plus frais. A quatre heures le matin il était encore vivant: etc.*' Would you like a weekly *bourriche*? Say 5 shillings' worth including carriage? We guarantee freshness.

I buy the *Daily Telegraph* at 2½d. a day *argent sonnant*. I read it from cover to cover, and Villon, and a Douay Bible Mrs. Stannard has given me. I have bought an oak *secrétaire* fit for a prime minister. I am leaving the casino and installing a studio in the room above my bedroom to get more sun and light and coke. I burn to controvert of an evening. Any one, any thing. . . . Any time a stamp is no object put it on the nearest thing about and post it.

<div style="text-align: center;">Yours always,<br>WALTER SICKERT</div>

*La belle rousse*, mentioned in this letter, was Mme. Villain, one of the notabilities of the fish-market and a great friend of Sickert's. She was a remarkable woman, which is to say that she would have been remarked in any surroundings. Tall, beautifully made, with the carriage of a Veronese, flaming Venetian hair and a milky freckled skin, she attracted attention from the entrance of the market as much by her appearance as by the excellence of her ware. She was witty, intelligent, and very polite. Her fish were the best in the market, fresh out from her special fishing boats: and she kept the pick for her favourite old clients, to whom it was a daily treat to go round and chat with her. '*Madame la duchesse peut demander à M. Sickère si j'ai de la riche marchandise,*' she would say to the Duchesse Caracciolo. In the winter she wore a long black shawl and wooden sabots like the Venetian women.

Sickert had known her from his earliest years in Dieppe, when she was courted as a model by all the painters of the holiday season. By this time she had several children. Titine, the youngest, was his favourite. Of the boys he was rather afraid,

and was very careful to put everything out of their reach. Mme. Villain said to him laughing: '*Mais, mon ami, ils ne sont pas des tigres!*' She was devoted to him, and cared for him through all his moods and troubles. Sickert never forgot her, and went back to see her many years afterwards when she was dying.

This second stage in Sickert's association with Dieppe had an importance in his life quite as great as that of the first. That had canalised his mind to the currents of French culture. This confirmed him in a distrust of the artificialities and intellectual snobbishness of 'Society', of everything that went into or came out of the drawing-room, and in a preference for the middle-class, for *l'homme moyen sensuel*, his way of life, and all his surroundings. As a subject Sickert found him completely satisfying, and looked no farther for the material of his art.

Early in the new century he took a villa on the hill of Neuville which looks down on Le Pollet and the new docks as far as the race-course. Installed in his new abode he soon became, by reason of his reputation and his hospitality, the head of a little colony of residents on the slopes of the hill, like Thaulow on his headland further to the west. The *mises-en-scène* of the two painters, however, offered the same contrasts as their characters or their work. Sickert's retreat contained no richly carved ornaments or works of art. On the mantelpiece were two china dogs and lustre-ware vases beloved of the English middle class. In place of the book-cases lined with vellum and morocco, unopened and unread, the classics of dead and living languages were scattered everywhere, dog's-eared and dusty. There was sand instead of carpets on the floors. The furniture was of the plainest. Favoured guests were taken up to the attic where he worked, and shown piles of squared-up pencil or pen drawings, canvases with under-paintings in three tones, unfinished studies, and lovely notes of Venice and Dieppe, which he would sell for a louis or two, but more often preferred to offer as gifts with the same ceremonious grace with which he handed the tea and bread-and-butter.

There was a constant flow of visitors from England. Most of the members of his circle there, the circle which revolved around the New English Art Club and the Yellow Book, came over at different times, some more frequently and for longer periods than others. Conder and Beardsley were devoted Dieppois. Others included Symons, Dowson, Moore, Rothenstein and MacColl. In the 90's he used to see Whistler 'in the Grande Rue, looking very well and very dignified', or lunching at Lefévres. 'Whistler's doctor has forbidden him to paint out of doors: has told him that it is at the risk of his life. He gets such attacks of influenza. Poor old Jimmy! It was all such fun 20 years ago.'

Then there were particular friends among the English residents, especially Mrs. Price and her sister, Mrs. Fairbanks, the wife of the American Consul. These two ladies still retain memories of the time at which they knew him, of his unfailing kindness, his generosity and his amusing talk. He had a studio next door to their mother's house at the Tour-aux-Crabbes, and at one time used to have lunch with them almost every day.

Meanwhile Jacques Blanche had married and moved out to Offranville. 'When Sickert was lonely', he writes, 'we saw him come in for the afternoon, tea, dinner, a long quiet doze on my study's sofa. If he woke up, my wife and her sisters read aloud to him, Dostoievski, Tolstoy, Balzac, Stendhal. Late at night, refusing to remain any longer, he put on a heavy coat, took his shepherd's stick, disappeared in the pitch-dark garden and village streets, down the steep hill to the station, often missed his midnight train, then walked up two hills, five miles from Offranville to Neuville, which made us miserable. . . .'

In 1905 Sickert returned to London. That year marked not only a change of residence, but the beginning of those changes in technique and subject matter, which will be described in their due place. For that reason it has served to define the end of the first part of his life. But that is not to say that there was any sudden break in its continuity: and in particular in the con-

tinuity of his connection with Dieppe. He still kept his villa at Neuville and went over there every summer, until prevented by the war of 1914. His visitors now included his associates of the Camden Town Group. Spencer Gore had been brought over and introduced to him in 1903 by Albert Rutherston. Others followed; and it was there that the plans were laid for the formation of the London Group. To Neuville again he brought his second wife Christine in 1911, though soon afterwards they gave up the villa there and bought a house at Envermeu some miles inland. Even after the war they returned, and Sickert's final leave-taking came only after his wife's death in 1920. All these things will be described in later chapters; but they have been given here in *résumé* in order to make clear how long and intimate was his connection with the town and people of Dieppe.

\*　　　　\*　　　　\*

The personality which emerges from the known facts and legends of Sickert's life is strangely complicated. I make no apology for including the legends, because they, too, even when not literally true, have a basis in reality. The legend indeed is to the reality as art is to nature. But it is clear that the complexities and anomalies of Sickert's character were on the surface of his behaviour. Beneath them was a sound common sense and self-control which made him independent both of the world itself and his own reputation in it. If there were no other evidence of this, it can be found in his work, both drawn and written. That it pleased him to lead double or even treble lives may be admitted; that he was often undependable, flippant and inconsistent, likewise; and that an apparent courtesy sometimes covered a masked but grinning snare. But the spelling of his outward non-conformity is simplified, if we remember how important a part the theatre had played in Sickert's life: not only in his life as an actor on the stage, but on his mental attitude to the stage of life itself.

Sickert has always had a tendency to dramatise whatever situation he may find himself in. Like a true actor he sets himself to

get within the very skin of his part. If he is to be poor among the poor, he will be poor indeed, not only in pocket, but in the habits and language of the poor. Nothing is more typical of this actor's attitude to situations than the care he took always to dress the part. By nature a dandy, he easily exchanged the smart cut of Savile Row for the corduroys and peaked cap of the port. His genius for *camouflage* was already evident: at one moment as polished as a tailor's dummy, at another as ragged as a tramp. There was nothing 'arty' about these sartorial instabilities, but rather a barbaric and child-like delight in dressing up. But whatever the disguise: clean-shaven or bearded: cropped like a convict, or with his thick fair hair waved back from his forehead: one minute a man, the next a boy: whether in a drawing-room or a sailor's *bistro*: anyone who noticed him for the first time would ask, 'Who is that noble lord?' Unpredictable aristocrat, now on his dignity, now the comedian, he was disconcerting to everyone except the simplest. The rest made puzzles out of their own innuendo, and went home shaking their heads.

His love affairs, too, had often a touch of the theatrical. Few of these attachments went deep. More than one lady complained that he had a stone where the heart should be. The truth? Simply, I think, that Sickert, so generous in every other respect, of time, of attentions, of things, yet retained one thing he could not give—himself. As soon as either friendship or love laid claim against that inviolable entity or threatened to interfere with his freedom as an artist, the friend would find himself frozen by a word, the lady—left. Sickert had the kind of selfishness peculiar to some artists, praise it or condemn it as you will, in which everything is sacrificed to the art. Neither duty nor emotion were allowed to trespass on that sacred ground.

But it must be premised that in all such psychological delvings there is an element of distortion, the factor of an outside interpretation of another man's inner life. The straight course of biographic fact becomes weighted by the bias of opinion.

What is certain is that, during all this time, he was working:

experimenting, developing, consolidating. At first he was full of theories. Each time he met one of his friends he was trying out a new method: a new ground, a new medium or a new varnish. But he was not a mere theoriser. Like all great craftsmen he thought with his hands as much as with his brain. Once he had proved the value of a method he held on to it and never let go his hold. This care for the materials of his craft was recognised by D. S. MacColl as early as 1895. In a review of an exhibition at the Dutch Gallery, which included the portraits of George Moore and Aubrey Beardsley as well as studies and sketches for music-hall subjects, he wrote:

'Mr. Walter Sickert is one of the few painters among those whom the critic has recently been invited to consider, who can be called a student of painting. Masters of that art are rare, but students also. The man is much commoner who, under the sway of a poetic sentiment, has scrambled some kind of expression of that sentiment upon his canvas, and who has never been aware that it is possible to cherish for the paint he uses sympathy and affection—to watch its behaviour with a curious and expectant eye, to refuse to bully it into husky declarations beyond its register, to extract from it its natural singing tone. . . . The unusual measure of sense and wit that have marked Mr. Sickert's writing on matters of art reappear in his painting, in his fastidious, scrupulous handling of the material.'

The output of these years was enormous; how great will never be known until the collections still hidden in France are brought to light. The influence of Degas grew stronger year by year. His simplicity and devotion, as well as his realism, supplied the stabiliser to a certain recklessness in his pupil's activity. As a matter of fact there is no echo in Sickert's work of the theatrical element in his behaviour. The paintings of the Dieppe period are sober to the point of austerity. It is not only that they are dark, sometimes almost funereal, in tone. The whole conception of colour form and design is made subservient to a discipline which utterly denies all ostentation or display. More and

more, as one studies the work of the painter, does it become clear that such extravagancies as appear in the social life of the man were in the nature of a blind, behind which he might follow his desire, unseen and undisturbed.

We have seen that Sickert's association with Dieppe extended over the greater part of his life. Thus there are pictures from there of each of his 'periods', following the development of his style up to 1922, when he left for the last time. The earliest and longest of these periods has been the subject of this chapter, and since it was concerned most closely with that place, it is usually known as the 'Dieppe period'. All the pictures belonging to it have in common the dark tonality which Sickert inherited from Whistler. Degas used to find this constant obscurity disturbing and complained that everything seemed to be happening at night. And so in truth it was. A painter may pitch his key to any desired octave, irrespective of the time of day. But Sickert had a definite preference, also no doubt a legacy from his first master, for the hours of sunrise and sunset, when local colour was half effaced, and trees and buildings stood up in sombre masses against the fading light. 'One fourteenth of July,' writes Blanche, 'in the gardens decorated for the National Fête, I drove off the rag-tag and bob-tail who were making fun of his painting. After a broiling day, he was lingering before the old Hotel Royal, grey-green beneath a sky in which the moon was but a rose ring in the violet mist. Some soldiers in red breeches and white gaiters were promenading with light-skirted girls. Sickert made notes of the values in a copy-book, the light being no longer strong enough to render them on the panel.'

Most of the early Dieppe pictures are of architectural subjects. The city possessed just those qualities which were likely to appeal to Sickert. It was pictorial, without being 'picturesque'. It had grown up naturally, without plan, around its churches and the fishing port which gave it food and shaped its working life. It was ancient without being decrepit. Its stones

were worn by many weathers and by centuries of change. Style
jostled style through the narrow streets, running a gamut of all
the ages from the Gothic of S. Jacques to the little round casino
of glass and cast iron with its two flanking pavilions.

Once a week he went to Paris to teach in some school, and to
arrange for the sale or exhibition of his pictures. Thus, about
1900, he wrote to Steer:

MY DEAR STEER,

Send me George Moore's portrait for my exhibition. I
will take care of it and send it back promptly. Send it quickly.

Paris has taken kindly to the brush that struggled rather vainly
in Robert St. German papers quote new appearance in Paris of a
painter 'of the first rank' etc. *J'aime autant ça.* As Jimmy said . . .
'mayn't all be true, but makes very pleasant reading.' I am ex-
hibiting Trelawney of the Wells and Katie Lawrence at Gatti's
at Munich, invited by the Ministère des Beaux Arts on French
section; they moved thereto by my exhibition at the Indépen-
dants. It's odd over here: critical, but almost too responsive to
*every* and *any* effort of art. Prices too low. But at low prices
demand *unlimited*. *Very* able dealers. Some make, though,
*hundreds* per cent. Durand-Ruel, alone, very generous, almost
quixotic. Takes 10 per cent.

I am showing Bedford Gallery, bought by Simon, and a S.
Jacques which was unnoticed in London, belongs to Tavernier,
in Venice, in French section. What a lucky chance brought me
to Dieppe! I should have been art critic of the Licensed Vic-
tuallers' Gazette by now, and doing articles for them on Johns
and Albert Rothensteins! if I had stayed in Robert St.

Moore was divine in Paris. Talked in a bus to a hardened old
friend of Courbet's and Degas's for *half an hour* about whether
in one of *your* pictures you had not better have cut off a LITTLE
of the sky, with the gesture, quite absorbed, and allusions to
Tonks, incidentally, as to the Vendôme column, or any other
familiar monument of Paris. Said to some Parisians, 'He for his

part had come to an age where he didn't care *what* other people thought; his own *personal independent* taste was, he liked Corot!!' with defiance, as of a man holding a most eccentric opinion *alone*. A pro-Boer in Trafalgar Square as it were ! He wanted to buy a Renoir of a man with whiskers for £200 or so! a bad Renoir portrait head.

Yours ever. I wish I could *write* letters. Hate a pen. Too much journalism in London.

<div style="text-align: right">W.S.</div>

Evenings were spent at one or other of the Parisian *théâtres de variétés*. 'I want another fortnight here,' he wrote, 'to finish four or five pictures as good as *Noctes Ambrosianae*, only red and blue places instead of black ones, the Eldorado, the Gaieté Rochechouart, the Théâtre de Montparnasse.' At Dieppe, too, in place of the music halls, he went to the *cafés chantants* to draw, and also to the circus when it was there.

<div style="text-align: center">*      *      *</div>

As was to be expected, there is an immense advance in power and fluency between 1885, when he was scarcely out of the nest, and twenty years later when he had the splendid series of Venetian paintings behind him and was the acknowledged leader of the secessionist school in England. The earliest Dieppe townscapes are careful exercises in the key and the manner of Whistler. They were painted from nature, and truth of local colour, even though subdued, is given full weight. The drawing is 'tight'. The patches of paint which represent 'things' are not only in the right place and of the right tone and colour, but also follow the shapes of the things, and each one comes up to the next and is attached to it neatly and smoothly as though with glue. In the latest series the actual patches of paint do not represent 'things' nor follow their outline. They remain simply patches, small or big, in the right place and of the right tone: and their attachments are disjointed as though loosely knitted together.

The pictures of Dieppe painted between 1905 and 1914, the Camden Town period, are few, and their technique follows the changes which all his painting underwent at that time, and which is really a continuation and intensification of the process outlined above. They have also a higher key and brighter colour than the earlier ones. By the time he returned to his old haunts after the war, his palette had undergone still further clarification and even pure colour was sometimes used over the underpaintings of pale blue. Moreover, the subject interest had altered, and the last pictures he painted there were mainly interiors, either of cafés or the baccarat tables at the Casino, or portraits.

But certainly it is for the many scenes of town and harbour of the earlier years that Sickert's name will always be associated with Dieppe. He has been called her Canaletto, and not without justice, for he interpreted her life through her buildings, S. Jacques, the arcades, the market place, the old Hotel Royal, the port: with the figures, in miniature, that circulated around them and gave them reason and movement.

# THE NEW ENGLISH ART CLUB

⟨◠◠⟩

The last chapter described Sickert's life in Dieppe from 1885 to 1905. But for the earlier part of that time, from '85 to '98, he was much more in London than anywhere else. His mother and brothers were still living in Pembroke Gardens. He and his wife had a house at Broadhurst Gardens, South Hampstead. In addition to a studio on the top floor there, he rented various rooms in different parts of the City for working, one of the most permanent being in Robert Street. He was intimate with Whistler, and was forming a circle of friends who shared his enthusiasm and advocacy for the new ideas in painting which they had learnt in France. His own work was beginning to be known, at first simply as by a pupil of Whistler, later on its own individual merits. His first public appearance was in 1884 at the Royal Society of British Artists, where he continued to show until 1888 (the first music-hall picture in 1886), the date of Whistler's abrupt resignation from the presidency, taking the Artists, including Sickert, with him, and leaving the British behind, according to the well-known legend. The old guard of the R.B.A. indeed had never taken kindly to their beautiful new president or to the reforms and reformers that he introduced to them. 'Of course, when you send to a half-savage society you must expect anything.' Sickert was writing to Blanche, who was another new member. 'It appears that the hanging committee was a stodgy lot, and Menpes and William Stott, who

L'ANCIEN HÔTEL ROYAL, DIEPPE

fortunately for us were what they called supervisors, had great difficulty in getting any newer work taken. I only sent one picture and Menpes tells me he had hard work to get it in. I don't think the President exerts his influence in any one's favour—except that this year he brought in against the general wish a picture by Lady Colin Campbell, and insisted on its passing without being submitted to the committee. I am very hard at work just now. I received, very much to my surprise and delight, an invitation to send to the XX at Brussels this year, and I am painting a, for me, large picture for them, 1.75 × 1 m. Have I to thank you for pointing me out to the Kingdom of Belgium, for I cannot imagine that my unassisted fame would have led any society, however perspicacious, to single out the genius that is modestly hidden in the suburb of Hampstead?'

Sickert would have continued to expose at Suffolk Street, but for his desire not to offend Whistler. In another letter to Blanche he says, '*Au dernier moment je me suis rappelé ce dont j'aurais dû me rappeler avant, que je n'étais guère connu que comme élève de Whistler et qu'on méconnaîtrait pour sûr mes intentions et qu'on m'attribuerait quelque dent contre Whistler au lieu de trouver tout simplement que je me fichais des brouilles intestines des Suffolk Streeters et que je voulais tout simplement exposer mes machines et gagner mon pain à la sueur de ma palette.*'

Meanwhile in 1886 a number of painters, the chief articles of whose charter were opposition to the academy and admiration for French painting, had joined together to found the New English Art Club. Even the rules, drafted by Fred Brown, were revolutionary. Juries were elected by members plus exhibitors, and works of members as well as of exhibitors were submitted to, and had to be passed by, the jury. Sickert was not a founder member, but he began to exhibit with them two years later, and was soon taking an active part in the policy and committee-work of the new society. In this he was associated with a group of friends, all imbued with the same ideas, to whose genius and devotion must be given the main credit for the revolutions in

professional practice and in public taste, which were then only being adumbrated. These included Wilson Steer, Fred Brown, Henry Tonks, Max Beerbohm, Harrison, D. S. MacColl, Roger Fry and George Moore. The three last acted as go-betweens, in the faculty of criticism, between the painters and the public. The appointments, in '92 of MacColl to the solid conservative *Spectator*, and a little later of Moore to the *Speaker*, and after 1902 the fulminations of Roger Fry in the *Athenaeum*, were reinforcements from a powerful, if rather unexpected, quarter. When Brown was invited to the Slade, an improvement in the standards of painting was practically assured, and in fact, under his and his successor, Tonks's, professorships, many notable draughtsmen and painters were given their first training: for instance, John, Orpen, Gore, Innes, Wyndham Lewis, McEvoy and Edna Waugh, afterwards Lady Clarke Hall.

The friends met frequently in each other's rooms, particularly on Sunday mornings at Steer's studio in Cheyne Walk, where they were often joined by Conder, Beardsley, Furse and others. Long and animated were the discussions upon ways and means. Each had strong and distinctive characteristics, and opinions, of their own. They were held together chiefly by the good nature and pregnant silences of Wilson Steer.

Sickert had a particular admiration and affection for Steer, though he also greatly respected the sound sense and critical acumen of Max Beerbohm. It was a great pleasure to him when Steer later gave his portrait of George Moore to the Tate, thus linking their names together for ever.

Moore had gone to Paris originally with the intention of studying art. While there he knew Manet and Degas, and became an enthusiastic admirer of the Impressionists. He settled in London in 1881, but retained his French connections. He met Sickert at Dieppe and through him the other English painters who became his friends. He loved to talk, especially about painting, about which he understood very little. He found his best listeners in Steer and Tonks, the former through indol-

ence, the latter from a certain community of taste, though later they disagreed, Tonks referring to Moore as 'a spoilt child of four'. To Sickert, Moore was always a subject of gay derision. His pronouncements on painting were treasured as delicious tit-bits of the sublimely ridiculous. What else was to be made of a man who could write (many years afterwards), 'In old times your skies were blue paint broken with a little vermilion, sym-bolic skies, curtains, and I remember poking you up in an article, saying that your eyes did not see values. I have nothing to retract; I still think that your early pictures were as remark-able for a lack of values as your present pictures are remarkable for an exquisite sense of values. I especially admired the railings; never were railings so well painted before.'

In the house at Broadhurst Gardens there was a speaking tube from the ground floor to the studio at the top of the house. One day the servant called up to say that Mr. Moore wished to see him. 'Is it important?' asked Sickert. 'Yes: Mr. Moore says it's very important.' Moore, entering the studio: 'I have been reading a life of Michael Angelo, and it seems that the David was carved out of a piece of marble that had been improperly quarried. I could no more have carved the David out of a piece of marble that had been improperly quarried than I could have flown!'

Sickert never forgave him for his part of *Conversations in Ebury Street*, which he considered only just short of actionable. Never-theless in the '90's he was on the side of the angels and much was forgiven him.

They were all confident of victory, but the struggle was keen and the battlefield hotly contested during the whole of the last decade of the century. It is necessary to look back through quite other spectacles than those we put on to-day, when pre-sented with the latest -ism, to be able to understand the sound and fury which greeted the exhibition of Degas' *L'Absinthe* in 1893 at the International Society's show at the Grafton Gallery. MacColl and 'The Philistine' of the *Westminster Gazette* went to it hammer and tongs. Moore, W. B. Richmond, Walter Crane,

and Sickert himself were drawn into the fray. To those who know how the battle went, who see *L'Absinthe* as a treasure of the Louvre, it is difficult to imagine the passion of indignation such pictures aroused. But the fact only shows that Sickert could expect no greater success for his music-hall pictures or his portrait of George Moore, unless it were, as he said, a *succès d'exécration*.

Even behind the closed doors of the New English Art Club all went not smoothly. Sickert fell under the displeasure of a group of members, powerful if not very far-sighted, on account of his subject-matter, which was considered vulgar, and had to take a more backward seat for a time. 'Our friends,' he writes to Blanche, 'i.e., the Impressionist nucleus in the N.E.A.C., have all advised that *my name must not this year appear* much in proposing or seconding people, as my work is said to be most unpopular with a dull but powerful section of the N.E.A.C., the people whose touch is square, and who all paint alike and take their genealogy, I believe, from J. P. Laurens.'

These were the people, original members of the Club, who followed the *plein air* methods of Bastien-Lepage, and who later became known as the Newlyn School. At first they had a controlling influence on the committee, but already in 1887, scarcely a year after the foundation, Brown wrote of 'a clique consisting of myself, Steer, Starr and Roussel, strengthened by the addition of Francis Bate and Walter Sickert. We met frequently at the house of the last named, and planned to have a greater, and, if possible, a dominating influence. I need not say that, with Sickert as host, our little conspiracies were not very sombre affairs. . . . He was beloved by all of us, his gaiety was contagious, his manner charming, his wit bubbling.'

This group held a separate exhibition in 1889 under the title of the London Impressionists at the Goupil Gallery in Bond Street, Mr. David Croal Thomson being the sponsor. There were ten exhibitors, Sidney Starr, Francis James, George Thomson, Bernard and Walter Sickert, Wilson Steer, Fred Brown,

Paul Maitland, Theodore Roussel and Francis Bate. There was a flourish of trumpets in the shape of a manifesto at the beginning of the catalogue, written by Sickert, the final and most important paragraph of which ran as follows:

'To attempt anything like an exposition of the aims of painters so varied in their intentions as the present group, would be a difficult and thankless task. It may, however, be possible to clear away several sources of error by endeavouring to state what Impressionism as understood by its votaries is not. Essentially and firstly it is not realism. It has no wish to record anything merely because it exists. It is not occupied in a struggle to make intensely real and solid the sordid or superficial details of the subjects its selects. It accepts, as the aim of the picture, what Edgar Allan Poe asserts to be the sole legitimate province of the poem, beauty. In its search through visible nature for the elements of this same beauty, it does not admit the narrow interpretation of the word "Nature" which would stop short outside the four-mile radius. It is, on the contrary, strong in the belief that for those who live in the most wonderful and complex city in the world, the most fruitful course of study lies in a persistent effort to render the magic and the poetry which they daily see around them, by means which they believe are offered to the student in all their perfection, not so much on the canvases that yearly line our official and unofficial shows of competitive painting, as on the walls of the National Gallery.'[1]

Although Sickert disclaimed the label of realist for his Impressionism, his first important contribution to the literature of criticism appeared under the title of 'Modern Realism in Painting'. It was one of four essays in a book, published in 1892, on the art of Bastien-Lepage and Marie Bashkirtseff. In it he contrasts the false with the true realism, taking as his protagonists Bastien-Lepage and Jean François Millet. It is important as containing the first indication of many of the principles which guided his practice throughout life, and which recur again and again in different contexts in his subsequent writings. Not only

99

the false realism of posed models, but the fallacies involved in all painting from nature on a large scale, and the mistake of the *salonnier*, who must paint every year one 'important' picture for exhibition purposes (but useless for any other), are exposed. The essay is longer than usual, but the following extracts will give the key to the whole:

'To begin with it was thought to be meritorious, and conducive of truth, and in every way manly and estimable, for the painter to take a large canvas out into the fields and to execute his final picture in hourly *tête-à-tête* with nature. This practice at once restricts the limits of your possible choice of subject. The sun moves too quickly. You find that grey weather is more possible, and end by never working in any other. Grouping with any approach to naturalness is found to be almost impossible. You find that you had better confine your compositions to a single figure. And with a little experience the photo-realist finds, if he be wise, that the single figure had better be in repose. Even then your picture necessarily becomes a portrait of a model posing by the hour. The illumination, instead of being that of a north light in Newman Street, is, it is true, the illumination of a Cornish or a Breton sky. Your subject is a real peasant in his own natural surroundings, and not a model from Hatton Garden. But what is he doing? He is posing for a picture as best he can, and he looks it. That woman stooping to put potatoes into a sack will never rise again. The potatoes, portraits every one, will never drop into the sack, and never a breath of air circulates around that painful rendering in the flat of the authentic patches on the very gown of a real peasant. What are the truths you have gained, a handful of tiresome little facts, compared to the truths you have lost? To life and spirit, light and air . . . ?

'Millet, ninety-nine times out of a hundred, had seen his picture happen somewhere in nature. . . . Dealing with materials in their essential nature living and fleeting, his execution was in the main separated from his observation. His observation was thus uninterrupted by the exigencies of execution, and his

execution untrammelled by the fortuitous inconveniences in-cident on the moment of observation, and undisturbed, more-over, by the kaleidoscopic shifting of the pictorial elements which bewilder and mislead the mere *plein-airiste*. He did not say to the woman at the washtub, "Do as if you were washing, and stay like that for me for four or five hours a day, while I paint a picture from you." Or to the reaper, "Stay like that with the scythe drawn back, pretending to reap." "*La nature ne pose pas*"—to quote his own words. He knew that if figures in movement were to be painted so as to be convincing, it must be by a process of cumulative observation. . . . Millet observed and observed again, making little in the way of studies on the spot, a note sometimes of movement on a cigarette paper. And when he held his picture he knew it, and the execution was the singing of a song learned by heart, and not the painful perform-ance in public of a meritorious feat of sight-reading. The result of this was that his work has style—style which is at the same time in the best traditions and strictly personal.'[2]

The exhibition of 1889 stamped the New English Art Club as Impressionist. Immediately both press and public became severely critical. The new subject-matter, particularly Sickert's delving into low life, was the chief stumbling-block. The Royal Academy, hitherto benevolently neutral, non-belligerent shall we say, awoke to a sense of outraged decency. At one of their banquets the portrait of George Moore was described as an 'intoxicated mummy'. It was long before the championship of the group by MacColl and Fry brought about a better apprecia-tion of their aims and qualities.

Many of Sickert's best early pictures were shown at the New English exhibitions; in '90 the portrait of Charles Bradlaugh: in '91 that of Moore: in '93 *The Hôtel Royal, Dieppe*: in '95 *The Old Bedford*: in '96 *The Lion of St. Mark's*: in '98 a portrait of Lady Eden: in '99 *Le Grand Trianon*: in 'o2 a nocturne of St. Mark's: in 'o4 the portrait of Israel Zangwill: in 'o6 *Noctes Ambrosianae*. He resigned from the club in '97, but soon re-

joined it. Altogether he resigned three times, including the final one in 1917. This restlessness was characteristic. It was one of the origins of the group system which developed later under his tutelage. Sickert liked to be associated with other painters, but after a while was sure to find such contiguity irksome. His gregariousness was but a skin. Always beneath it was the cat that walked by itself.

As time went on the New English became more and more the blackboard on which the children from Messrs. Brown and Tonks's kindergarten at the Slade pinned up their first exercises. Years later Sickert wrote an appreciation of it, not without a hint of malice. 'The New English Art Club has now run for about a quarter of a century, long enough to make it possible to gauge the direction of its influence. Like all organisms endowed with the wisdom of self-preservation, it has grown and consolidated itself on reasonably practical and diplomatic lines. If it had not, it would not be alive to tell the tale. It has accomplished what it could, and like most middle-aged bodies resigned itself cheerfully to not accomplishing what it couldn't. Most of the more serious reputations of the day have been made or strengthened on its walls. Of the makers of these many remain, and many have moved on, urged by a natural desire for larger and more popular audiences. But I doubt if any unprejudiced student of modern painting will deny that the New English Art Club at the present day sets the standard of painting in England. He may regret it or resent it, but he will hardly deny it. Technically we have evolved, for these things are done in gangs, not by individuals, we have evolved a method of painting with a clean and solid mosaic of thick paint in a light key. I should like to be able to trace this method more closely to its sources, but I am safe, at any rate in describing it as the New English technique, and in saying that a whole generation holds it at the present time in common. . . . The pictures at the New English Art Club are often described as Impressionist, and their painters called Impressionists. This always surprises and

amuses French visitors to England. A painter is guided and pushed by his surroundings very much as an actor is, and the atmosphere of English society acting on a gifted group of painters, who had learnt what they knew either in Paris or from Paris, has provided a school with aims and qualities altogether different from those of the Impressionists. The New English Art Club picture has tended to be a composite product in which an educated colour vision has been applied to themes already long approved and accepted in this country. In this tendency, some may see the wisdom of the serpent and others dangerous compromise. . . . It is certain that the Impressionists *put themselves out* more than we do in England. We all live like gentlemen and keep gentlemen's hours. A glance round the walls of any New English Art Club exhibition does certainly not give us the sensation of a page torn from the book of life. There is an over-insistence on two motifs; the one the august-site motif, and the other the smartened-up-young-person motif. It may be that it is just this concession which is leading on the plain man to appreciate us. My diagnosis inclines the other way. It is admitted that the painters in this country are crying out. Whatever we utter, from north, south, east or west, is one long litany. Art is not encouraged! The Briton is inartistic, and will not buy our bow-wow! etc. Are we quite sure that we have not overlooked one little point? Is he perhaps too artistic, and do we perhaps disappoint him?'[3]

That was written in 1910, the period of his most frequent eruptions in the press, but already in the '90's he had started to write, in defence of the new school of realist painters, of Whistler, and of the French Impressionists. He was a contributor at different times to the *Pall Mall Gazette*, the *Whirlwind*, the *New York Herald* and the *Saturday Review* among others. In company with Rothenstein, Steer, and, of course, Beardsley, he contributed reproductions of paintings to the *Yellow Book*, which appeared in 1894, and carried the war of independence into the ranks of literature.

He had also started teaching, though at this early date less in the hope of honour than of material support. In 1893 he opened a school at the house of William de Morgan in the Vale, which he had rented. The prospectus announced Whistler as patron. It did not attract many pupils, but the night-classes for practising artists proved more attractive. To this among others came Rothenstein and Roger Fry and Alfred Thornton. There were discussions both technical and otherwise, Sickert being a keen advocate for drawing on the scale of nature. Thornton says, 'This period with Sickert was invaluable; for his brilliance of mind, linked with an even then profound knowledge of *métier*, also his sub-acid comments on the life around him, were a perpetual delight. He loved the red-faced sporting men with big buttoned box-cloth coats, who thronged the King's Road, and the racy retorts of the dingy little London *gamine* as she strolled the streets of Chelsea.'

Meanwhile sales continued few although prices were ridiculously small. Sickert believed in selling at any price. His market was not improved by his habit of giving away pictures to those who could not, and often to those who could, afford to buy them. Also he preferred the French system of selling in batches to dealers. It was all advertisement, and at least enabled the artist to live and work. English dealers sold only on commission and English painters starved. Sickert, when he was hard up, took over a trunkful of canvases to Paris. To impress the dealers he reserved a room at a good hotel, though he had to wait for the pictures to be sold before he could pay for it. As soon as that was done he was off to his 'low' haunts and his 'low' friends, Degas the first.

In 1898 the Carfax Gallery was started by a young archaeologist, John Fothergill, Rothenstein being responsible for the choice of artists, Arthur Clifton for the business side, and Robert Sickert for the management. They gave exhibitions of Rodin's drawings and small bronzes, of Conder, John, Orpen, Max Beerbohm and Rothenstein. Sickert supported the venture from

the beginning; there were always drawings or paintings of his to be seen there. *Noctes Ambrosianae* hung long on the walls at £40, but found no buyer. Nevertheless the gallery was of great assistance to the younger generation, especially to John and Conder. Later, when Robert Ross had taken over the business, with Clifton as manager, he extended its scope to include both old and modern masters, the most important of the former being Rembrandt's *Polish Rider*, which roused Sickert to lyrical enthusiasm (see Chapter XIX). At that time it was closely connected with the Camden Town Group, and Sickert held several individual exhibitions there.

Towards the close of the century he was less and less often to be found in London. When there he lived in his rooms in Robert Street. His landlord was also the bailiff, and when the rent was overdue he came and installed himself in the studio. Sickert fetched him a drink, made him comfortable, and explained that if he was allowed to finish his picture he would get the rent. He then began to work on the *façade* of St. Mark's. Taking a plumb-line, he asked the bailiff to see if an upright was correct. Oh! yes, that was all right. A few minutes later: 'And now this one, if you don't mind;' and so on, until the wretched man could stand it no longer, but got up and went away. And so the painter was left in peace.

A near neighbour was Fred Winter, the secretary of the New English Art Club, a sculptor, and a rough diamond, whose racy talk delighted Sickert. One year he had shown a little statuette of Trilby, in plaster, which the Prince of Wales bought. When Winter complained of being hard-up, Sickert asked him why he did not deliver it. Winter replied, 'His Royal Highness is at Sandringham. When he comes back, I shall take it myself and see if I can *chat him into a bronze*!'

Sickert used to have lunch at the Gatehouse, a public house in the Hampstead Road, where you could get a steak-and-kidney pudding the size of a billy-cock hat for 9d. He was taking Max Beerbohm there one day when they met Winter.

'You're surely never going to take young Master Max to the Gatehouse, are you?' he said.

In London, as in Dieppe, Sickert had several hide-outs where he did most of his work, including a small dingy room at the wrong end of the Embankment, west of Beaufort Street. It was always an amazement to Rothenstein that anyone with the opportunities and charm of Sickert should bury himself away from society, and choose for preference the drab and dreary middle-class for his subjects. He did not understand that the painter had other game than lions to hunt, and that they could only be tracked and brought down in country that was free from the distractions of the *beau monde*.

# CHAPTER IX

# VENICE

◦◦◦◦

Sickert went to Venice for the first time in 1895. His impressions and activities there are described in a letter to Steer.

<div align="right">

*788 Zattere,*
*Venice.*

</div>

MY DEAR P. W.

Send us a line or two of gossip about the N.E.A.C. Tell me *truly* how my work looks and whether you like the Afghan and the little drawing. I hear on the very best authority that your portrait of Thomas is excellent. Not that this is a hint in the manner of actresses in the green-room: 'You look lovely, dear! How do you think I look?'

Venice is really first-rate for work. A friend—you know Mrs. Leigh Smith—well, Miss Leigh Smith her sister-in-law has lent us a 'very nice flat', as George Moore would say (Do you like my nocturne at Goupil's?) with a south aspect over the Zattere, next door to the Montalbas. Good food, good wine, good cook (nearly sat on a *scorpion* in the W.C. Thought of you at once: of what you would say.) and I am getting some things done. It is mostly sunny and warmish and on cold days I do interiors in St. Mark's.

It may be a poor compliment, but for all practical purposes the more experience I have, the more I find that the only things that seem to me to have a direct bearing on the practical

purpose of painting my pictures are the things that I have learnt from you. To see the thing all at once. To work open and loose, freely, with a full brush and full colour. And to understand that when, with that full colour, the drawing has been got, the picture is done. It sounds nothing put into words, but it *is* everything put into practice.

St. Mark's is engrossing and the Ducal Palace and 2 or 3 Renaissance gems, the Miracoli and S. Zaccharia and the Scuola di San Marco.

Of course one gets as familiar with Tintoretto and Titian and Veronese as one was with Reginald Cleaver and F. C. Gould. The more one sees of them (the former I mean) the more preposterous is the pessimistic contention that we who live now should not paint. We aim at and achieve totally different results, results that they neither dreamt of nor could compass. A fine Whistler or Degas or Monet could hang with any of them. It would be intrinsically every bit as good, and for us have the added sparkle and charm of novelty.

Don't tell MacColl or anyone these sentiments. He would deduce therefrom that I considered the sisters Lloyd superior to the presentation of the Virgin! You, thank God, are not too damned clever to understand anything.

What news? what gossip?

Always

Votre affectueux et dévoué,

W. S.

He did not stay long on this first visit, though the fine painting of *The Lion of St. Mark's*, exhibited at the New English Art Club the following year, shows that his time was not wasted. Nor did he return until the winter of 1900-1901, when he was living at Dieppe. This time he stayed longer, about eight months, and in 1903 he went again for an equally long visit. Perhaps Bernheim's had something to do with his return. Through the good offices of Blanche he had made an arrange-

THE RIALTO
*Pen-and-ink sketch*

ment with them a little earlier, by which they took his canvases in 'roped-up (and unseen) batches of 10 at £40 the batch, with one batch thrown in as make-weight'; and they may have suggested to him that scenes of Venice would be more saleable than the back-streets of Dieppe. If that were so, they may well have been disappointed at the results, for Sickert's version of the much-painted city on the lagoons is very different from the more usual and more popular one. He painted Venice as he painted Dieppe, or as he would have painted any other town (or indeed any other subject whatever) at that time, dark, crepuscular, and massive. Instead of the Italian sun, he painted the Salute by moonlight and the Ducal Palace at dawn. Instead of the brilliant colours of Turner and his post-card successors, he adhered to the violets and umbers and greys, which had hitherto dominated his palette.

<p style="text-align:center">*     *     *</p>

To Venice, then, he went, and to Venice in winter! I can see him standing at the station exit some cold grey evening, cumbered with parcels, and looking out over the Grand Canal, empty of life, and whipped by a sleety wind. I can see him rowed to his hotel over that dreary waste by a half-numbed gondolier, forlorn, homesick and alone. *Ostrega!* So this is Venice!

But in the morning there is a different scene. The sun is shining, frosty but warm. The pigeons wheel about St. Mark's. And the little tables are put out in the Piazza for morning coffee and gossip, while the Venetian girls pass back and forth on their way to work, their black shawls swinging around their hips. The first thing to do is to explore, an exercise more fascinating in Venice than anywhere. Immediately outside the Piazza you enter a new and marvellous world. The streets, called '*calle*', so narrow that you can touch both sides at once, winding and twisting at haphazard, crossing and recrossing the small canals on delicate arched bridges, are more bewildering to the uninitiated than any maze. They swarm with life, lined with gay shops, in which the electric light is always on, since not enough

comes down from the slit of blue sky above. Sickert had been given an address by his hotel porter in just such a street, 940 calle dei Frati, San Trovaso, where he might perhaps find a room. The groundfloor was occupied by a tiny bar, behind which sat the *cara padrona*, plump and good-natured: above her, the figure of the Virgin with her ever-burning flame. The room was at the top of the house, with a good light from its single window. There was a wooden bed, a wash-stand with a canopy tied with pink ribbons, a chest of drawers with a brass candle-stick on it, a sofa with a pink pattern, and on the walls a large map, in which Venice shows pink against a green lagoon.

Here the painter was soon installed and from hence he sallied forth on new quests. His first visits may have been to one or other of the families to whom he had brought letters, the Fortunys for instance, 'where I go every Sunday—a delightful poly-glot tea with cakes and sweets and Xeres and fair Venetians. They are really charming people (the Fortunys) with a fascinating cordiality which remains discreet and well-mannered. I wonder if all Spaniards are so charming. Rico too is a darling. He has bought the palace next to his own. He paid me a visit the other day in a splendid overcoat of black English duffle magnificently cut, the red ribbon and a magistral billicock, and gave me golden counsels.' Some of his other visitors were even more helpful. 'I have sold two pictures to Gonze. A nude on a bed and a girl in a shawl sitting on a sofa. And another to Schlesinger. Nine hundred francs altogether. I should have had to do nine canvases for the Bernheims for the same money.'

But as soon as he could escape from formal visits, he set out on quite another pilgrimage, across the Rialto and then south to the Scuola di San Rocco. For, though Sickert has never been in-fluenced by any particular old master, he had an especial admiration for Tintoretto, who, perhaps more than any other, stood for him as the archetype of draughtsman-designer-painter, the inspired illustrator telling his story through the weight and movement of the bodies of the actors.

For a week the weather remained fine. It was cold, but not too cold to work out of doors in the sun. Sickert was busy with drawings of San Marco and the Salute. In the evenings there was opera or variety (more drawings) at the Fenice. And day or night there was always the moving panorama of the Piazza.

Then the rain started again, a cold drizzle, which never ceased, damping both paper and enthusiasm. Some alternative became necessary. He decided to have a model in his room, 'which is a change, and prevents me wasting my time worrying for the spring. So I am sure of working every day. The Hotel Royal, Dieppe, has left its mark on my talent. I am perhaps only a rectangular painter. And, like everyone else, I am considerably annoyed at not being an "*Universal-genie*"—though I don't believe in them.'

There were no professional models in Venice, even had he preferred one. He applied to *la padrona*. Of course! That very evening she would introduce the painter to a nice girl, *una beia puteia*. And by the next morning Giuseppina was installed in one of the stiff chairs, chattering away in the Venetian dialect; and the first of many portraits under way.

Shall a painter be known by his models, as a man is known by his friends? It might perhaps seem so, if one compares those of Gainsborough, shall we say, with those of Toulouse-Lautrec. Giuseppina's sharp features and shock of black hair are more familiar than any others in Sickert's work. As usual she was a girl of the people, simple, unaffected and warm-hearted. There are portraits of her in every position and every light. Later, first the black shawl and then the plain black dress were cast off, disclosing a long white petticoat, frilled and gathered, and the most wonderful blue corset. Halt there! '*Ol d'un can*'—Enough! The figure, one knee raised to make easier the loosening of the stays, goes back to Rembrandt for fullness and weight, to Chardin for the quality of paint. Later still the petticoat and corset will come off in turn, and Giuseppina will be there, naked on a

tumbled bed. And all the while the soft Venetian chattering goes on. *Mamma mia povereta* is ailing and needs her more than ever. *La piccoia soreia* is in trouble with a bad man. If the *sior inglese* needs another model, there is her friend Carolina dell' Aqua. That evening Sickert buys a pocket edition of Goldoni, henceforth an inseparable companion.

Paint well and quickly, painter! *Male gut und schnell!* Hardly again in the cold north will you recapture the warmth and softness of this Italian spring.

Sittings started at nine in the morning and went on till four, with a break for lunch. Giuseppina took her friend the round of the *osterie* of the quarter, and particularly to one, near the Rialto, where the notabilities of the market-place foregathered. There he was introduced to *risi-bisi* and *bisi-risi*, to *polenta e osei*, above all to *scampi fritti*, most succulent of fish. There, too, with or without introduction, he soon became friends with the above-said notabilities. Would Sig. de Rossi (who supplied vegetables, wholesale, to the city of Venice) oblige by sitting for his portrait? *Ma certo!* There is nothing more agreeable to the Italian temperament than posing, especially if one is allowed to strike an attitude. Signor de Rossi, however, is permitted no attitude. He is painted in his absurd loose collar, his hair *en brosse*, one arm thrown negligently over the back of the sofa. But what is this? No colour? Nothing but reddish brown and grey? Sickert, who considered it the best portrait he ever painted, guessed that it would not be greatly appreciated by the sitter or his family, and in 1927 wrote to his friend Mrs. Hulton in Venice to buy it back from them.

Other sitters also came to the bed-studio in the calle dei Frati. *Mamma mia povereta* came, and her portrait, now belonging to Mark Oliver, hangs without shame between a Rembrandt and a Tintoretto. Carolina dell' Aqua came, and, with Giuseppina, posed for the first of those conversation pieces (see *A Marengo* in the Tate Gallery) which were afterwards to take more definite shape in the Camden Town period. Then there

was Maria Bionda, and a little girl, Inez, with round face and round black eyes.

Meanwhile out-of-school hours were equally well employed. Besides the Fortunys he made many friends in Venice. He was always in and out of the Montalba's hospitable home in the Piazza Sant' Agnese. He knew Horatio Brown, the historian of Venice. And he often used to go on drawing expeditions with Miss Mary Hogarth. Social distractions counted for much in those crowded months, but they were not allowed to interfere with the serious business of painting.

At the same time he was experimenting in technique. 'I have learnt many things. *Not* to paint in varnish. *Not* to embarrass the canvas with any preparations. And so to give the paint every possible chance of drying from the back of the canvas. To paint with $\frac{1}{2}$ raw oil and $\frac{1}{2}$ turps. To state general tones once and *once only*. And when this first coat is dry, to *finish*, bit by bit. I had the bad habit of restating the tones all over an indefinite number of times and getting no further, not improving the colour, and making the canvas, specially in the darks, more and more disagreeable. And after twenty such sittings the canvas remains a sketch.'

As spring advanced and the trailing wistaria covered balconies and courtyard with fresh beauty, Sickert worked more and more in the open. He made detailed drawings of St. Mark's, the Ducal palace, the Salute, the Rialto, to be squared up at leisure and used for the larger canvases, most of which were actually painted at Dieppe after his return. But also he made lovely swift sketches in oil of the less monumental parts of Venice, behind the scenes, as it were. A bridge over a small canal with one or two black-shawled figures, anonymous units of the ceaseless come-and-go across the water-ways of the city, a *sandalo* passing beneath with its freight of fruit or vegetables. The fondamenta di Malcanton, mysterious and eerie, reproduced in Wedmore's book. A church with its little white piazza and a procession of first communicants just entering. The fish market. A long line

of windows on the Zattere. Painter, paint well and quickly! And well and quickly must Sickert have painted when we consider that the whole Venetian 'period' was compressed into three visits of a few months apiece.

At last the day came for leaving. Again he stands on the station steps of the Grand Canal. But now the September sun shines warmly. The water is alive with movement. There is a song in the air. The sketch books and panels are filled with good work done. Giuseppina is there to see him off. There is a promise of return, but it is always harder to be left behind.

In the heart of the painter there are no misgivings.

*'To-morrow to fresh woods and pastures new.'*

# PART II

1905-1921

# CHAPTER X

# CHANGES

∽〰∾

In 1905 Sickert returned to London, unheralded and unex-
pected after an absence of six years. He had never, of course,
entirely lost contact with England; but his home, so far as he
had one, had been at Dieppe. Henceforward London would be
'home', Dieppe and the Continent 'abroad'. The immediate
occasion of this return was the Whistler exhibition. Whistler
had died in 1903, and it was the sale of some of his etchings that
provided the funds which enabled Sickert to come to England.

But there was a deeper inward ferment underlying the out-
ward movement. 1904 to 1906 were to witness changes, not
only in residence, but in manners, associations and (symptoma-
tically) in style.

Sickert was now forty-five. For some years he had known
periods of depression, partly financial, but chiefly psychological,
in origin. In Dieppe he had been aware of a sense of isolation
from those life currents which had hitherto been the source of
his strength. He was in danger of burying himself alive on the
Continent: of finding himself cut off from his English friends.

In his work, again, in spite of his friendship with Degas, and
the encouragement which he found in the appreciation of
French painters, he was not fully satisfied with himself. The in-
spiration of architecture as a subject was exhausted. Dieppe had
yielded up her last secrets. The field of vision had become too
narrow for an expansive mind. In Venice, after the first trance

of joy had worn off, he came to realise that he was painting only the surface of her stones, not the life within. Contrary to his true nature, he was choosing subjects for their own intrinsic beauty. He had been content for a while with the *façade* of things, but he was content no longer.

For all these reasons Sickert's mind at this time was particularly susceptible to new influences, both in sentiment and practice. Hitherto Whistler and Degas had been sufficient mentors. Now he was going to feel the power of another, simpler, approach to art, of which Jean François Millet and Camille Pissarro were the type. Perhaps the antithesis is between the spirit of the country and the spirit of the town. The great city brings many gifts, but often it leaves also an intellectual stain, a taint of pride or weariness, on its citizens. The countryman is nearer to the earth. So also his art, being the mirror of man's unity with nature, touches us more intimately than the art of the town.

Sickert himself never attained this pastoral singleness of heart. A confirmed town-dweller, to whom the salad of intellectual give-and-take was a necessary food, he had no impulse towards it. There is a passage from one of his favourite authors, Martial, which he quotes with evident sympathy. 'Martial, writing from his exile in Spain to Rome, the dedication of his twelfth book to his friend Priscus, excuses himself for the years of "most contumacious idleness". This excuse, in five lines of Latin prose, has always thrilled me with a vivid and present sense of what was Rome. "Accept then the reason; in which the greatest and first is, that the ears of civility, to speak into, are here to seek, and that I seem to myself to be pleading in an alien forum. For if there is anything in my booklets which may please, it is the hearer who has dictated it. That subtlety in the judgements, that wit so rich in matter, the libraries, the theatres, the assemblies, in which for sheer pleasure one scarcely feels that one is studying: the fill of all these things that, being fond of, we have left, and that, deprived of, we desire." '[1]

THE PARK RAILINGS

But though he had no pastoral feeling himself, yet his strong love for these two artists, who had it in supreme degree, influenced his work in many ways. Pissarro, whom he had known personally, and who was one of the Impressionist group, to which he owed his artistic parentage, was the nearer to him of the two. But of Pissarro himself he said, 'It is the material of Millet, seen with a gayer and more objective eye.'[2]

References to Millet, written with a filial devotion and respect, are frequent in his writings. Whenever a good example of his work appeared in an exhibition or the sale room, it was sure of a 'notice'. Speaking of 'a tiny passage in one of his pictures', he says: 'On the thatched roof of a far-off cottage Millet had applied, like a postage stamp, a little image of a man in blue trousers mending the thatch. The little figure was so far off, so touching, so flattened out, and so deedy. And the more absurd and nugatory my words in describing this must appear, the more I prove my case that Millet was giving here just that something that only the pencil or the brush can give, an emotion whose bouquet will not survive decanting from the skin of painting into that of letters. Something of this essence belongs to any painting that is art. It can only be distilled from leisure, from a painless arrest in the passage of time. The drunkard knows these moments, and we can often see small children lost in the timeless contemplation of what to us may seem a trifle. Haunted as we are by duties, griefs and diseases, what we can ask of art is what is known in America as a "let-up".'[3]

Of Pissarro also he wrote and preached without stint, complaining always that the true measure of his work had never been recognised. In 1911, in the course of a preface to an exhibition of his (Pissarro's) pictures at the Stafford Gallery, he said: 'To study the work of Pissarro is to see that the best traditions were being quietly carried on by a man essentially painter and poet. For the dark and light chiaroscuro of the past was substituted a new prismatic chiaroscuro. An intensified observation of colour was called in, which enabled the painter to get

the effect of light and shade, without rendering the shadow so dark as to be undecorative. . . . There was nothing sensational about his gentle painter-like art. It did not make good copy. Nor was he concerned that it should. To reminders that this one had had a medal, and that the other was making money, his invariable answer was: *"Il n'y a que la peinture qui compte."* '4

Sickert's debt to Pissarro, however, was not paid directly to him, but to two painters with whom he became intimate very soon after his return to England, Lucien Pissarro, the son of Camille, and Spencer Frederick Gore. His friendship with the latter quickly ripened into what was to be for him one of the closest personal and professional attachments of his life. The influence of the two painters on each other's work was mutual. 'I may as well say that it is my practice that was transformed from 1905 by the example of the development of Gore's talent. (On the other hand) I taught him certain things about drawing.'5

After his death in 1914 Sickert wrote of him: 'Spencer Frederick Gore built his astonishingly accelerated and fragrantly personal development on the good and stable foundation of a faithful reverent and obedient studentship. It was at the end of this studentship that I first made his acquaintance. . . .

'If leisure for reflection, musing, a kind of playing chess with ideas, may be said to be the ultimate aim for which we all grunt and sweat, and, as the French say, derange ourselves, it was Gore's secret that he wrung, out of a life of incessant intellectual and material service to colleagues and friends, seemingly twenty-four hours a day for the exercise of the purest, the serenest, and the most exhilarated reflection. But it was brush in hand that he reflected.

'How conscious most painters are all their lives of this difficulty! They can truly claim, perhaps, to have wielded their pick and spade with energy during the appointed hours, but the magic moments seem always to find them unarmed. Either it is too early in the day, and their wits are not yet with them, or it is too late and they have laid down their tools. The most magnificent

game seem always to be started when they have not their gun handy. It was Gore's secret that he seemed to have bagged his bird before or after hours, without prejudice to the regular day's work. . . .

'His view of the function of a modern realist in painting can be clearly deduced from his practice. Firstly he was to accomplish his purpose by means of his chosen instrument, which was oil-paint. He accepted the instrument as he found it handed down to us by Monet and Pissarro, let us say, for brevity. He accepted it for what is to be got out of it as an opaque mosaic. He held the not unreasonable conviction that nature was a thicker lexicon than what was bound between the covers of any one human being, and he drilled himself to be the passive and enchanted conduit for whatever of loveliness his eyes might rest upon. . . . Gore understood very well that the painter can give only a sample of each kind of nature, can only make of each canvas a microcosm of each mansion in the house of life. There was a month of June a few years ago, which Gore verily seems to have used as if he had known that it was to be for him the last of its particularly fresh and sumptuous kind. He used it to look down on the garden of Mornington Crescent. The trained trees rise and droop in fringes, like fountains, over the well of greenness and shade, where little parties of young people are playing at tennis. . . . But it is not only out of scenes obviously beautiful in themselves, and of delightful suggestion, that the modern painter can conjure a panel of encrusted enamel. Gore had the digestion of an ostrich. A scene, the dreariness and hopelessness of which would strike terror into most of us, was to him matter for lyrical and exhilarated improvisation. . . . THE ARTIST IS HE WHO CAN TAKE A PIECE OF FLINT AND WRING OUT OF IT DROPS OF ATTAR OF ROSES.'[6]

\*          \*          \*

The changes in Sickert's own practice were developed slowly, over the years 1904-1908, the year of the first exhibition of the Camden Town group. On the one hand there are portraits, such

as that of Mrs. Swinton, painted in the Venetian manner and with Venetian backgrounds: on the other those pictures, usually interiors with one or two related figures, which show more and more the Gore-Pissarro influence. In these the colour changes come first with an increased use of violet in the shadows, though not as yet with any lightening of the key. 'About six or seven years ago,' he wrote in 1910, 'under the influence of Pissarro in France, himself a pupil of Corot, aided in England by Lucien Pissarro and by Gore (the latter a pupil of Steer, who in turn learned much from Monet), I tried to recast my painting entirely and to observe colour in the shadows.'[7] Following the change in palette came a new method of laying on the paint, referred to with more wit than relevance in George Moore's *Conversations in Ebury Street*. This also was an adoption from Pissarro, and consisted in the use of dots or small patches laid close to but discrete from each other on a groundwork of the chief masses of tone and colour. Of course, there was nothing revolutionary in such a method, which is almost as old as painting and certainly as old as mosaic. Speaking of William Hunt he says, 'I was thinking how he had anticipated the Impressionist technique, in his multitude of small touches, building up a sensitive whole. I was thinking of him and of Pissarro, and of how the extreme division into small touches in each case brought about this desirable result. The more touches, provided they are dictated by sensation and observation, the more frequent is the revision. Hence the juster the sum.'[8] It was not new, but it was new to the pupil of Whistler and Degas, for whom smoothness and calligraphy had been the chief virtues of execution.

In drawing also there was a corresponding change: a loosening of the structure, through the use of short divided strokes, by which the form is built up from within rather than outlined. The new drawings were made always with an eye to the painting for which they were to be the documents, not for their own sake. 'This is not the time,' they seem to say, 'to show that I can draw.' In spite of this abnegation, or rather because of it, the

power and beauty of these drawings will always be appreciated for their own sake by anyone to whom the art of the draughtsman is dear.

And with new methods we find also new subjects. With the abandonment of calligraphy went the abandonment of the façade. There were to be no more of the august-site or the quite-nice-young-person motifs, of the first of which errors at least Sickert himself had not been guiltless. The new subject was to be no less than the whole human comedy, unrestricted by either sentiment or prudery. 'Our insular decadence in painting can be traced back, I think quite surely, to Puritan standards of propriety. If you may not treat pictorially the ways of men and women, and their resultant babies, as one enchained comedy or tragedy, human and *de mœurs*, the artist must needs draw inanimate objects—picturesque if possible. We must affect to be thrilled by scaffolding or seduced by oranges. But if the old masters had confined themselves to scaffolding by night and oranges by day, we should have had neither Rubens nor Tintoretto. And what landscape by a pure 'landscape-man' can you set beside a landscape by Rubens?'[9]

The interiors, which form the background of the Camden Town period, as it is usually called, are the homely suburban bedroom or first-floor front, and the actors in the human comedy to be played there are taken from the indigenous population of London. Giuseppina in her Venetian shawl or her Venetian nothingness had been but one step removed from the Chelsea model, that 'aluminium doll', whom Sickert found so artificial and so ineffectual in later years. 'They turn her to the left. They turn her to the right. They put behind her a curtain or a mirror or a black hole. But it is always Tilly Pullen, too large for her interest and for the spaces in a house. . . . But now let us strip Tilly Pullen of her lendings and tell her to put her own things on again. Let her leave the studio and climb the first dirty little staircase in the first shabby little house. Tilly Pullen becomes interesting at once. She is in surroundings that mean some-

thing. . . . Follow her into the kitchen, or better still, for the artist has the divine privilege of omnipresence, into her bedroom; and now Tilly Pullen is become the stuff of which the Parthenon was made, or Dürer, or any Rembrandt. She is become a Degas or a Renoir, and stuff for the draughtsman.'[10]

His aversion to the drawing-room and all that pertains to it became more pronounced. He rails at the supergoose and the portrait painter who exists by flattering her: though for the latter there are excuses. 'The professional portrait painter, I admit, is dragged by the nature of his work along a diagonal resultant. If one side of his triangle may be said to be "pull painter", the other may be said to be "pull duchess". The hypotenuse is what we know.'[11] On the other side of the medal there was the 'occasion when Whistler, yielding to the persuasion of a fair sitter, allowed himself to introduce, step by step, certain modifications in the scheme of a portrait that he was painting. As time went on he saw his conception overlaid with an image that he had never intended. At last he stopped and put his brushes slowly down. Taking off his spectacles, he said, "Very well, that will do. This is your portrait. We will put it aside and finish it another day. Now, if you please," he added, dragging out a new grey canvas, "we will begin mine." '[12]

His own portraits are fewer, partly perhaps because sitters were unwilling to trust themselves to his untender mercies. But he did not court them. Nevertheless there are heads, such as those of Jacques Blanche (in the Tate Gallery), of himself in bowler hat (*The Juvenile Lead*), of Mrs. Barrett, of little Rachel, and of Mrs. Swinton, which witness to his constant interest in portraiture.

At this time also he turned again to the music halls, as has been mentioned in the chapter devoted to them. Probably his close association with Gore, whose own music-hall pictures date from this time, was a factor, although the effects arrived at by the two painters were so different. Gore's key in particular was always higher than Sickert's, who still kept to the dark tones of

the earlier series, now enriched with an impasto of 'encrusted enamel'.

\*     \*     \*

In no department of his art was Sickert's changed outlook more manifest than in etching, which he now took up after an interval of fifteen years. At the time of his apprenticeship to Whistler, he had done literally dozens of plates, most very small, a few larger: most etched direct from nature, a very few worked up from other documents. He used to tell an amusing story to illustrate the unconscious movements of the needle over the copper in the former method: of how he was once thus drawing a street scene with a horse and cart, and how, when the plate was bitten and printed, he had been amazed to find a little boy pissing against the wheel! But by far the greater part of these early etchings were slight evanescent things, which he would roll up and send to his friends with a penny stamp on their backs. I do not think he attached very much importance to them; nor indeed to his later work in the same medium.

Nevertheless when his attention was again (about 1906) drawn to it, it was with a much more experienced and critical eye that he viewed, not only the art itself and his own work in it, but the whole English revival of etching, of which Whistler had been the figure-head. In a review, called 'The Old Ladies of Etching-needle Street', written in 1912, he says in part: 'I have never forgotten a brief but pregnant conversation at which I assisted in the early 80's over a muffin and a cup of tea. An ambitious young student at one of our government schools of art was lamenting the fact that, try as he would, he could not learn to draw. There was a pause in the conversation; the angel of success flew through the room and touched the young man with his wing. ''Why don't you etch?'' said a young lady who was present, and sealed his fate. . . .

'My present business is to show that the young lady . . . summed up in those six (sic) words the greater part of a whole movement, not only retrospectively to '65 or thereabouts, but,

prophetically, to the year of grace 1911. . . . Let us face the fact that the "revival" was a revival *ad hoc*, and that so far as the art of etching goes, it was rather a galloping decline. . . . Into an estimate of the commercial value of any one of the limited number of proofs that the copperplate will yield, enter not only considerations of art but of rarity; so that an art-collector with the well-formed head of a connoisseur may tail off, like the siren, in a mere philatelist. . . . Moreover, till it occurred to Mr. Fry, over-ballasted by excess of learning, and to Mr. Lewis Hind, flighty perhaps for the opposite reason, to take it into their amazing heads to find salvation in the "spoof" of Matisse and Picasso, the critical press has been somewhat gravelled for lack of matter. In etching there is always a subject ready to hand. . . . It is this state of things that has led and will always lead to the creation of etchers *ad hoc*. Dealers will say, " Business in Whistler's proofs must needs come to an end soon, and *etchers we must have*. Unique proofs of precious states must be manufactured over the well-known initials T., D., and H., and a guinea or two more is charged, if Tom, Dick, and Harry can be prevailed upon to add 'imp' to their names in the margin." So etchers are created *ad hoc*, whether their drawings are interesting, and call for multiplication, or not. The public have been educated to expect that an etching should, if possible, contain a mast or two. . . .

'All these things are the last ripples of a dying backwash. The etchers of the rising generation have their eyes fixed on quite other and nobler traditions. First and foremost they recognise that if they are to become strong, they must have their plates printed like visiting cards. They will take gratefully from Hook the motto: "Lose your line and you lose your light." They will disdain entirely to rely on dirt left on the plate by a skilful printer. . . . They will do it all themselves on the plate to the best of their ability, like Vandyck or Karel du Jardin. . . .

'There are two distinct and different intentions with which a man may set about to etch. He will do well to follow either or

both at different times, but it must be at different times. There is, firstly, the draught from nature, made, as it were, at white heat with a current reed. Of this Whistler's *Rialto* or his *Long Lagoon* (in dry-point) may be taken as the type. And secondly there is the deliberately built-up composition, which relies on an accumulation of studies, on memory, or on spontaneous invention. Of this we may take Claude's *Bouvier* as the type. The greater masters have spent their lives in the pursuit and culture of the second of these intentions, and have constantly achieved the former as a by-product. It is the etcher of the *Death of the Virgin* who is able to give us, in half an hour and fifty strokes, a couple of willows and ten miles of plain.'[13]

From this time forth Sickert would have nothing to do with the trade uses of etching: neither with 'states', nor 'impressions', nor 'editions'. Later still he refused even to sign his prints, on the ground that they should be bought and sold on their own merits and not on that of the name. An etching was to be no more and no less than a multiplied drawing, so that twenty might enjoy what otherwise would give pleasure to one only. For this purpose they were to be (technically) simple, clear and straightforward, with nothing left to the printer save to print. All the effects usually associated with etching, such as the burr of dry-point, were eschewed: as were also the extremes of blackness, which the revivalists had so misused. 'He works,' says Middleton Murry, 'as it were, in the open, with the subtlest combinations of grey. His etched line is never lost in an inspissation of ink not seldom used as a cloak to conceal an utter nakedness beneath. . . . To use this method of Sickert's appeals, as a method, because it involves his laying all his cards on the table. The possibility of fudge is eliminated. I know I am not being deceived by pasteboard scenery. The bricks and the mortar are visible. I can count the bricks, or pick out the mortar with my penknife.' Sickert's theory was that the edition of a print should be unlimited, or limited only by the demand, the price low, and all incentive to speculation avoided. 'In

planning the Carfax series, which was lettered by a professional engraver, printed by a journey-man, and published at something like half-a-guinea a print, he put his theory into practice.'

It would be unnecessary and beside the point to consider Sickert's individual etchings separately from his other work, for the very reason that they are merely reproductions of his favourite drawings, and recur not only in that form, but also in paintings. They have had no influence on the practice of etching in England, which has not followed those 'other and nobler traditions' to which he dedicated it, but has continued to give its specialised public that which it asks for, which it is willing to pay for, and which is all it deserves.

## CHAPTER XI

# CAMDEN TOWN

S oon after his return to London Sickert took a studio at No. 19 Fitzroy Street: and began at once to look up old friends and to make new ones. As is so often the case, he did not see so much of the former as of the latter. His one-time allies of the Vale, Steer, Tonks and George Moore, complained that he had deserted them, that they did not know where he stood. They looked for the help of his sharp sword against the gorgon-head of post-impressionism; and lo! he was himself deserting the pleasant pastures of the New English Art Club, and adopting a new realist attitude which amazed and confused them. But while they remained faithful to old ideals when he was away breaking new ground and finding new associates, none the less they remained good friends, understanding the waywardness of his character, and accepting it for the sake of his delightful company and the spice of the unexpected which he brought to their gatherings. Later there arose a coolness between him and Tonks, due to an unfortunate phrase in one of his articles, and many years passed before the damage was repaired.

The new friends included Gore, Lucien Pissarro, Augustus John, Henry Lamb and Harold Gilman. With Sickert as host, a rôle he played to perfection, these painters combined to receive their friends and show their pictures every Saturday afternoon in the Fitzroy Street studio. The germ of these Saturday after-noons had already been incubated in the 90's, when it was the

W.R.S.

work of Steer, Starr and his brother Bernard that was on view with his own. The social element no doubt predominated over the commercial, though prices, from £10 to £25, were ridiculously small; but at least one patron, Mr. Morton Sands, laid the foundation of his fine collection there. The group was enlarged in 1908 by recruits from the Allied Artists' Association, first Edwin Bevan and Walter Bayes, and later Charles Ginner and Malcolm Drummond. The ground was thus prepared for the Camden Town Group, which, however, did not come into being until 1911.

Meanwhile, according to his life-long habit, Sickert was accumulating odd rooms, in which he worked. Most of these were in Camden Town, one of the earliest being in Mornington Crescent. He did his etchings, and kept his press, in Augustus Street, near Grimbles and the Caledonian Market, always a favourite haunt. When he first went to the Westminster, he had a work-room looking over the figure-heads by Vauxhall Bridge. It was from here that the following letter was written, MacColl being then curator of the Tate Gallery:

RING MR. GARDNER'S BELL

~~64 Grosvenor Rd~~

19 Fitzroy St.

MY DEAR MacColl,

My neighbourhood alas! is only apparent. I leave by a bus from Waterloo at 7 A.M. and return to bed at 10 after my classes. Pimlico is my Twickenham as it were, while it is your St. Pancras, *si je m'explique bien?*

So much so, as I find I sleep in Camden Town 3 nights a week, I must give up the above-printed rooms of which I meant to make a kind of little tin Capua. No time for Capuas at all.

*Linquenda Pimlico et domus et placens*

*Mrs. Gardner neque harum quas colis figureheads (Castle's) etc.*

No I can't lunch. I never lunch. *je jeûne: et, quand je ne jeûne pas, je déjeune à Euston à midi platform 6.* We are more likely to meet on your way to Scotland. I pass his Majesty on his red baize oftener than I see my mother.

THE LONDON SHOREDITCH

When I am classed with Charlie Furse, I suppose you will hang me. Who knows?

But we will meet. I have some love left for the man—apart from the curator. And you are coming, I hear, to Hampstead, when Golder's Green and Mornington Crescent will *relier* us more than the Yellow Thames has done.

Yrs as ever, gratefully, even, in spite of appearances,

WALTER SICKERT.

The quotation is from the *Odes* of Horace, Book II, 14, 'To Postumus: on the inevitability of death'; lines 21-24.

> *Linquenda tellus, et domus, et placens*
> *Uxor ; neque harum, quas colis, arborum*
> *Te praeter invisas cupressos*
> *Ulla brevem dominum sequetur.*

The translation of which is:

'Your land (or Pimlico), and house, and pleasing wife (or Mrs. Gardner) must be left; neither will any of these trees (or figure-heads), that you cultivate (or draw), except the hateful cypresses, follow their brief master.'

The appointment to an evening class at the Westminster Technical Institute came to him through the good offices of Mr. Swinton, a member of the L.C.C. He had met Mrs. Swinton at a dinner party given by Mrs. Charles Hunter to Rodin, in order that he might meet the most beautiful women in London. They became better acquainted at Lady Hamilton's, who had become one of Sickert's clients. He asked her to sit for him, and painted a number of portraits, some of which were sent over to Paris. She used to go to a studio at the top of 8 Fitzroy Street. His favourite time for painting, then as always, was after tea in summer. He kept several canvases going at the same time, working at each in turn according to the light, the mood, or the frock she was wearing. He was never in a hurry to start. First they had tea and talk. She recalls that beneath this leisurely

appearance, he seemed to be gradually 'boiling up inside': then suddenly he would pull out the desired canvas and begin to work. One evening she rescued her collection of early etchings just as he was going to burn them up. She also used to go to the Saturday afternoons, on one occasion taking with her the youthful Edith Sitwell, whom Sickert enchanted by the gift of a drawing. At this time his visitors and occasional customers included Morton Sands, his sister Ethel and her friend Miss Hudson, Edmund Davis and Mrs. Errazuriz, whose daughter he·painted and who was a great friend of Steer and Tonks. Others who knew him socially and sometimes bought his pictures were Judge Evans and his wife and the Hammersleys, whose hospitable home at Hampstead was a frequent meeting place for the friends of the Vale.

It was at the Westminster that he met Madeline Knox, afterwards Mrs. Clifton, who was a pupil. In 1909 he had proposed starting an etching class, but only received two applications, of which hers was one. They decided to start a school together, and a year later 'Sickert and Knox' opened a class for etching at 208 Hampstead Road. McEvoy was one of the pupils. This was superseded almost at once by a more ambitious school, for which a house opposite with a garden (No. 140 Hampstead Road) was taken, the etchers being relegated to the top floor. It was named Rowlandson House after the comic draughtsman. A caretaker, named Hayward, who apparently was something of a 'character', was installed. Malcolm Drummond was the foundation pupil, others being Frank Griffiths, Col. ('the Major') Armstrong, Maresco Pearce (for etching), Miss Jean McIntyre, Mrs. Rowley Bristow, and Miss Sylvia Gosse. The women were as remarkable for their beauty as their talent, perhaps more so. After less than a year Miss Gosse, who from this time on was Sickert's firm friend and guardian angel, took Miss Knox's place, and attempted to evolve some order out of the financial chaos. Of course the school did not pay. Hardly were expenses covered. Sickert would order huge stoves and special

easels regardless of cost or bank balance. When the students were hard up, they were kept on without fees. But otherwise it was all great fun. Gore used to come and paint in the garden, and then go out to lunch with the staff at the Euston Hotel. Sickert painted his portrait of Jacques Blanche there, and several pictures of Dieppe for Judge Evans. He taught every morning: slept in the afternoon at one of his rooms, with a handkerchief round his head to keep his jaw up: worked by himself from models after tea: and taught again at the Westminster in the evenings.

For a while he shared a studio with Gore in Brecknock Road, and he had a room for many years in Granby Street, where some of his most important pictures were painted; *Ennui*, for instance, *Jack Ashore*, and the other pictures in which the figure of 'Hubby' appears. The latter was a childhood friend, having gone to the same school at Bedford. He had run away to sea as a youth, sailing in Eastern waters under a Chinese captain, and had later fallen on bad times. The woman who posed with him was called 'Marie'. The room in Granby Street had French windows, which help to place some of the pictures.

<p style="text-align:center">*  *  *</p>

In 1911 Sickert was married to Christine Angus, the daughter of a Scotch leather merchant of Porchester Terrace. He was always attracted to women and was himself attractive to them. Feminine society was important to him. He liked to watch their movements, their thousand and one devices, calculated by instinct, and not by reasoning or rule of thumb. He enjoyed the tickling flattery of their approval. And well he knew how to please them, not only by the exercise of his personal charm, but also by all those attentions which women love, letters, telegrams, flowers, theatre-tickets and such-like.

His heaviest batteries were brought into action for the winning of Christine. Telegrams and letters arrived at the house every two hours, until the poor girl became quite ill with excitement. She was sent off for a visit to Chagford in Devon-

shire, and Walter was to see her off from the station. Not content with that, however, he accompanied her all the way, after changing her ticket from third to first in his usual extravagant fashion. In fact he completed his conquest on the way down in the train, and they returned together, engaged. At first there was opposition at home, Christine's father disapproving of artists in general and of Sickert in particular. Christine had a small allowance, but her father was more than doubtful that his would-be son-in-law could make up the necessary balance. He was finally convinced by the anonymous purchase of one of Sickert's largest pictures, the portrait of Hilda Spong in 'Trelawney of the Wells', which had 'belonged' for a time to his brother Oswald, and its acceptance by the public gallery of Johannesburg. It need no longer be any secret that the donor was Miss Gosse, or that the picture had previously been refused by the perspicacious authorities at the Tate. It is no secret either, that, only a short time before this, Sickert had been engaged to a girl-student at the Westminster, a beautiful creature with a swan neck and creamy complexion which seem to have gone to his head, nor that he was most fortunately jilted at the last moment. His attachment to Christine on the other hand was far from being a mere love on the rebound, but proved itself to be deep, lasting and true. They were very happy in each other so long as it was given them to be together.

They were married one hot summer day at the Paddington registry office in the Harrow Road. Spencer Gore was best man. Christine's sisters were tremendously excited and impressed; not so the Registrar, who, on Sickert's giving his profession as 'Painter', enquired laconically, 'House?' to the latter's great delight.

Christine had been a pupil at Rowlandson House, although her particular art was that of embroidery. She was about thirty-three years old, not strong (she was slightly lame), but of a sweet, gay nature that overcame all adversity and endeared her to everyone. As she stitched at her work, she sang. Although she

had a little money of her own, she was always worried over the expenses of her irresponsible husband. Sickert never 'had any ideas' about money; or rather he had but one idea, to spend it. The ticking of a waiting taxi never sounded in his ears, as it does to most of us, like the doom of time. In point of fact he was quite oblivious of it. After a honeymoon at Dieppe, they went first to a house in Harrington Square, which Sickert had chosen while they were still engaged. Every morning he went to bathe in the Euston baths, because, as he said, the vitamins from the little boys' feet were surely beneficial to his health! and afterwards to a hearty breakfast at the Euston Hotel. The Harrington Square house was soon found inconveniently large: so they moved, first to Gloucester Crescent (1912–1914), and then, still seeking to cut expenses, to Kildare Gardens, where they had only the upper half of the house. Every summer they went to Dieppe. In 1911 Sickert still had his house at Neuville, but soon afterwards he gave it up, on account of the long climb up the hill, and bought the villa d'Aumale at Envermeu, a village about 15 kilometres inland. While they were there, Sickert himself used to go into Dieppe by an early train, Christine following later *pour faire les courses*, and home together in the evening. It was at this time that the café scenes under the Arches were painted.

<p align="center">*　　　*　　　*</p>

Meanwhile life was full of activity. The years from 1907 to 1914 were those in which the full force of his personality, as well as his fullest powers as a painter, were in action. He still contributed regularly to the New English Art Club and the Grosvenor Gallery, and also sent pictures to the Salon d'Automne and the Barbazanges Gallery in Paris, and to Bradford, Cardiff and Bath. In 1908 he was made Sociétaire of the Société du Salon d'Automne and in 1912 a member of the Society of Twelve, exhibiting prints and drawings at their seventh exhibition at Obachs, including unique etchings of Whistler at work in his studio and of Mrs. Whistler, and two studies for illustrations to Esther Waters.

At first he was still looking chiefly to France for a market. In 1904 he had had a show at Durand-Ruel's, for which Blanche wrote a foreword; in 1907 another at Bernheim's with nearly a hundred pictures, mostly of Venice. The Paris press was on the whole favourable. Collections in which his work was to be found included those of André Gide, Tavernier, Hoentschel, Moreau-Nelaton, Sainsère, E. Strauss, Paul Robert, Goujon, Lebey and Baron Caccamisi. Montaigne and Martial were mentioned as two of his favourite authors. In 1909 he again exhibited at Bernheim's, and afterwards put some of his pictures up for sale at the Hotel Drouot, his old friend Tavernier writing a preface to the catalogue. Blanche, Hermann-Paul, Luce, Signac and Bonnard were successful bidders, but the prices were pitifully small, the highest being 440 francs. In England he had no one-man exhibitions until 1911, when he held two, one of paintings at the Stafford Gallery, and one of drawings at Carfax. At the Stafford Gallery, among other pictures, he showed *The Rialto, The Old Hotel Royal, The Salute, Mamma mia po'areta, The Old Mogul Tavern, The Blue Stays, The Old Offices of the Morning Post*, and *La Gaîeté Rochechouart*. There were also some pastels of Venetian scenes. The response of the critics was varied, but Roger Fry wrote enthusiastically that 'we have to admit that, amid all the pretensions and deceptive promises of more ambitious and exciting art, we have all the time had a real master among us and made no stir about him. . . . By calling him a master I mean that everything he produces is really done; he does not make shots at things; the particular thing that he sets out to do is actually and almost infallibly accomplished. . . . His vision is curiously detached, not only from the commonplace, utilitarian values of everyday life, but also —and herein lies his peculiarity and his limitations—from the values of the imaginative life. . . . Things for him have only their visual values, they are not symbols, they contain no key to unlock the secrets of the heart and spirit.' . . . and so on.

# CAMDEN TOWN

The Saturday afternoons in Fitzroy Street were followed by the Allied Artists' and that by the Camden Town Group and the London Group. And at the same time he was pouring forth his views in the series of essays, from which most of the excerpts in this book are taken. They covered the whole range of painting, ancient and modern, as well as the political economy of art, criticism, education and many subjects with only a secondary relevance to art itself. Both style and matter have been allowed to speak for themselves. Of their influence it is more difficult to judge. If it is there, it is working below the surface, awaiting its time. Probably an ephemeral press is not the best seeding ground for either revolution or counter-revolution: and Sickert's doctrine contains something of both of these. To rescue it from that, and present it to a wider audience, has been one of the main objects of this book.

Behind the formation of the three societies mentioned above there was a common principle, which was due to Sickert's advocacy; that of equality of opportunity. Undoubtedly his first and greatest enthusiasm was given to the Allied Artists' Association, which embodied that principle in its purest form. All the other exhibiting bodies, including the New English Art Club, were barred to those who did not share the particular ideologies of their juries. By its constitution every one who had paid their subscription to the Allied Artists' had an equal right to show their pictures. To the perennial fault-finder he answered, 'I have been accused, because I am convinced of the supreme necessity for the existence of at least one no-jury exhibition in England, on the lines of the Paris *Indépendants*, of asserting that one picture is as good as another, I, alas, the most "picksome" of critics, as they say in Sussex. In the old Bedford Music Hall, the dear old oblong Bedford, with the sliding roof, in the "days beyond recall", before the Music-halls had become two-house-a-night wells, like theatres to look at, there was sung a verse which will always remain with me for its concentrated philosophy and insight:

*"Go away, naughty man, go away!*
*One man is as bad as another!"*

I take this opportunity of stating publicly that I do not believe
and never have believed that one picture is as good as another.
What I do believe is that it was urgent, in the present ferment
of opinion on art, that all students and painters should have
equality of opportunity to exhibit.'[1] It was a call to a new genera-
tion and a new fashion to come out into the open. At least they
should not cry that they had not been given a chance. 'Measure
yourselves as soon as you can, *mes petits enfants!*' he cries to them.
'We are not afraid of you. And on the other hand we shall be
enchanted to be beaten by you. Especially if you are our pupils!
. . . We are what we are, and the terror of having the gilt
rubbed off our nobility is a craven terror, and generally the
mark of the profoundest inferiority.'[2] And again, 'A hurricane
has swept Europe, and the tail of it is already wiping our eye.
The Channel is no longer a bar. True patriotism forbids us to
palter with reality. The women and children, and the members
of existing societies, must be put in places of safety, and vic-
tualled. The youth of the country is being called to arms. In
Paris the existence of the *Indépendants* for twenty years has done
its work. The 'Allied Artists' will bring about the same result
here in a very few years, the quicker as the victory has already
been won over the water. The defeated will call it anarchy. But
it is no more anarchy than is the stream of people you meet in
the Strand. You meet all sorts, and can take your choice. No
one is forbidden to walk.'[3]

The first law of the Allied Artists, which was laid down and
underlined by Sickert, was: 'FOR THE PURPOSES OF THIS
ASSOCIATION, THERE ARE NO GOOD PICTURES AND NO BAD
PICTURES. THERE ARE ONLY PICTURES BY SHAREHOLDERS'; on
which he comments, 'Our system draws the sting of all artistic
tyranny. Heavens! Don't I remember the vague and stuffy spools
of verbiage, in which the painter-man of the 80's used to wrap

up his rather deaf likes and dislikes! "As long as it's the right sort of stuff, and the artist is sincere!" Stuff and nonsense, as my Aunt Maria used to say! The right sort of stuff was, of course, my sort of stuff, and the wrong sort of stuff was your sort of stuff!'[4]

The Association held its first exhibition in 1908 at the Albert Hall, and was well received by the critics, who seemed surprised that the average level was no lower than that of jury-selected shows, but rather disappointed that no more revolutionary 'advances' were to be discovered. At the succeeding annual exhibitions at the same place, it was the members or affiliates of the Camden Town Group, together with some of Sickert's pupils, that obtained the most notice. But the response of the public was poor. The size of the shows was unwieldy. Subscriptions fell off. After some years the exhibition was transferred to the Grafton Galleries. The last one was held in 1919.

The Camden Town Group was conceived, as seems so often to be the way of it, in the genial atmosphere that accompanies food and drink. In the winter of 1910–11 a number of painters, most of whom had shown their work at Sickert's studio in Fitzroy Street and had taken an active interest in the Allied Artists', used to meet for dinner at a little restaurant in Golden Square on Saturday nights. Persuaded by the importunity of Harold Gilman, they decided to break with the New English Art Club, which had recently rejected the work of some of them, and form a society of their own. Spencer Gore was elected president because of his unfailing tact and the general esteem in which he was held; but Sickert was the breath and bellows of the group. Walter Bayes, who soon joined them, recalls that it was he who gave them their name, insisting that the district had been so watered by his tears that something important must sooner or later spring from its soil. Pissarro, capitalising a little on his name, was regarded by many as the fountain of true principle. The rough impasto, which became associated with

their methods, arose from the practice of working from nature and returning again and again to the same paintings. Another lump of paint could always be poised on a surface so rough and corrugated that it would not show as a scar. When Bayes suggested the possibility of other methods, Gore answered that it would imply an 'infidelity to the present', a delightful phrase. Gore had an open mind and was ready to find merit in the most varied work. But Gilman's outlook was narrow. For all his real friendliness, he always regarded himself as a dark Diogenes. When no one bought any pictures at the Saturday afternoons, he would glower and say, 'Get some cake at six-pence a pound, *with stones in it*—do 'em good!' He had a great determination to succeed, and really believed that no one counted outside his own group. Bevan, who had a gruff voice and the appearance of a fox-hunting squire, was the Maecenas of them. The rest were very poor. Indeed it was a marvel to Bayes that they all managed to dine so well once a week, and even give their wives, those that had one, pêche melba for dessert!

Clifton regarded the Saturday afternoons as a form of financial suicide. From him and Sickert they got plenty of contradictory advice as to how to sell their pictures, but they seldom sold any. When Lady Cunard bought a Sickert for £40, she was regarded with the awe that attaches to a plunger.

The other members were Ginner, Innes, John, Lamb, Lewis, Lightfoot, Ratcliffe, Turner and Manson. The first exhibition was held at Carfax in 1911. Their object was to give free expression and equal opportunity to painters of various tendencies, chiefly realistic in aim, whose views did not find favour in other circles. Sickert sent four pictures, as did the rest, including two of the Camden Town Murder series. A good deal of ink was spilt by the critics in showing that Sickert's style was not adapted to bloody murder. Only a few appeared to realise that this title, like so many of his others, was no more than a peg on which to hang the study of two related figures under a given fall of light. On the whole, however, the exhibition was well re-

ceived. The more extreme post-Impressionist contributions of Wyndham Lewis were passed over, though not condoned, as being out of line with the spirit of the other members.

Three more exhibitions were held and then the society was merged into the larger London Group. This was a body with the same aims and the same directing force as the Camden Town Group. The members of the latter formed its nucleus; but among the new recruits the post-Impressionist element was more in evidence. Some of the names were Sylvia Gosse, John and Paul Nash, Walter Taylor, Thérèse Lessore, Eric Gill, W. B. Adeney, Fred Etchells, E. Wadsworth, Jacob Epstein, David Bomberg and C. R. W. Nevinson. The group held its first exhibition at Brighton in December 1913, when it had a mixed welcome. The choice of pictures was left to the Camden Town Group, acting through Spencer Gore. J. B. Manson and Wyndham Lewis wrote forewords to the catalogue. Sickert made a short speech after the opening by the mayor. He stressed the fact that the group would not be associated with any one society or academy. Art should not be made into a party question. Such a course was both illogical and insincere. Even the New English Art Club, to which he belonged, was found shaking one fist at the Academy while it held on to the frock coat of Mr. Sargent with the other. He dissociated himself personally from the extremist views of post-Impressionism, but insisted on the healthful influence on art of free speech.

The critics on the whole seemed willing enough to accept new talent wherever it could be found, but had difficulty in finding it outside of Sickert himself. 'Where is the group, either of London or Camden Town,' complained he of the *Pall Mall Gazette*, 'who can show a fraction of his genius?'

The second exhibition took place in London in March 1914, with the significant abstention of Sickert himself. His relations with the post-Impressionists were becoming embittered. Correspondence in the press on the subject, in which he took part, was acrimonious to say the least. In a letter to the *Pall Mall*

*Gazette* he spoke of their 'meaningless patterns',[5] and elsewhere he had some hard things to say about Mr. Epstein's sculpture. Wyndham Lewis retorted that 'Mr. Sickert for 20 or 30 years was the scandal of the neighbourhood (as a painter) and he was very proud of it. His bed-room realism, cynical and boyish playfulness with Mrs. Grundy, his French *légèrté* (as he would write), all marked him out as a Bohemian plague-spot on clean English life—part indeed of that larger Yellow plague-spot, edited by Arthur Symons. But now he has survived his sins into the bandit's mellow and peaceful maturity. He sits at his open front door, and invents little squibs and contrivances to discomfort the young brigands he hears tales of, and of whose exploits he is rather jealous.' To whom Sickert, 'The position of the *refusé* has in the last few years, I know, assumed a complex nature. The *refusé* was, at first, always a painter who was simply doing his best, and whose work was in theory supposed not to reach a certain professional standard of competence. But the sense of advertisement has created the intentional, we may almost say the professional, *refusé*, the type of the *douanier* Rousseau in Paris. The fun, the joke, the point of the existence of the *douanier* Rousseau was just that he was a painting custom-house officer, like our annual policeman who is hung in the Academy. It was fun for once to see palm trees and orange groves painted by a custom-house officer, and to wonder that they weren't really worse than they were. . . . Our Nevinsons, Wyndham Lewises, Phelan Gibbses, etc., are not custom-house officers, but more or less clever and superannuated art-students trying to paint like custom-house officers. The consequence is that they are not even fun.'[6]

Sickert later modified much of his harshness towards the post-Impressionists. The irony of the years decreed that he should resign from the Academy in defence of Epstein, as Augustus John in that of Lewis! At that time, however, the fight was on, and he was a stalwart in the opposite camp. In 1911 the great French post-Impressionist exhibition had been held at the

Grafton Gallery, and England was formally introduced to the very latest, as well as a good deal that over there was already *vieux jeu*, from the Continent of Paris. Sickert welcomed the show in characteristic fashion from the pages of the *Fortnightly*. 'Perhaps the very nonsense element in this exhibition, and in the claims gravely put forward for it with some ingenuity of undergraduate ratiocination, has its utility. It has caused a rumpus. The rumpus has collected a crowd, and the crowd is quite ready to listen to reason and to learn. Who knows whether, without the rumpus in question and the consequent crowd, I should at present have the honour of addressing a culti- vated audience of my countrymen again on the subject nearest my heart? Monsieur Matisse obligingly parades before the Graf- ton Street booth with a string of property sausages trailing from the pocket of his baggy trousers. John Bull and his lady, who love a joke, walk up, and learn a few things, some of which have been known in Europe for a decade and some for a quarter of a century.'[7] Of the painters represented, Manet and Cézanne were old friends, old masters within their limitations; Gauguin and Van Gogh had been long familiar to him, but he was glad to recognise the widening acknowledgment of their genius. 'A strange grandeur has crept into Gauguin's figures, a grandeur that recalls Michaelangelo. . . . Was ever painted figure more sculpturesque than the awe-stricken *Vahina* prone on the couch, not daring to move in the haunted room? Has paint ever expressed perfect form more surely and with more fullness? Look at the muscle of the right fore-arm, and at the perfect hands laid out, plump and *élancées* at the same time. What an atmosphere of forest is created in *Les Laveuses*! And with what sober means! Here is no war with the medium, no exasperation, no rebellion. The paint obeys the inspiration with the suavity of the mastered thing. All the old weapons of the old masters are here. Gauguin disdains to use none of them, while he en- riches them with a modern vision. Cunningly chosen and ex- pressive silhouette is here. Learned chiaroscuro is here, no

longer, as in the later old masters, in shades of brown, but
again, as in the primitives, in the subtlest harmonies of lovely
colour. And all these the painter accomplishes without distress,
without raising his voice, without loading or embroiling his
paint. This picture is sonorous because it is not shrill. The tones
are brilliant because they are never colourless. . . . Look at the
figure in blue looking off on the prompt side of the picture, and
holding a basket. Is not all freshness, all youth, all innocence,
and all woodland poetry expressed in that one figure? The
proper study of mankind is man; and no country can have a
great school of painting when the unfortunate artist is confined
by a puritan standard to the choice between the noble site as dis-
played in the picture post card, or the quite nice young person,
in what Henry James has called a wilderness of chintz.

'And Van Gogh; why he went mad! I think Voltaire some-
where thus defines madness. If I remember him rightly, he says
that madness is to think of too many things, too quickly, one
after another, or to think too exclusively of one thing. I must
say I wish Van Gogh would bite some of our exhibitors, who
think, not of too many things, nor too insistently of any one
thing, but, as the yokel said, of "maistly nowt".

'I have always disliked Van Gogh's execution most cordially.
But that implies a mere personal preference for which I claim
no hearing. I execrate his treatment of the instrument I love,
those strips of metallic paint that catch the light like so many
dyed straws; and when those strips make convolutions that fol-
low the form of ploughed furrows in a field, my teeth are set on
edge. But he said what he had to say with fury and sincerity, and
he was a colourist. *Les Aliscamps* is undeniably a great picture,
and the landscape of rain does really rain with *furia*. Blonde
dashes of water at an angle of 45° from right to left, and sud-
denly, across these, a black squirt. The discomfort, the misery,
the hopelessness of rain are there. Such intensity is perhaps
madness, but the result is interesting and stimulating.'[8]

With Picasso, Matisse and the true post-Impressionists he had

nothing whatever in common, and did not hesitate to expose their deficiencies and those of the critics who sponsored them. As an example let us 'look at *Le Château* by Maurice de Vlaminck, after examining a landscape by Cézanne. Look at a patch of sky or foliage by Cézanne, and you will see the meticulous labour, the Benedictine application of fitting strip to rectangular strip, in the search for infinitesimal variation of what he called accords of colour. In the Vlaminck we have what has been well called in French *la blague extérieure de la chose*. There also we find rectangular strips, gradations which assume in a sky, as in Cézanne, a disconcerting suddenness, as of a blot of ink on a page; only there are no accords, there is no observed and subtle variety, there is no travail, no sweat and no groans. There is a jaunty and superficial imitation of a style which chances of association, and, be it said, Stock Exchange speculation, have placed in a fashionable position on the European and American markets.'[9]

And of post-Impressionism in general he wrote, 'The conspiracy of semi-unconscious "spoof", which is looked upon by some as an alarming symptom of the artistic health of the present day, is in reality a very small and unimportant manifestation. In the story of the "Emperor's New Clothes", it was the whole nation that affected not to see that his Majesty was naked. The modern cult of post-Impressionism is localised mainly in the pockets of one or two dealers holding large remainders of incompetent work. They have conceived the genial idea that if the values of criticism could only be reversed—if efficiency could be considered a fault, and incompetence alone sublime—a roaring and easy trade could be driven. Sweating would certainly become easier with a post-Impressionist *personnel* than with competent hands, since efficient artists are limited in number; whereas Picassos and Matisses could be painted by all the coachmen that the rise of the motor traffic has thrown out of employment. It is, after all, an extremely small circle of very unoccupied ladies who find amusement and excitement in going one better than the other in ecstasy at the incomprehensible.'[10]

Alas! he miscalculated badly the fertility of imagination of the dealers as well as the gullibility of the public. Having discovered a gold mine they were not likely to let it peter out for lack of new 'talent', or a new advertising campaign. Futurism, under new names, is still with us.

By contrast, Sickert describes his own idea of the 'True Futurism' in an article under that title in the *Burlington Magazine* of March 1916. 'The wealth of Balzac', he says, 'can only be compared to the wealth of Turner. We are not only dominated by a city of sumptuous palaces, but each palace is stiff with a mass of detail, each detail again complete in itself; and each one carrying in itself innumerable seed for the future to develop, into the infinity of time and to the unfathomable limit of human achievement. It is only in this comprehension of the fructifying nature of art that lies the true futurism, unforeseen and unforeseeable. ''Things designed'', Mr. Lethaby has said, ''by a single mind are mostly sports which must quickly perish. Only that which is in the line of development can persist.'' And again, ''No art that is only one man deep is worth much; it should be a thousand man deep.''

'PROGRESS LIES IN THE SLOW UNFOLDING OF A PROFOUND AND COMPREHENDED CONSERVATISM.' [11]

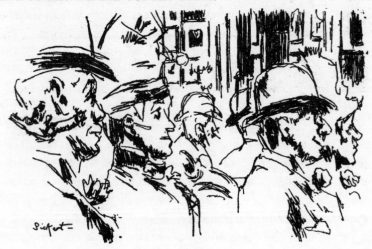

W. R. SICKERT, 1911

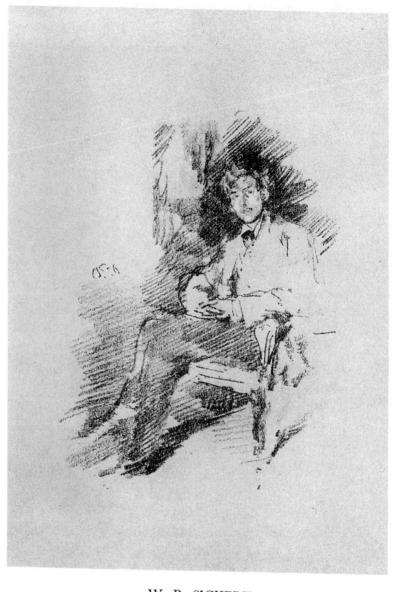

W. R. SICKERT
*From a lithograph by James McNeill Whistler*
*In the British Museum*

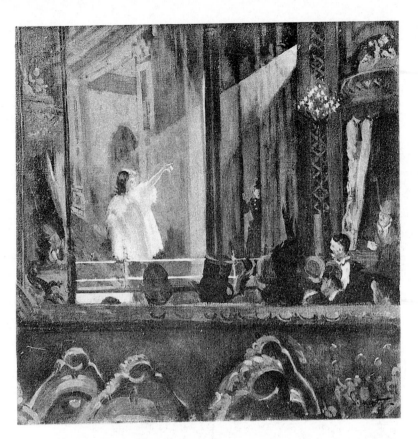

JOE HAYNES AND LITTLE DOT HETHERINGTON AT
THE OLD BEDFORD MUSIC HALL
'The Boy I love is up in the Gallery'
*Oil on canvas, 1889*
*In the Author's collection*

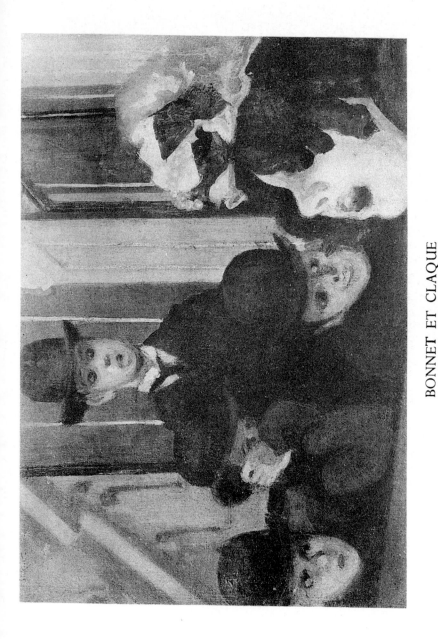

BONNET ET CLAQUE

Ada Lundberg at the Marylebone Music Hall   "It all comes from sticking to a soldier"

GAIETÉ MONTPARNASSE
*Pencil drawing, about 1897*
*In the collection of Maresco Pearce, Esq.*

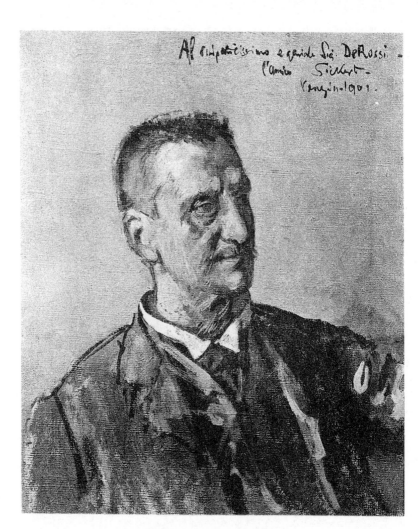

**SIGNOR DE ROSSI**
*Oil on canvas. 1901*
*In the Author's collection*

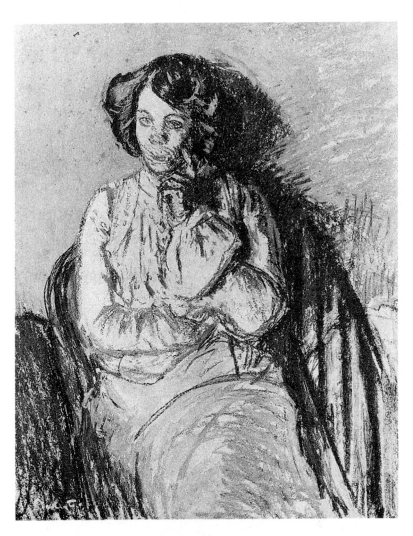

BLACKMAIL
*Pastel, about 1904*
*In the Author's collection*

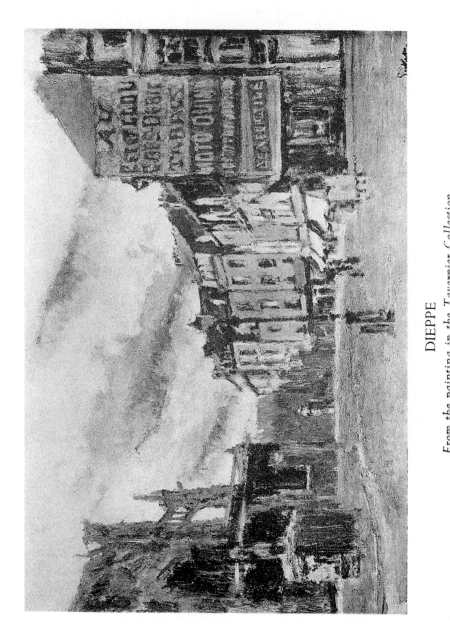

DIEPPE

*From the painting in the Tavernier Collection*

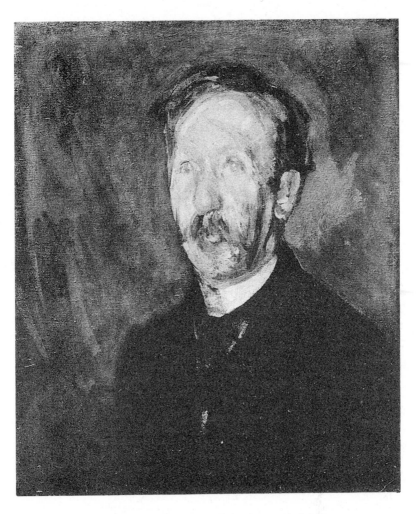

PORTRAIT OF GEORGE MOORE
*Oil on canvas, 1890*
*In the Tate Gallery*

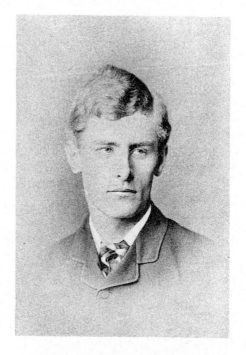

W. R. SICKERT, 1884
*From a photograph by R. Faulkner & Co.*

NOCTES AMBROSIANAE
*From an etching*

LA GIUSEPPINA

*Oil on canvas, 1901. In the Author's collection*

THE OLD BEDFORD—'CUPID IN THE GALLERY'
*Oil on canvas*
*In the collection of the Right Hon. Vincent Massey*

'WHAT SHALL WE DO FOR THE RENT?'
*Black-and-white chalk drawing, 1909*
*In the Author's collection*

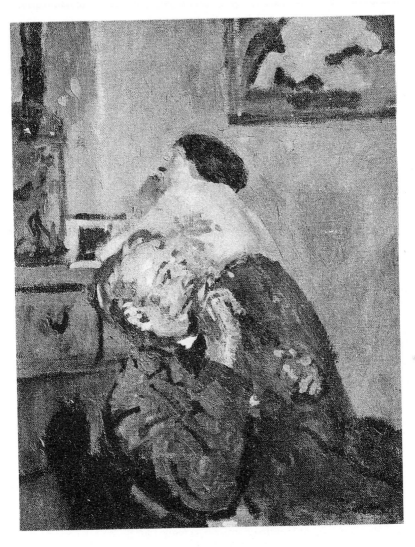

ENNUI
*Oil on canvas, 1910*
*In the collection of H.M. The Queen*

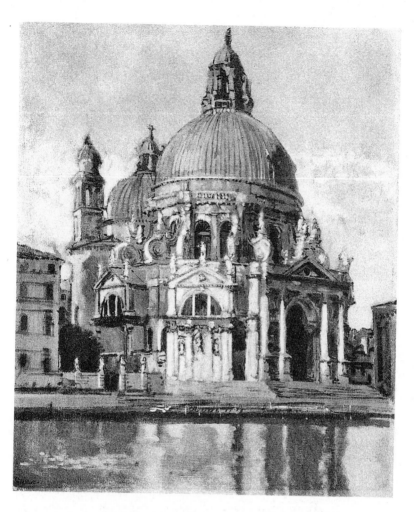

SANTA MARIA DELLA SALUTE
*Oil on canvas, about 1903*
*In the Author's collection*

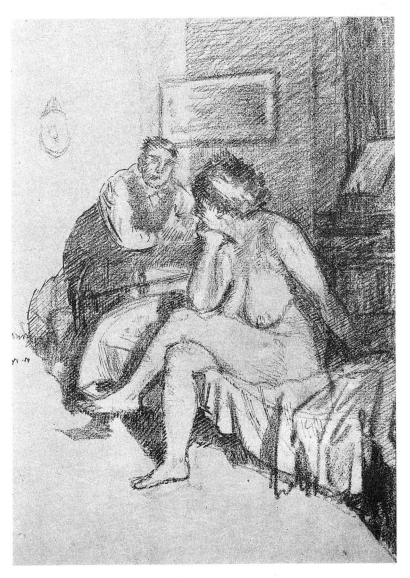

JACK ASHORE
*Charcoal-and-ink drawing, 1910*
*In the Author's collection*

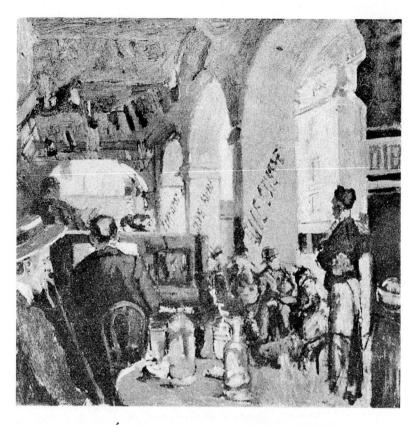

CAFÉ UNDER THE ARCHES, DIEPPE
*Oil on canvas*
*In the collection of Mrs. Rowley Bristow*

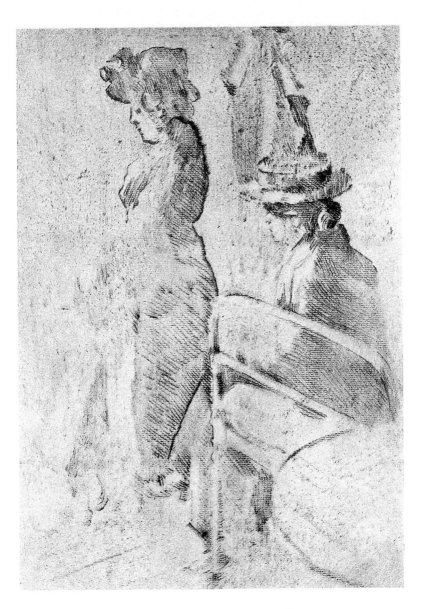

THE PASSING FUNERAL
*Soft-ground etching, 1910*
*In the Author's collection*

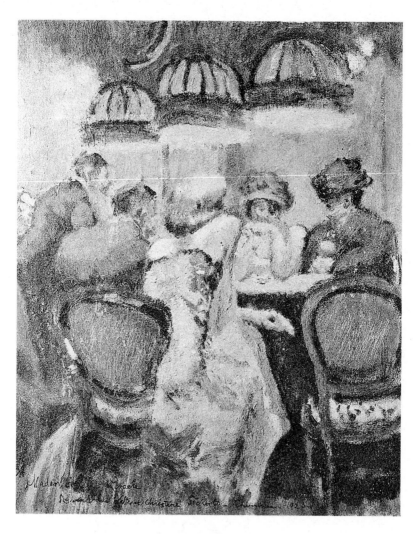

BACCARA
*Oil on canvas*
*In the collection of R. S. Humphrey, Esq.*

THE BRIGHTON PIERROTS

*Oil on canvas*

*In the collection of Morton Sands, Esq.*

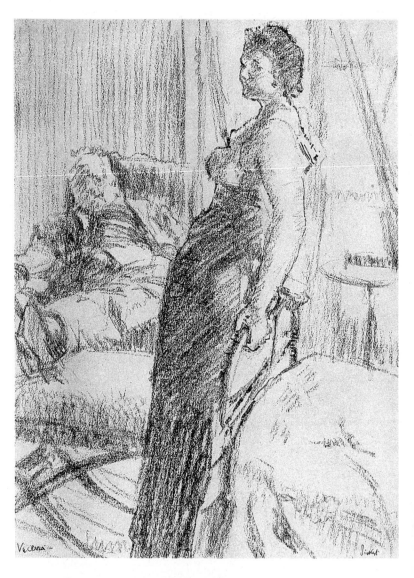

VACERRA
*Charcoal-and-ink drawing, about 1913*
*In the Author's collection*

THE NEW BEDFORD
*Tempera on canvas, 1916*
*In the Municipal Art Gallery, Leeds*

PULTENEY BRIDGE, BATH

*Oil on canvas, 1917*

'THAT BOY OF MINE WILL RUIN ME'
*Charcoal, ink, and wash drawing*
*In the Author's collection*

THÉRÈSE LESSORE
*Black-and-white chalk drawing, 1920*
*In the Author's collection*

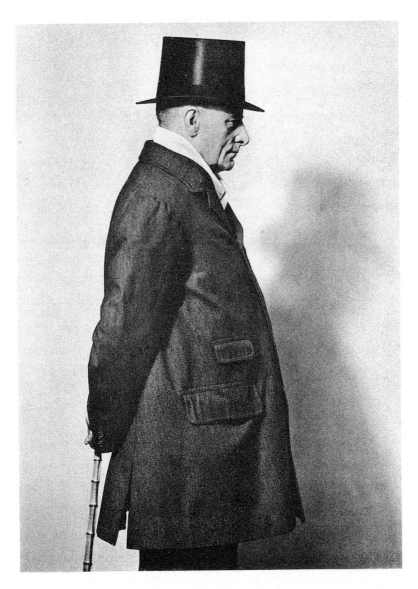

W. R. SICKERT, 1923
*From a photograph by W. & E. Drummond Young*

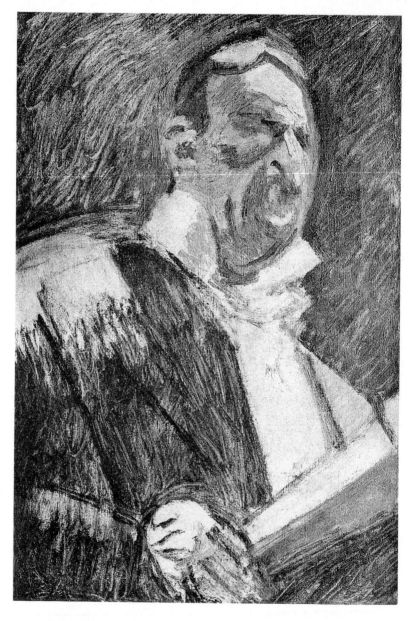

PORTRAIT OF SIGNOR BATTISTINI, SINGING
*Oil on canvas, 1925*
*In the possession of the Beaux Arts Gallery, London*

LAZARUS BREAKS HIS FAST
*Oil on canvas, 1927*
*In the Author's collection*

THE STATION WAITING-ROOM—AN ECHO
*Oil on canvas, 1921*

THE ACTOR ARTIST
W. R. Sickert at Sadler's Wells, with *The Raising of Lazarus*
(1932)

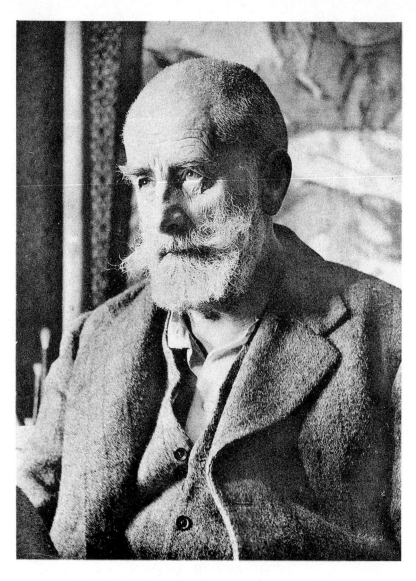

W. R. SICKERT, 1936

# CHAPTER XII

# CÉZANNE

Post-Impressionism and all the fungoid cults which followed it: everything that calls itself 'Advanced' or 'Modern' or, still more delightfully, 'Contemporary' art, looks to Cézanne as prophet, priest and king. First Roger Fry, then Clive Bell with his significant form, preached the gospel of Aix. Painters, who found salvation in the abandonment of representation: dealers, who discovered that the ugly and incomprehensible, when suitably advertised, paid bigger royalties than anything before known: critics, who found themselves in the delightful position of laying down a law that nobody could dispute: combined to impose on an ever-gullible public the biggest racket of the century. It is indeed pitiful to think of the derision with which future generations, however well they may recognise its mercantile origins, will look back on the spoof of post-Impressionism and on the people who took it all so seriously. They will not, however, make the mistake of associating anything more than the name of Cézanne with it. Cézanne the man and the painter will be put back where he belongs, with the Impressionists: and his failures and successes judged without reference to the schools which have taken his name in vain.

It was impossible that Sickert should not have come into almost daily contact with a creed so widespread or that he should not have had very definite opinions about it. But it is clear that his greatest difficulty always was to do justice to the painter,

while harbouring such strong feelings on the over-emphasis which had been placed on his work, and on the theories that had been built on his supposed message. The very qualities which to Sickert were the signs of failure, a noble struggling failure if you will, but still failure, were those which his disciples praised and emulated the most. The so-often-quoted aphorisms and maxims take on a new meaning, more simple, but much less revelationary, when deprived of their biblical glosses. Above all, the technical methods of Cézanne were just those which seemed to Sickert the least likely to produce fine painting. He could understand and approve of the rapid sketch from nature, as well as the slow up-building of a capital picture, architected at leisure from drawings or other documents; but not of the laborious posing of the same models day after day, life, movement and mystery lost in a static trance.

Yet he admits that 'the difficulties that a painter must always experience in dealing with the Cézanne cult are the very real beauty of the tiny percentage of Cézanne's successes.'[1] He was one of the Impressionist group, striving after a beauty, which had its base in the representation of nature. He was the friend of Pissarro, and was influenced by him. It was only an accident that he never met Sickert himself. More than anyone else in England Sickert was of the faith, and so more than anyone else has the authority to give him his true place in the hierarchy. After all, 'the bell-boy who was present at the accident is a better witness than the bishop who wasn't!'

Cézanne was anything but a born painter. What he achieved, was achieved with blood and sweat and superhuman effort. After years of labour he had no more facility than at the beginning. He never learnt the ease, rapidity or sureness of the great draughtsman. Of course, he himself had nothing whatever to do with his posthumous lineage.

'It is absurd to call Cézanne a Post-impressionist, embedded as he was in the Impressionist movement. Influenced at first by Delacroix, Daumier and Courbet, he was drawn into the Im-

SUSPENSE

*Pen-and-ink drawing, 1912. In the Author's collection*

pressionist group by his sympathies. In No. 48 of the Grafton exhibition we can see some traces of painting with the knife, the legacy of Courbet. Indeed, at one time Cézanne had some enormous palette knives made to order, so as to cover large spaces of canvas with paint. It is impossible to disentangle influence and counter-influence in the work of a group so closely connected as were the Impressionists. They spoke one language. They modified it daily in replies, and echoes, and quotations, tossed forwards and backwards in the heat of their eloquence. A fluid style was modified by daily and passionate reference to, and inspiration from, nature. If Pissarro influenced Cézanne, certain canvases of Pissarro, certain preferences of Pissarro, would not have existed except for his association with Cézanne. Is not Gauguin's art distilled from essences gathered shrewdly in the gardens of Degas, of Cézanne, and of Pissarro?

'History must needs describe Cézanne as *un grand raté*, an incomplete giant. But nothing can prevent his masterpieces from taking rank. . . . The landscape numbered 8 at the Grafton is a marvel of tones in mother-of-pearl. The delicate but abrupt transitions lead the eye down to the shore, and away round the magic bay without *trompe-l'œil*. It is the painter who wields the *bâton*. It is he who conducts, and compels us to accept the time and rhythm he chooses to impose. . . .

'Cézanne was fated, as his passion was immense, to be immensely neglected, immensely misunderstood, and now, I think, immensely overrated. Two causes I suspect have been at work in the reputation his work now enjoys: I mean two causes, after all acknowledgment made of a certain greatness in his talent. The moral weight of his single-hearted and unceasing effort, of his tragic love for his art, has made itself felt. In some mysterious way, indeed, this gigantic sincerity impresses, and holds, even those who have not the slightest knowledge of what were his qualities, of what he was driving at, of what he achieved, or of where he failed.

'Then we must remember that in Cézanne there were all the

conditions most ideal for the practice of great "operations", as they are called in Paris, by the able "brewers of affairs" who control the winds from their caves full of paintings.

' "*Ah! Mademoiselle, je n'arrive jamais à faire quelque chose de complet*," Cézanne said to someone I know. I can hear her imitation of his particular accent. Canvas after canvas was begun, worked on eternally, redrawn, worked on again, and abandoned anywhere, while the fury-driven painter pursued the perfection he had in his mind on new versions of the same problem. Cézanne was a rich man, these essays had no market value. He left them anywhere, as one leaves the shell of a walnut or a half-eaten apple. We know that twenty years ago *le père Tanguy* sold them, retail, at 40 francs. Decidedly, for a dealer, Cézanne was a great painter! And if, of two unhappy apples standing by a shaky saucer, one is without the authenticating contour, would it be a very great crime to employ a talented youth to surround it—oh! for Germany or America?

'The greatest living painter, now an old man, was looking regretfully the other day at canvases that he knows he is not destined to finish. Thus, at least, a sympathetic visitor thought to interpret his sigh. "No, it is not that. It is that they will take care to finish them for me when I am gone." . . .

'But the Cézanne question must be faced seriously. To us, born—in parts—of the Impressionist movement, Cézanne has always been a dear, a venerated and beloved uncle. We have known him all our lives. I who speak to you am filled with suppressed pages, respectful and *attendri* pages, on what is beautiful in his painting and admirable in his life. But when Dr. Kenealy-Bell "asserts without fear of contradiction" that Cézanne is Sir Roger Charles Doughty-Tichborne we really must begin to examine the evidence!

' "Cheer up, Sir Roger," the old song ran:

> "*Cheer up, Sir Roger, you are a jolly brick!*
> *For if you ain't Sir Roger, you are old Nick!*"

'Hear Mr. Bell.*

' "Cézanne is one of the greatest colourists that ever lived."

' "We feel towards a picture by Cézanne or Masaccio or Giotto."

' "Cézanne is the type of the perfect artist." He is *the* archetype of the imperfect artist.

' "Cézanne is the Christopher Columbus of a new continent of form!"

'Form! Great heavens! The reader asks himself in presence of such statements whether it is the writer or himself who is what my friend Hubby calls "roofy". . . . Cézanne less than anyone achieved significant form. What is the first gift needed to achieve significant form? A sense of *aplomb*. Cézanne was utterly incapable of getting two eyes to tally, or a figure to sit or stand without lurching. I admit he was looking for something else, for certain relations of colour. But the great painters get their objects *d'aplomb*, and get finer, richer and more varied relations of colour than Cézanne ever attained. The often-quoted saying of Cézanne's that he wished to make of Impressionism something durable like the art of the Museums, has been quoted too often. I know he wanted to. But while he only wanted to, and tried to, others before and after him not only wanted to, but did it, and will do it, when Cézanne is only remembered as a curious and pathetic by-product of the Impressionist group, and when Cubism has gone as lightly as it has come.

> "*Quel che vien de tinche tanche,*
> *Se ne va de ninche nanche.*" "[2]

Sickert would never have had anything to say against Cézanne himself, if he had not been goaded into it by the absurd claims made in his name.

'It is not Mr. Fry, but a still more greatly daring colleague,†

---

* Note. The quotations are from Clive Bell's 'Art'.
† Frank Rutter in 'Revolution in Art', 1910.

who has written of Cézanne: "We who forget the mighty effort
put forth by Nature to produce the fruit spread idly on our
tables, have to be stunned and knocked over, as by cannon-balls,
with the pears and apples of Cézanne, before we call to mind
the hidden forces which brought them to birth."

'I remember a play in which Marius played a King and Flor-
ence St. John his Queen. The King had a way of embracing,
*vicissim*, with effusion, the ladies of the Court. He would turn,
on each occasion, with perfect courtesy and deference to the
Queen, with the remark, "You tellll—me if I go—too—farrr!"
I conceive it to be my mission from time to time to remind the
more saucy of the *critiques d'avant-garde* when they go too far.'³

And, as if it were not enough to father on to the poor gentle-
man from Aix the worst extravagancies of modern painting, the
repercussions of his cult were carried backwards as well as for-
wards in time, and the world was asked to regard the fumbling
of the old masters as a prelude to the Messiah. It was not easy to
make Sickert really cross, but this touched him on the raw.

'We were invited', he says, 'to worship Cézanne. We were
told in the same breath, I understand, that we are permitted to
wave a censor before El Greco. But, without any Abracadabra,
what is the plain difference? Like the lady of whom Carlyle said,
"She'd better," I accept El Greco. First, El Greco was not
present with a Hook easel at the chasing of the bankers from the
Temple. Second, El Greco practised pre-tube painting. His pic-
tures were emotion reassembled in tranquillity and solitude.
His pictures were brought about (*amenés*, to use the word of
Degas) by successive full and liquid coats of paint in ordered pro-
gression from a *camaieu*. There was no material matching of
tones, as Queen Victoria invited Benjamin Constant to practise
on a sample length of the ribbon of the Order of the Bath. And
El Greco knew that the idea of the true is best given, to quote
Degas, by the false. By the side of such intellectual transposi-
tions the works of Cézanne are poverty-stricken reach-me-
downs. There is no connection whatever between El Greco and

Cézanne, except the connection of direct antithesis. It makes me as cross as Moses. But I shall not break the tables of the law. I shall continue to bore my contemporaries by holding them up.'[4]

The truth is that Cézanne's reputation will continue to oscillate between the sublime and the ridiculous, according as the fashion of the day leans first towards the purely formal, and then towards the human and dramatic elements in art. The devotees of either cult will never quite understand the transports of the other, for the simple reason that they are speaking a different language.

But it must not be thought that Sickert was himself indifferent to the element of design. 'In a picture', he once remarked, 'design is the only thing that matters, and its lucid expression the whole of pictorial art. . . . "Style", it has been said, "is economy of the reader's attention." '[5]

Design, however, where it is limited to geometrical shapes, is properly adapted to rugs and other decorative materials, not to the limitations of a rectangular frame: and the spectator's attention is not economised by presenting him with a jumble of forms without natural links or human associations.

## CHAPTER XIII

# TEACHING

⧉

That good teaching is essential to the health of the Arts, as of the Sciences, would appear a redundant truism, if it were not so often neglected in practice. Of all the qualifications necessary to a professor, none is so essential as that he should be a successful practitioner of the art he teaches: that is, that he should not have turned to teaching for the livelihood that he has not been able to extract from his own productions. This is much better understood to-day by the sciences than the arts. All too often the best painters shut themselves up in their studios, and feel neither interest nor responsibility for the next generation. Many of them, of course, have taught at some period of their lives in rather a desultory fashion, but there is no regular accepted connection between them and the schools, as there is, for instance, between Harley Street and the hospitals. The truth is that the art-school, as at present constituted, is not the right medium for teaching art at all. It is certainly much inferior to the system of apprenticeship.

'In the old days such apprentices as were to earn their living by the practice of an art learnt their business in the work-shop of a master, on strictly trade lines, and eventually, whether they had the genius to become first-rate or not, developed at least into efficient craftsmen. Not only this, but, what is equally important, they grew up in contact with the commercial realities of their trade, gathering a momentum of connections as years

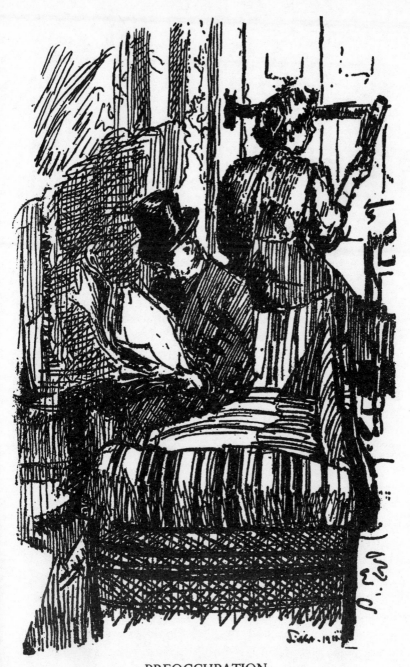

PREOCCUPATION

*Pen-and-ink drawing, 1911. Published in* The New Age,
*1st February 1912*

went on, either, like the modern fore-woman at a dress-maker's, carrying off some of their employer's customers and setting up for themselves, or, marrying their master's daughters, succeeded in the fullness of time to the good-will of his business. But these boys began their life-work at eleven, twelve or thirteen years of age, and were accomplished in their craft before a modern art-student has quite decided what career he is going to pursue. In these most sentimental days, in this most sentimental of countries, nothing can be more unpopular than the enunciation of the truth that boys are more and more beginning their life-work too late. I suppose that no satirist, who set himself to write the most outrageous caricature of the sentimental Liberalism of the day could surpass the fact that we have actually legislated against the too early rising of milk-boys, lest the deadly atmosphere that prevails before—is it six o'clock?—should injure their tender constitutions. I believe the underlying assumption is that they nod over their lessons, poor children, later in the day. And no wonder. But is not the cruelty in the lessons, and not in the early rising? But their "culture", I hear my Liberal friends exclaim! *Ma che coltura!* My milk-man is quite happy without what you call culture. He may be unacquainted with the latest ideas of Mr. Wells on the relation of the sexes. He may not have grasped in their entirety the theories of Mr. William Archer on the drama, or bathed in the delectable romances of Mrs. Elinor Glyn, but he is perhaps none the less cultured for that. It only remains to pass a law that all scene-shifters must be in bed before half-past nine.'[1]

No one was more alive to present-day deficiencies in art education than Sickert. In season and out, in speech, in lectures, and in any paper that would publish his views, he denounced a system whose chief product is 'an immense mob of idlers, male and female, to whom art-schools serve as a kind of day nursery, well in the limelight, with prospects of promotion to the Café Royal.'[2]

Art schools, he points out, however laudable their begin-

nings, however disinterested their professors, tend inevitably to the fate of any institution, in which self-preservation, the primary instinct of all living organisms, takes precedence over its original purpose. The number of students enrolled becomes the sole criterion of the success or health of the school. Instead of a periodic weeding-out on the score of inefficiency, there is no limit to the length of their stay, as there is equally none to their staying-power.

Methods become stereotyped. 'Again and again the student has filled his uniform canvas with the single figure, and has made it emerge from the buff vacancy entitled "background". Fenced off by circumstances from nine-tenths of the field over which the creative spirit ranges, from a search for the savour of life, for the composition and arrangement of figures, for their relation to each other and to their surroundings, architectural or landscape, the student ends by confining his mind to such problems as whether he is to put the paint on in lumps like Mr. X. or to spread it thinly like Mr. Z.: whether he is to make his shadows brown, as they did at so-and-so's studio, or whether it is what's-his-name who has the tip of tips when he makes them ultramarine. It is difficult for him to believe that none of these things matter.'[3]

The set subject for composition has the same effect, that of stifling individual tastes and interests, where just the reverse should be the real aim of the school. His own talent, says Sickert, is the most precious gift that you can make to a student. 'Just as religious delusions and pre-occupation with the supernatural are fostered by a life of seclusion, so in our art-schools does the entire divorce from nature and life throw the professors and students into a succession of critical obsessions with this or that modern or ancient school. They have in their class-rooms no inspiration. The stomach turns and the spirit groans at years of practice at making uniform enlarged paintings from the succession of nudes, with or without drawers, standing on the same table with the same wall behind, the whole

scene stripped of any definite effect of light and shade. What wonder if, not having found their way to the exuberant breasts of nature, the unlucky foundlings continue to suck wind from the empty teat of academic india-rubber!'[4]

What is the result of all this? Large numbers of men and women are thrown out on to a competitive world, without direction and without a thorough knowledge of any particular branch of their craft. Their fates are various. At best, much precious time has been wasted. Economic pressure forces many, failures as practitioners, to become teachers in their turn: a state of affairs only made possible by the fact that the number of students has continued to increase in geometric progression, with the inevitable result that still more will have to succumb to the hard laws of supply and demand—or else again, teach!

Sickert's remedies for these ills were aimed in two directions: firstly towards the reduction in the number of students engaged, and secondly towards the revision of the curriculum with the object of freeing it from its more deadening uniformities. Besides the periodic elimination of the unfit, he advocated a drastic reduction in the public contribution to art-schools.

'It is time to ask', he said, 'whether the money and time that is spent yearly in art education in this country is being wisely spent. There will probably soon be a considerable revision of opinion among municipalities as to the utility of spending the money of the rate-payers on indiscriminate art teaching at all. It has often struck me as an anomaly that the poorest tram-conductor, and the poorest charwoman, are taxed, through their rents and otherwise, in order to pay the salary of the likes of me for teaching classes, largely consisting of well-to-do ladies and gentlemen, to paint pictures that no one wants.'[5]

At the same time he would like to see a curtailment of public and semi-public purchasing of paintings which, for the most part, are unsaleable on the open market. This includes both the municipal art galleries (including the Tate) and subscription funds such as the Contemporary Art Society. Quite apart from these

artificial stimulants, 'the real trade in efficient art goes on quietly and regularly, and, like the happy woman, has no history. A man who knows the points of a horse as Herring did, has no need of doles from the Chantrey or any other bequest. No one ever thought of forming a society to protect the interests of a painter who understood the sea and shipping as does W. L. Wyllie.'[6]

As to methods, the first necessity is that the professors should be practising artists, both painting and speaking in the idiom of the day. 'There are still admirable traditions in the hands of men now living. Such contact I find more stimulating, more interesting, and more helpful even than teaching that comes to us from further off. Somehow his mother's milk has more interest for a baby than that of his great-grandmother.'[7] His own practice was based on his father's theory that:

'A student should from the first stroke of his pencil be making studies for pictures of his own. That is to say that he should not be studying in a vacuum for the sake of abstract study. My father maintained that as the actual need arises for a study of such-and-such a subject, that study should be made, and that it would then be made with the kind of avidity and success—shall we say?—that would be a man's who hunted a rabbit or speared a salmon when he felt the need of a dinner. All history favours this theory, which is like throwing a child into water that he may learn to swim, instead of keeping him for years suspended with his stomach on a music stool, making the gestures of a swimmer. If we take examples from the lives of those artists who have "come off" in whatever style, whether we like their work or not, the same sequence may be found. Turner was colouring views and drawing marines in the way of trade at the age of eleven. There is no greater mistake than to say that he survived this because he was a genius. It is the other way about. He was a genius partly because he knew his trade when our gentlemanly young art students are entering the antique. Keene learnt his trade "on the job", doing drawings for a threepenny

comic paper to make his living. It was on this diet that he became one of the master draughtsmen of the world.'[8]

<center>*　　　*　　　*</center>

Sickert had a particular aversion to the Nude (as distinct from the Naked), whether in the schools or the Academy.

'I was sitting one night,' he writes, 'sadly, in one of the two-house-a-night "Empires" in a distant suburb, when a living picture act was put on the stage. . . . "The Wave" is an unvarying item. Clad in pink tricot from the neck downwards, not only as to her five-toed feet, but to the tips of her pointed stays and the tips of her ten fingers, a somewhat stiff little packet, like a second-hand lay figure of the cheapest make, floats, not without a strand of gauze, on the crest of the property billow. The only thing human is the pretty little face, fixed in a discreet and deprecating smile. A friend who was with me said, "There you have it. There is the academic nude. There is the simplified nude." The audience, nourished for generations on Academy and Chantrey Bequest nudes, responded with enthusiasm, convinced that here was Art, without what the papers call "vulgarity". The Puritan and the artist may well join hands and cry, both equally shocked, "If this is the nude, for heaven's sake give us the draped, and let's say no more about it." . . . The nude is even becoming fashionable. I hear that the latest thrill discovered by enterprising dilettantes is to collect little bevies of the super-goose, *de la haute*, to draw from "the life". Magical phrase! I would wager that the major part of these enthusiasts could not put on paper a respectable drawing of a boot-jack or a gingerbeer-bottle, both of which at least keep still.'[9]

In the schools the problem is another.

'The nude, having become the almost exclusive pass-subject, the standard and criterion of official draughtsmanship, has become overlaid with cribs and glozes. That the student may not sink, the subject is encased in cork jackets and bladders. On the head of the nude is what the Germans call a *Fall-hut*, a baby's tumbling-cap, and the feet of the nude are girt around with a

<center>169</center>

go-cart. The cyclists' touring club of art have riddled the nude
with triangles and notices of danger, with scorings and sound-
ings and finger-posts and elevations, to such an extent that fresh
observation by the student is very difficult. I speak from experi-
ence, and my greatest difficulties as a teacher have always been
with students whose minds were so entirely crammed with this
abracadabra of precautions, that they had lost the faculty of
tracing freely and naïvely on paper the gentle lines they saw in
nature before them. . . . The problem in teaching drawing is to
present the nude sufficiently varied by the draped for it to
retain its freshness of impression for the student. We must try
so to pose, so to light, and so to "cut" the nude that the student
can forget the lifeless formulae of generations of ushers, and see
what creative artists have ever seen in the nude. He will never
learn to do this except by drawing constantly from the draped
figure. The nude occurs in life most often as only partial, and
generally in arrangements with the draped (Giorgione, Velas-
quez, Manet, Degas). I think all great and sane art tends to
present the aspect of life in the sort of proportions in which we
are generally made aware of it. I state the law clumsily, but it is
a great principle. Perhaps the chief source of pleasure in the
aspect of a nude is that it is in the nature of a gleam—a gleam of
light and warmth and life.'[10]

\*            \*            \*

Sickert himself has been, all his life, an *enragé* professor. His
first *atelier* opened its doors, 'with the approbation of Whistler',
in 1890 at No. 1, The Vale, Chelsea. At Bath, at the age of eighty,
he is still teaching. For many years (with intervals from 1908 to
1918) he taught at the Westminster Institute; and again at Man-
chester from 1925 to 1926, where great things were expected
from his appointment: no less indeed than the birth of a new
'movement'. *Parturiunt montes!* There were also private ventures
too numerous to compute. References to his methods and prin-
ciples occur also in his lectures (see Chapter XVIII) and in many
of his letters to the press.

# TEACHING

To the profession of teaching Sickert brought not only an unrivalled knowledge of the craft of painting and a clear understanding of the functions of the painter's art, but also an extraordinary gift of the gab, and a delight in using it, whenever given the opportunity. His descriptions were simple and incisive, and his talent for story-telling enabled him to point the moral of his lessons by anecdote and reminiscence. Epigrams served as mnemonics. Never was professor less dry-as-dust. The attention of the students was little likely to wander. The danger, if danger there was, lay rather in the wandering of the lecturer, through excess of material: so that, one story leading to another, the point of departure was eventually lost, or picked up again by chance half an hour later.

Sickert's method of teaching was always that of the lecture-room, never of the apprentice shop. He gave little criticism of individual work. No doubt he found little that deserved it. Good painters are not born proportionately to the numbers that attend art schools: and probably the advice he would have liked to give most often would have been to 'give it up and do something else'. The only occasion of which there is record of his actually having given this advice was an unfortunate one. As one of Whistler's most promising pupils, in the early days at Dieppe, he was once asked his opinion of a *pochade* by a young man who had recently abandoned his position in a bank for painting. His advice had been that '*il fallait mieux rester dans la banque*'—and the young man's name was Gauguin. That was the only occasion on which the painters met, but Sickert became later so much an admirer of his work as to earn the remark of Degas: '*Ce Sickert: il est Gauguiniste!*'

Sickert had no trade secrets. In his teaching he gave freely of his knowledge and experience. His principles were few and simple. They were not to be taken as an absolute set of laws, one and indivisible; nor yet as a criterion for the separation of sheep from goats. There are more ways than one, as he is the first to admit, in which oil paint can be applied to the making of

beautiful and permanent pictures. Some of the loveliest of his own, for instance, especially among the Venetian portraits and interiors, were painted in a few sittings direct from nature, not from drawings. That he is little dogmatic is shown by his frequent praise for pictures painted by techniques widely different from those which he himself employed. On the other hand there are some methods, such as the use of the palette knife, which do such violence to the nature of the medium as to be at all times inadmissible. He was always very distrustful of the use of glazes in modern painting. 'Some people like their herrings fresh: others like them kippered. Personally I like mine fresh,' he said to McEvoy.

The following notes were taken from some of his lessons. They were not recorded *verbatim*: but represent the essential basis of his teaching.

<p style="text-align:center">*  *  *</p>

Sickert has always insisted that the artist is a craftsman (a 'joiner'), using certain materials to a certain end. He must first know the properties of those materials and the ways in which they have been used by the great masters. He mocked at the prevalent ideas that artists are men of superior sensibility and delicacy of soul, or that sincerity is a peculiar virtue in them. The artist must know his job like other men, and abide by success or failure according to the excellence of his work within the limits thereof. Bad work is not excusable on the ground of sincerity. On the other hand he holds no brief for modesty. 'Modesty is the root of all evil: pride the source of all the virtues. Damn it! you don't want a woman you're going to sleep with to be MODEST!'

The origin of a picture lies in enthusiasm, the 'letch'. The production of the picture depends on intelligence. The object of the picture is to awaken enthusiasm in others.

The artist paints because he must: because visual impressions enchant him and he wishes to record them and pass on his pleasure to others. Every man—*ergo* every artist—has his own

special enthusiasms. It is these only that he must cultivate. Every artist will similarly develop his mannerisms. He will do so naturally, without thinking. Let him be content with them and not ape the tricks of another.

The chief element in a picture should be moving, breathing, life. It may be a tree, a wind, a passing light, an expression. It should *not* be a monument or a scene chosen for its own intrinsic beauty: St. Mark's, for instance, or the Venus de Milo, or the *Queen Mary*. For subjects such as these can only lead to *façade* painting. This sense of movement in a picture has been likened to the 'rustling of the lizard'. Without it the picture is dead, and there is nothing so dead as a dead picture. To keep the expression or pose of a model animated, it is necessary to talk to them. Boldini was noted for the sprightly expression of his models. Lady So-and-so, who sat to him, said that she had always one hand on the bell-rope!

The subject of a painting may be any visual scene or impression which has aroused the letch of the artist. Therefore it can never be a staged scene; witness the nemesis which follows the studio artist posing models to illustrate a given title. The most productive subjects are found in ordinary people in ordinary surroundings: neither too large nor too small, neither very rich nor very poor, neither very beautiful nor very ugly. Rare phenomena or extremes of any sort are bad subjects. A grey sky is better than an impossible sunset. 'Tintoretto created jewels of painting from the most ordinary subjects: Sargent ordinary paintings from the most jewelled subjects.'

Paintings should be made from drawings, not from life. For the subject will never remain the same long enough for the processes of oil painting. The sun cannot be put back. The fleeting expression is gone.

*Aimer ce que jamais on ne verra deux fois**

is the painter's golden rule. A model is the most decharac-

* De Vigny.

terised thing in the world. The character must be given by the painter, working in solitude from drawings.

Sickert used to quote the lament of Cézanne, who would labour for days on a still life of cut flowers: '*Elles me fanent, ces emmerdures de fleurs. Eh bien! Moi, j'ai eu l'idée d'aller chez un marchand de fleurs artificielles. On ne les distinguait pas des vraies. Eh bien! Vous ne me le croiriez pas—mais ces emmerdures de fleurs artificielles* ME FANAIENT ELLES AUSSI.' That is the whole story of painting from life.

Since drawing is to be the basis of every picture, it was natural that Sickert should give the greater part of his attention to it in his teaching. If the document be faulty, what could be expected from the painting? The students are urged to carry with them a note-book wherever they go, and to make notes and sketches of anything that interests them: remembering that, 'the flighty purpose never is o'ertook, unless the deed go with it'. As much information can be put into a small drawing as a large one. Draw with a hard pencil; the harder the drawing, the easier to paint from.

In a letter to *The Times* (3 July 1913) he says in part: 'As to methods of teaching: (*a*) Students should be taught to draw on the scale of vision, according to their nearness or farness from the model, and not on the uniform scale now prevalent. (*b*) Backgrounds, whatever they are, should be drawn or painted inextricably knit with the model. (*c*) Students should, from the first, be taught how to make pictures from their studies. Too much time is generally given to imaginary sketches extorted by routine from students who may be without imaginative fancy. If a student cannot draw his brother, whom he has seen, how shall he draw Ulysses or Ariadne, whom he has not seen? The work of such imaginative painters as Veronese, or, in our own time and country Leighton, Watts or Poynter, is entirely founded on a long and arduous series of objective studies that I believe the school of my friend, Mr. Roger Fry, would condemn as "perceptual".'[11]

Speaking of subjects that have not been seen, however, there are two sides to every question, and Sickert is quite capable of appreciating even three, if well relished with wit. How he roared (Sickert never chuckles) over the story of Delacroix and the horse of Attila. M. Thiers was doing the honours of his *protégé's* latest fresco, when the guest-in-chief, looking up at the ceiling, said, '*M. le Ministre, il faut que j'avoue que je n'ai jamais vu un cheval comme celui-là.*' '*Auriez-vous la prétension, Monsieur,*' responded the minister, '*d'avoir vu le cheval d'Attila?*'

But to return to the art of drawing.

The kernel of every drawing is the eye-catch, the point which caught the attention and roused the letch of the artist. The eye-catch is usually a point of movement and includes the outline of something living against its immediate surroundings, for instance, the gondola passing a doorway, or the tree cutting a line of windows. The drawing starts from the eye-catch and radiates from it in one direction after another until the attention flags and the pencil falters. These points will form a rough rectangle, which then becomes the picture. Accuracy is of importance secondary to fluency. First lines, like first thoughts are best. Never rub out. NEVER DENY. The point of the pencil and the surface of the paper must be kept fresh: also the mind. When impatience comes and a certain detail becomes a painful or a weary task, leave it, if necessary for ever. On the other hand, when a subject particularly pleases the artist, he may make many preliminary drawings of it, either fresh or on the traced outline of the first. Similarly more than one painting may be made from the same drawings, successive approximations to the artist's ideal vision. 'When I paint the first', says Sickert, 'I say God——; when I paint the second, I say God save——; and when I paint the third, I say God save the King.'

Never throw away a drawing. Ten out of a hundred may be good. The others? There is nothing lost. You leave them to your widow.

In connection with accuracy in drawing the following para-

graph is taken from an article on Solomon J. Solomon's book on the practice of drawing and painting.

'With his teaching I find myself mainly in agreement. His insistence on drawing by the background shapes enchants me. It has always been the main article of my constructive creed. I am of course also with him heart and soul for incessant plumbing. On the other hand I venture to disagree with his recommendation to use estimated measurements, and for this reason. Drawing a bit at a time, as we agree that the student should from the first do, a certain coefficient of error will be accumulated at every step. This coefficient of error, in handmade work, such as drawing, is not a defect; but it will entail either some expansion or some contraction, so that any foreseen or fore-guessed points are useless. We will for a moment suppose that omniscience had foreseen and marked some correct points for us. This even would be useless, since it is not the correct points that the draughtsman requires, but the point that falls due with his personal greater or less accumulation of error, that is of expansion or contraction. *Constet sibi.* I am accustomed to say to my students that any foreguessing of stated points is like enclosing a baby in a pair of Bessemer breeches. Readjustments would certainly very soon impose themselves!'[12]

And again, 'Deformation or distortion in drawing is a necessary quality in handmade art. Not only is this deformation or distortion not a defect. It is one of the sources of pleasure and interest. But it is so on one condition: that it results from the effort for accuracy of an accomplished hand and the inevitable degree of human error in the result.'[13] Art is opportune exaggeration (Mérimée). None of the best pictures ever existed in nature.

When a drawing is to be used for making a painting (it may be the last of many careful studies, or a scrawl on the back of an envelope), it is squared up and transferred to canvas, enlarged to any dimensions desired. Then an underpainting is made in three tones, preferably of a cool colour such as ultramarine or

Indian red, and allowed to dry. Since each succeeding coat must also be allowed to dry before being reworked, it is best to have several canvases on the stocks at the same time. As a medium Sickert uses equal parts of unbleached linseed oil and commercial turpentine, sticky in texture and resinous in smell, and the paint is thinned until it runs easily from the palette-knife. The same medium and the same degree of thinning must be used throughout any one painting, both for underpainting and final colour. Except in the more delicate details, the paint should be applied quickly and eagerly, the brush scrubbing the canvas 'as a man would wipe his boots on a slab of granite'. The energy with which paint is applied has two advantages, first that it makes the coat thin, and second that it creates texture by the variety of direction of the brush strokes. Where greater subtlety of form is required, however, a different technique is necessary. The strokes are now applied discretely, near to each other but not overlapping, and if necessary a second or third series superimposed on them in the same way. Sickert used to illustrate the method by a pack of cards scattered loosely over the surface of a table, and then on top of them a second pack, some of which will partially cover those of the first and others those portions of the original surface of the table (the underpainting) which still appeared between the cards of the first pack. Each layer must, of course, be dry before the application of another. This practice will then give a beautiful quality to the surface of the paint, besides allowing the painter to make successive approximations to the form, tone and colour desired. Similarly a long outline such as that of an arm or body should be painted with strokes directed away from the direction of the line: like a series of bricks laid up to the edge of it, whose slight irregularities will convey a more subtle sense of form than is possible with long sweeping strokes following the outline.

Never paint with a palette-knife, a criminal method. There are men in the circus who can stand on their heads; but that will not take them further along the road.

Sickert has little to say on the subject of composition: another contrast to the present fashion, in which the composition bears the same relation to the picture as the smile to the Cheshire cat. He himself adopted the practice of the Impressionists of accepting nature's compositions as transmuted in the artist's drawing, leaving to the latter only (1) the choice of the subject, (2) the view point, (3) the cut, that is, the points at which each of the four sides of the picture are to cut the scene, and (4) the colour. Certain elements in the composition, however, had an especial appeal for him: for instance, the shape created (against the background) by the intersection of two dominant masses in the pictured scene.

## CHAPTER XIV

# THE WAR YEARS

❧

The death of Spencer Gore, the closing of Rowlandson House and the outbreak of war, all in 1914, combined to mark a period in Sickert's life. It was the end of the Camden Town period, though not of his personal associations with that well-loved quarter of *Londra benedetta*. He and his wife were still living in Kildare Gardens, and he was still teaching every evening at the Westminster, the income from which formed an important, because stable, item in their monthly budget. In the summer he had had the fun of choosing a beautiful new studio in Red Lion Square, and had then gone off to Dieppe for the holidays. They were at Envermeu, at the Villa d'Aumale, when war was declared, and had great difficulty in getting back, waiting at the port for days for the boat that would not come. Sickert had offered his services in the *Garde Civique*, but evidently they were courteously, but firmly, refused. At any rate by September they were home, and Sickert at work in the new studio. There was a new printing press, and a grand piano, and a model called 'Emily'. That autumn and winter he painted various piano pictures and a few war pictures, including *The Soldiers of Albert the Good*, *Tipperary* and *The Nurse*. The first was a large picture, for which the design was taken from a photograph, but the details from numberless drawings of Belgian soldiers, whom he had met at cafés and invited round to the studio. For a while the room was tripping-full of rifles, boots and other military

accoutrements. The etching press was used for teaching purposes, though there were no regular classes. A new band of students was collected, among them John Wheatley (now curator of the Graves Gallery, Sheffield), Adrian Allinson, Maurice Asselin, and Enid Bagnold.

Red Lion Square lasted two years, until 1916, when Sickert was driven away from this out-post of his activity by some bombs from a Zeppelin which fell uncomfortably near. He loathed the war and was terrified by the air raids. He now fell back on to more familiar ground, Fitzroy Street. This was No. 8, Whistler's old studio and Duncan Grant's to be, where he and his wife were again 'at home' on Saturday afternoons; but now only his own pictures were on view. It was a splendid place for large parties. He was always a most entertaining host, one of his favourite acts being to recite *Hamlet*, imitating the voices of each character in turn. There was a huge cooking stove in one corner, for Sickert fancied himself as cook, particularly in a chef's white hat and apron. There were special dishes of which he was very proud. Rosa Lewis came from the Cavendish to teach him new ones, notably a certain roast quail, very succulent.

He got to the studio in the morning in time for breakfast, which he cooked himself. Rising at six he used to go first for a swim, and arrive, properly hungry, between 8 and 9. Breakfast was a ritual not to be hurried, so that work rarely started before half-past ten. At this time he was working from Old Heffer, the fiddler, and there are drawings and panels of Nina Hamnet. In her book she has remembered his charm and kindness, looking in every morning, when she was ill, and buying her pictures when she needed the money. There must be many, who have not written books, but who have the same memories. Sickert's thoughtfulness was especially open to young painters dependent on uncertain markets.

At this period he also had a room in Warren Street for a while, where he painted *The Objection* (1917: but from a drawing of 1911), the portrait of Sylvia Gosse on a sofa, and various

PULTENEY BRIDGE, BATH

pictures with a shiny round table on which reposed the effigy of Napoleon III, in the form of a tobacco-box, a much-prized relic.

At No. 8 there was another class, the prospectus for which, dated from Bladud Buildings, Bath, 6 August 1917, announced that 'Mr. Sickert retains the option of accepting such students only as he believes are likely to profit by his method of training. To avoid correspondence, it may be found convenient to state the principles by which Mr. Sickert would be guided in his acceptance of students. Unlikely to benefit would seem to be: (i) painters whose practice is already thoroughly set in methods, its (sic) continuance in which Mr. Sickert would be unable to encourage and indisposed to check; (ii) students who have already studied with him long enough to have absorbed—or failed to absorb—the little he has to teach. An intelligent student who cannot learn whatever is to be learnt from a teacher in three years will learn no more in thirty. Mr. Sickert prefers not to be a party to the creation or perpetuation of what may be called the professional or eternal student, with no other aims than to haunt the art schools as an occupation or distraction in itself.'

No. 8 having been occupied by the school, he moved his own work across the road to No. 15, where he painted the large *Bar Parlour*, the portraits of Cicely (Mrs. Tatlock), and various still-life pictures of food, including a very good one of some asparagus.

<p style="text-align:center">*　　　*　　　*</p>

During the war years, Dieppe being denied to them for summer holidays, they went first to Chagford in Devon (1915) and then to Bath (1916–17). Thus it was the chance of circumstance rather than deliberate choice that turned Sickert's attention to pure landscape. The term is applicable, even though the Bath pictures are largely architectural in subject: because most, even of these, contain elements, such as trees or running water, which belong to landscape, and which are lacking in the pure

town-scapes of Dieppe and Venice. Sickert painted country scenes merely because he found himself in the country, and came to love those scenes and to see them pictorially. He did not go to the country because he had a sudden desire to paint landscape: still less because he had a theory which had to be tested by reference to certain forms. Quite simply he says in these pictures, 'I loved this view, this summer wealth. I want *you* to have that pleasure, too.' 'PAINTINGS', he once said, 'SHOULD NOT BE REGARDED AS SIGNS OF CULTURE, BUT AS UTENSILS OF MEMORY AND VICARIOUS EXPERIENCE.'[1] It is a great truth, but how far from the accepted philosophy of art to-day!

At Bath the Sickerts had a house above Camden Crescent, and, as usual, a spacious studio was found in one of the old buildings of the beautiful city. Pulteney Bridge was a favourite subject, and the late afternoon or evening still the favourite moment of the day. The landscapes of Chagford, Bath and Envermeu are perhaps the most admired and sought-after of all his pictures, partly because the English public loves a pretty landscape, and partly because they are in fresh natural colours and higher in tone than anything he had yet painted. They are indeed lovely things, though to many they lack the bite of the portraits and *genre* subjects. And they bring to mind the saying of Degas, that '*l'air dans les tableaux des maîtres n'est pas respirable*'. Now the air in these landscapes is as sweet as summer.

During all this time he was exhibiting regularly: in December 1914 at the New English Art Club (*The Soldiers of Albert the Good*); in January 1915 at the winter exhibition of the Royal Academy (*The Integrity of Belgium*); in February at the eighth and final exhibition of the society of twelve (*S. Jacques, The Passing Funeral, The New Bedford*, and a unique proof of *Emily Lyndale in Sinbad the Sailor at Gatti's Arches, Tom Tinsley in the Chair*); at the Grosvenor Gallery in March; with the London Group at Goupils, also in March; and at Brighton in October. 1915 was also notable for the publication of the Carfax series of etchings. In November 1916 he held a one-man show at Carfax, including,

among other pictures, *Rushford Mill*, various views of Chagford, *Off to the Pub*, and *Brighton 1915* (now known as *The Brighton Pierrots*). In 1917 he contributed a picture of the interior of a cinema to the 22nd exhibition of the International Society at the Grosvenor Gallery: and the same year, *Suspense* (now in Belfast Public Gallery) to the London Group who were showing at Messrs. Heal's Mansard Gallery in Tottenham Court Road. In 1919, among other pictures at a private exhibition at the Eldar Galleries, were *Yvonne* (probably painted somewhat earlier) and the self-portrait called the *Bust of Tom Sayers*: and at the last of the Allied Artists', a picture of *Whistler's Studio* (No. 8 Fitzroy Street).

Also in 1919 there was a show of Walter Greaves' pictures at the Goupil. A benefit dinner was arranged at which Sickert spoke. That he was a great admirer of his fellow-Whistlerian is proved by an article which he wrote many years earlier on the occasion of another exhibition of the painter's work. After confessing that he had hitherto ignored (in the French sense) the existence of Greaves as an artist, he goes on:

'I am sorry to say that the fault must lie at the door of my really rather naughty master and of my careless credulity in believing him. In effect Whistler gave me to understand that the "Greaves boys" were negligible, that what they accomplished they had from him, and that when his influence was withdrawn they relapsed into the nullity from which he had lifted them for a while. To complete, while I am about it, my evidence on this subject, I must add that Whistler gave me his account of his reasons for breaking with them. His story was this; Whistler had had an exhibition somewhere (don't ask me for dates or places), and after it was over he asked the Greaveses if they had seen it, and they said "No." Act of *lèse-papillon*, and no mistake, here! They made it worse by saying "they didn't mean anything by not going". Worse and worse! "If you *had* meant anything. . . .!" Words failed! You see the scene from here. Whistler added that, some time after, a common friend had been to see

them, and that they had said that "they were painting pictures on the method of Whistler up to Academy pitch".

'My idea on the Greaveses remained ever after at that. I left them at that, with the dangerous fatuousness that is ours when we allow a tag to fill the place that properly belongs to a reality.

'However, so far as I am concerned, all's well that ends well. I came, I saw, and was bowled over, and herewith make public act of penitence. Walter Greaves is a great master. Henry doesn't count. Walter announces himself with an immense painting of Hammersmith Bridge on Boat-race day, a work of extreme youth. It is a staggerer. The only thing it reminds me of in painting is Carpaccio. Its perfect naïveté results in purest art. Simon Bussy once told me an enchanting story; a painter, entering the studio of a colleague, is so struck with a work on the easel that he seizes it and rushes to the door with it. "*Malheureux, où allez-vous avec mon tableau?*" "*Au Louvre!*" "To the National Gallery with *Hammersmith Bridge!*"[2] And to the Tate, I am glad to say, it has gone.'

\*　　　\*　　　\*

In 1917 the Sickerts moved from Kildare Gardens to a pleasant house in Camden Road. They had already, with great difficulty, got over Marie Pépin, who had been their *bonne-à-tout-faire* in Dieppe. She was a typical French peasant, and never learnt a word of English all the years she was here. The result was that Christine had to accompany her everywhere, so that Walter began to refer to his wife as '*la dame de compagnie de Madame Pépin!*' War conditions, especially rationing, began to tell on his wife's health. Sometimes she had to stand in a queue for hours in the cold and wet at the butcher's. By the time the war was over, her strength was exhausted.

The war once ended, like a pair of homing pigeons, they flew back to Dieppe. There were many changes, but much that was just the same. Blanche was at Offranville to welcome them. Miss Hudson and Miss Sands were restoring the Château d'Aup-

pegard. Audrey and Hilda Trevelyan had rented a house in the neighbourhood. The summer of 1919 was spent at the Villa d'Aumale, but for some reason this was later disposed of, and another house at Envermeu, the Maison Mouton, bought and renovated. It was on the outskirts of the village, and had once been an inn in the days when Envermeu had held one of the big horse-markets of Normandy. At one end was a *porte-cochère* leading to a yard, later dug up and turned into a vegetable garden, round which was stabling for 200 horses. Sickert at once ordered some expensive riding breeches, but the horses never materialised, and part of the stables was pulled down to give a clearer view of the valley behind.

They stayed on in the Villa d'Aumale for the winter of '19–'20, a very severe one, Sickert painting hard and going about the countryside in all weathers with the *notaire*, who was also the local auctioneer; but Christine became ill, and they returned to London at the New Year. In the spring she had recovered enough to remove, with all the Camden Road furniture, to their new home. But all the summer she weakened: and in October she died.

The shock to Sickert was terrific. He stayed on for a little at the Maison Mouton; then, unable to bear alone the surroundings they had shared and loved together, he moved into apartments in Dieppe. That winter he worked on cabaret scenes at Vernet's and the series of baccara pictures at the Casino. In the summer he wrote to Christine's younger sister, Mrs. Ronald Schweder, 'It will be lovely to see you here. Mind you let me know *some time before* the exact date and I will meet you at the boat. The air, and sea-bathing here are certainly doing me good. But my mainspring is broken and I have nothing to recover for. I met Orpen at the Casino the other night and he is going to put me down for election to the Academy. It would have seemed such fun to me while she was alive to share it!' The visit took place and evidently did him good, for in November he writes again:

44 Rue Aguado,
Dieppe.

My Darling Andrina,

. . . I have sittings by electric light nearly every day in my flat at No. 44 and am deep in figure subjects again. I sold a picture of a head of Marie's niece to a French Colonel on the Staff, and I am doing a portrait of the Colonel in his uniform. There is, I see, going to be as much market as I can supply in France for my work, where, I gather, my reputation is after all greater than I thought, outside, of course, of what I may call the neo-squinting circles, who after all are more *Geschreie* than *Wolle* as the devil said, when he shaved his grandmother. Of course I must be extremely careful not to let my work here fall into the hands of speculators who would take it to England and sell for double. But many solid and established people here buy things *not* to peddle or pawn, but to stick to, for a while at least. I shall stay here while these subjects inspire me, anyhow till the end of November. . . .

I am painting also Victor Lecour, a superb creature, who used to run the Clos Normand at Martin Église. As Marie's niece goes off like a hot cake I have sent for her again to-day, 5-6 by electric light at No. 44 to do some more canvases.

Love to you all. As I get stronger I shall occasionally take to my pen again.

Yesterday was the Toussaint. But as I have 365 Toussaints a year it was no exceptional day for me.

Your devoted brother-in-law,

W. S.

As it turned out he stayed on all that winter, working hard at new subjects, including the *New Tie* and the *Armoire à Glace*, afterwards utilised for etchings. Other pictures are mentioned in another letter, dated 19 January 1922, as well as plans for the summer and a new address:

*10^bis Rue Desmarets,*
*Dieppe.*

MY ANDRINA,

Such an age answering your letter! But I am now at work all day, fortunately, and very interested. I have got on well with a portrait of the *Sous-Préfet*, who is a beautiful gracious young creature, like a 'lion' of the time of Gavarni, and of Victor Lecour, a superb great creature like a bear. I am also doing large versions of music hall subjects. Did I tell you the Rouen Museum have 2 pictures of mine and ask for more? . . . I am now in rooms just opposite to the entrance of the *Petits bains*. I have a sheltered little dining-room leading out of the kitchen and warmed by the kitchen fire, a great economy of coal and trouble, and an immense salon on the front with a garden which will be charming in the summer, but which I now keep shuttered and use as a larder, and—great advantage—no spare-room.

Another thing. My work will keep me in Dieppe in the summer. I should be enchanted if you and Ronald and Ann would use my house at Envermeu. . . . Of course the earlier you come and the later you stay the better pleased I should be. If you found you liked your stay the little stable could be converted into a garage later on.

I must go back to supper. Marie and I go a great deal to the theatre whenever there is one.

Love to you all,

Yr. W.

Plans for bringing the Maison Mouton up to date occupied his mind continuously at this time. Sickert had an inventor's pleasure in designing things and seeing them carried out in bricks and mortar. The garage mentioned above was completed even to an inspection pit. Stoves were an especial delight. There was one in the villa at Neuville with two exit pipes, one for the smoke, the other to take away the bad air, a gadget of which he

was very proud. There was another at Highbury that stood on a cement base, round which was chipped out the motto '*Ce Londres que les anglais appellent London*', a *bon mot* of his friend Comte Robert de Montesquiou. His knowledge of physics, however, was scarcely equal to his architecture. One day, when he found this stove red hot, he thought to cool it with a bucket of cold water, and disastrous results. Then there were special easels to be built for every class-room, and at Bathampton to-day he has had a wonderful revolving throne constructed, with steps and a rail leading up to it. In the early days both ventilation and sanitation used to be subjects of concern and of various cunning devices.

That spring his mother died in London, as he mentions in the following letter:

'Thank you, my dear, for your letter. My poor old mummy is better out of it. Life was mostly by now made up of discomfort. I have a most agreeable last impression of her sitting last May in the garden in the sun and enjoying it. I knew I should not see her again. Christine wrote to me in the summer that my mother had not recognised her, and added, "I hope you will know me when you are 90!"

'About the Maison Mouton. Suppose for the moment you didn't exist. That house without a good garage is valueless to gentry of either country. With a good garage ready for use, and dry cement paths, fit to walk to the W.C. on in thin shoes, it becomes a very valuable property. English money being now worth double, I cannot invest it better than in making this freehold property of mine as valuable as possible. I suppose improvement of one's own freehold property on practical lines is as good an investment as any financial expert could desire. Then my long residence here, and my experience in a small way with workmen, makes me able to get twice as much in pace and quality out of them as most people. Christine used to say I could always get things done. It is the *porte-cochère* of which I am making a garage (here is inserted a plan of the house and out-build-

ings). It will make the garden more private and in the winter
one can hang a lamp in the garage, which is the only entrance
used.

'I know perfectly well that, as long as I have any health, I shall
work, as I do now, from 10 to 4 by daylight and 4 to 7 by arti-
ficial light, and frequently draw at music halls from 8 to 11. All
these things I can't do now at Envermeu. When Christine was
alive I loved the landscapes there, because they seemed to be-
long to her, and the still-lifes, etc., because they were seen in
her house. One of my last Envermeu pictures was called *The
Happy Valley*. But I can't bear the sight of those scenes now.
They are like still-born children. Then, when I become, as we
all must some day, too ill to work, it is probable that I should
either go South, or need the comforts and conveniences of a
town. But I have an instinct to perfect and complete my darling's
*trouvaille*, even if it were only to sell it eventually.

'Guess what the estimate for the garage and well, etc., is

3,238 francs, i.e., £65.

'And for cementing all the path round the garden over the
brick and flint you remember,

5,503, that is £110.

'Tell Ronald to tell me any special tip I might miss to make a
perfect garage. I may as well get it right, even if it is only to sell
the place to some ——— American.

'I am sure it is bad business to keep any property hung up. It
should be a complete instrument ready for use. When people
want to buy, they will pay a lot more for a place ready to in-
habit, than for one that needs completing. It will be delightful
to see my little Anne again. One of the last conversations I had
with Christine was to beg her to keep a diary of Anne's and
other sayings she appreciated so keenly.

Yr. W.'

The alterations and improvements were carried out, though the well, their sole water supply, could only be used for laundry, owing to a cat having been drowned in it the summer before: the result being that they had to drive into Dieppe every day with a large *cruche* on the back of the car for drinking water. Not unnaturally the profits on the investment never materialised. The whole idea ended in smoke over the fire of new interests. Instead of the —— American, the house and contents were handed over, lock, stock and garage, by deed of gift to the Schweders, who had so much enjoyed it. Sickert himself returned to London and settled in Fitzroy Street.

He never went back.

# PART III

1922–1940

# CHAPTER XV

# CHANGES AGAIN

One evening before he left Dieppe, Jacques Blanche encoun-
tered his old friend walking along the front. It was the hour
when the sea-wind drops, and land, sky and ocean are hushed in
the expectancy of night, the hour he loved the best. They began
talking of old times. Blanche complained bitterly of the excres-
cences which had sprung up all over Dieppe and disfigured the
familiar scene.

'I don't know,' replied Sickert; 'you're looking at them from
the sentimental angle. From the point of view of the painter
ugliness does not exist. . . . At any rate ugly objects need not
spoil the pictorial effect.'

They stopped, and Blanche pointed to the new modern-style
Casino, which had taken the place of the charming gardens and
ridiculous, but amusing, minarets and cupolas of the old build-
ing.

'What about that, then? You can't say that's any improve-
ment, even from the painter's angle.'

'I don't say it's any improvement; but you're still looking at
it with the eyes of your age. You had an affection for the old one
because you grew up with it. It was probably just as hideous
then to other people as this one is to you. . . . Personally I al-
ways think that the additions, which every period superimposes
on the buildings of a former age, increase their pictorial value
rather than otherwise.'

195

As they went on Blanche's mood became more and more sentimental.

'I know Dieppe and Venice are your favourites,' he began again, 'so stay here with us.'

But Sickert was contrarious and despondent.

'For a painter like myself one place is as good as another. It makes no difference. If only I were not obliged to go on painting!' . . .

'Come, you're joking!'

'No! To have a swim when you get up, a good breakfast, a comfortable chair by the fire, the papers, is all that one really needs.' . . .

'The Englishman's paradise! I don't believe you. Even Steer . . . You would always have to paint.'

They reached S. Jacques. The sunset gave a warmth of orange to the old stone, the shadows a deeper violet. Blanche started a vein of exalted reminiscence, recalling with enthusiasm the names and deeds of the past, Whistler, Pissårro, Degas. But Sickert refused to be moved from his melancholy.

'Ah! you are a lucky one, to be still able to FEEL! You would transport me, with the ardour of youth, to our London of old romance, to music-hall nights, to the singing-boats of Venice. Do you still cling to all that? I tell you there are no subjects pictorial in themselves. It is the painter who makes use of them for his own ends. Dieppe and Venice were convenient to me. That is all.'

\*      \*      \*

Changes again! Slowly the chariot climbs the long ascent, runs for a while on even keel, and then turns slowly down. The eyes of the charioteer look forward as he rises. The plateau reached, he gazes round, filled with the present glory, all his own. Descending, too often his glance turns back; there is nothing left but the past.

Not thus with Sickert. He knew well that it is impossible to go back, dangerous to stand still. And his was not a nature to

L'ARMOIRE A GLACE

give way for long to depression. He had great reserves on which to draw. Time and work, nature's own alteratives, purged him and left him free. Tonks describes him in London again 'as lively as a cricket, and dividing all painters into paleo-stuffers and neo-stinkers'. Already at Dieppe he had taken up his brushes with much of the old gusto. The portrait of Victor Lecour is not the work of a pining invalid, but one of the liveliest pictures of a lively painter. There is a crunch to it that only the vitality of health, both mental and physical, can give. This vitality, apparently inexhaustible, remained to him for long after his return to England.

Nevertheless such changes as did come, with gradually mounting emphasis, in his work, were the normal effects of age. Sickert was sixty-two when he left Dieppe, and, though still young even for his years, his painting followed the natural evolution of all artists who live long enough to play the tunes of maturity on the instrument which they had perfected in youth. A habit of looseness in construction, which had been characteristic of his work for years and sometimes passed the bounds of carelessness, grew on him and was accentuated. His colour was brighter and his tones higher than ever. Pure, or almost pure, colours, scrubbed over a light underpainting, occur frequently in his latest pictures. High-lights are often scumbled white. His control over all the processes of painting was now so absolute that he could afford to play with them, as a juggler plays with his plates. The quality of this painting is not to be described. It is just there to be enjoyed, like any other wizardry of craftsmanship.

One advantage, which greatly appealed to Sickert, of the looseness of finish mentioned above, is that the life of the original design comes through with an uncovered clarity. About this he says himself:

'All draughtsmen do two things in succession. First they draw, and then, sometimes, generally one may say, they upholster their drawings. This upholstery corresponds to padding

in literature, and may be very skilfully and beautifully done, as it may be poorly done. Among Rembrandt's etchings the *Boys Bathing* is pure drawing with no upholstery. There is not in it a line which is not alive. The *Burgomaster Six*, on the other hand, is a drawing that has been upholstered to death, skilfully, industriously, tenderly upholstered, if you will, but upholstered to death. If Rembrandt had known how to stay his hand, when the plate was at its most expressive, we should have had a masterpiece instead of a laborious wreck. I may say these things about Rembrandt. *Je suis très bien avec Rembrandt*. The shade of Rembrandt is not like the standardized *ancien-jeune*. He does not consider criticism "disloyal". He is no longer a vested interest.

'It has taken some generations of experience for us to suspect these truths, and it may take some more before we hold them firmly. The belief in the excellence of a task *quâ* task, of the merit of labour as something almost punitive and penitential, is a price we still have to pay for having taken upon our shoulders the religion of the Jews at the hands of S. Columba. (That is probably why the Scots are so good, having been good longer than the English.)'[1]

But the most significant change in Sickert's practice after 1923 was his gradual abandonment of drawing. He still went often to music-halls in the evenings, and his copy-book went with him. Certain etchings of the Shoreditch Empire, drawn with open perpendicular lines, were made from these drawings; but there are few paintings from them (a very remarkable one, and a favourite of his own, is the singing portrait of Signor Battistini from a scribble on the back of a programme about 1925), and they gradually became fewer as he came to rely more and more for his data on old prints and photographs. Such pen-and-ink or water-colour drawings as he did after this time were themselves transcriptions from other documents, not from nature. This is stated as a fact, not as a disparagement, with which it is often taken as synonymous. There are many people, admirers of his earlier work, who turn up their noses at the

Echoes. They call them 'pastiches', 'plagiarism', and 'not Sickert'. Luckily these pictures do not need anyone to defend them from their enemies. Works of art indeed cannot be defended. They must defend themselves. If they are good, they will do so very effectively. Shakespeare's plays, for instance, have done so, in spite of their debt to Holinshed and others. If they are bad, they cannot be bolstered up with arguments, either mine or anyone else's.

The same may be said of the use of photographs: but here Sickert can speak for himself. In a letter to *The Times*, 15 August 1929, writing at the time of the Haig statue controversy, he says:

'A couplet in one of the most treasured music-hall songs of the last century runs:

> "*Some do it hopenly,*
> *Some on the sly, etc.*"

A photograph is the most precious document obtainable by a sculptor, a painter or a draughtsman. Canaletto based his work on tracings made with the *camera lucida*. Turner's studio was crammed with negatives. Moreau-Nélaton's biography of Millet contains documentary evidence that Millet found photographs of use. Degas took photographs. To forbid the artist the use of available documents, of which the photograph is the most valuable, is to deny to a historian the study of contemporary shorthand reports. The facts remain at the disposition of the artist.'[2]

However, in another place he qualifies this licence by the admonition that 'the camera, like alcohol, or a cork jacket, may be an occasional servant to a draughtsman, which only he may use who can do without it. And further, the healthier the man is as a draughtsman, the more inclined will he be to do without it altogether. For a student who cannot, or will not, learn to draw, the camera spells suicide—neither more nor less.'[3]

Sickert himself used photographs occasionally from a very early period: and if anyone was qualified by the above proviso to

do so, he was. Nevertheless, except for portraits, and certain exceptional successes, such as *Lazarus Breaks His Fast*, these pictures are not often among his best.

Another innovation, which came later, but which may also be attributed to age, was the practice of having some of his documents (prints or photographs) squared up and transferred to canvas in *camaïeux* by other hands than his own. The purists may hold up their hands in horror, but wherein lies the difference between such methods and those of the sculptor who has his stone cut by a mason to the rough shape of his design, before he, the artist, starts his more delicate and personal work? Sickert knew well enough what he wanted, and was not likely to be squeamish as to how he got it. He was only returning in fact to the excellent system of the old masters' work-shops, where all the preliminary work on a picture was done by the pupils or apprentices. Some of these *camaïeux* were done for him by Sylvia Gosse, others by Thérèse Lessore, others by Morland Lewis and Hawthorne.

# CHAPTER XVI

# ISLINGTON

S ickert then, having turned his back on Dieppe and his old life, took up his lodgings in Fitzroy Street and prepared for a new one. In Fitzroy Street he renewed a long-standing friendship with Thérèse Lessore, who was living just opposite. Like himself Miss Lessore came of painter's stock, and had been a prominent figure in the London Group for many years. Sickert had long been a great admirer of her work, as she of his. He had written the foreword to an exhibition of her paintings at the Eldar Gallery in 1918, in the course of which he makes one of his students object, 'I can't see why you admire her so much. She can't draw.' To which he replies, 'That is just where you are mistaken, and your mistake is largely my fault. I have only been able to give you up to now a still-life education. I have only been able to teach what I know myself. My treatment, and therefore yours, even of figure subjects, is only a still-life treatment. When you and I are drawing, we are trying with more or less success to give a complete account of a street, or a woman in repose. Lessore is drawing—not the street, or the woman— but the impulse of a bargain in a crowd—the concentration of a hearth, which is or is not a home.'[1]

And even earlier he wrote: 'The greater personalities escape from classification. We may register and enrol as we please the work of Thérèse Lessore; she will always appear to be the most interesting and masterful personality of them all. She seems to

me to have the merits that all the groups would like to claim.
First and foremost she has human interest, without which art on
this planet probably cannot exist. Her pictures are seemingly
not painted from models pretending to do certain things. By
some strange alchemy of genius the essentials of their being and
movement are torn from them and presented in ordered and
rhythmical arrangement of the highest technical brevity and
beauty. She seems to have no *parti-pris*, like John, of a certain
processional solemnity, or, like Henry Lamb or Stanley Spencer,
of a certain fateful strangeness, only a point of cold and not un-
kindly malice. I cannot see her pictures going out of date.'[2]

Modesty apart, these descriptions might almost have been a self-
portrait. No wonder these two should be *simpatici* one to another.

She, too, was at no pains to hide the great influence he had on
her practice, particularly in the method of painting from draw-
ings, and his later use of bright colour on light grounds. She
used to prepare canvases with gesso primings, which they both
used. From this had come the idea of painting on porcelain,
with which she had been experimenting for some time. Sickert
was enthusiastic about her plates. 'Don't you think', he wrote
to Mrs. Schweder, 'that *anyone* would expect to give at least £1
for such lovely and valuable *bibelots*? In any case order one for
yourself, one for Anne, and one for me. But don't say it is for
me.' For some years they had gone out drawing together at
music-halls, always a favourite subject with both. Lately she,
like him, had been through an emotional crisis, in which again
he had been of great support and comfort to her. With such
bonds as these the friendship prospered, and then grew to an
even deeper affection. In 1926 they were married.

Meanwhile in 1924 he had been proposed by Orpen and
elected Associate Academician. His relations with the Academy
were now most cordial. He enjoyed the good-fellowship of the
banquets and the quality of their cellar; but even on a less
spiritual plane he had travelled far from the rebellious mood of
the nineties. As a matter of fact Sickert's rebellion had been

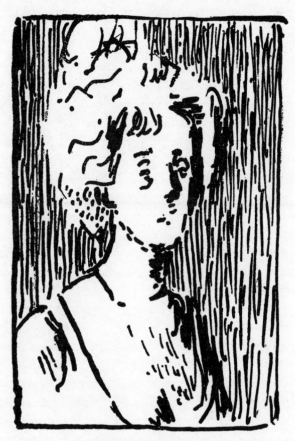

MRS. BEERBOHM

half-hearted at its worst. He realised, almost from the start, the power for good of such a central institution, and would always have preferred to use it for the best ends, rather than weaken it by standing outside and throwing stones. As far back as 1910 he had written:

'Unfashionable as the confession may seem, I have never attacked the Royal Academy; partly because scolding has always seemed to me to be a waste of time, and partly from a natural disinclination to behave like the boys who were rude to Elijah. . . . My moderation may also have been encouraged by a sneaking desire not to make myself ineligible for election to membership of a body which, if royal and august, is also human. I think that as an artist ages he should teach more, as he tends to produce less, and I am always disposed to use existing machinery where it is possible, rather than, in this short life, to begin the creation of new.[3] . . . My only quarrel with the Academy is that it is not academic enough. Many years ago (in the columns, I think, of the *Speaker*) I urged the Royal Academy to "hold the *dragée* high". I even had the *naïveté* to protest publicly against certain elections, goodness knows not from any personal hostility to the successful candidates. I protested against the election of merely popular painters on the following grounds, and I think justly enough. The popular painter who becomes the successful purveyor to the vanity of the super-goose fulfils, quite honourably, a legitimate demand. He has his reward, ample and sufficient, in money and popularity. With prudent insurance his widow need fear nothing. Academic distinction should be kept for serious achievement, and should be a finger-post to the public from a *sachverständig* body. All the more would this be appropriate and fitting because such achievement sometimes hardly pays its expenses. Endowment of research is a reasonable ideal for academic bodies, whose wealth and accumulated momentum of authority give them great power and influence.'[4]

Another article, on the Academician La Thangue, illustrates his dislike of anything that savours of party-politics in art.

'Mr. H. H. La Thangue, one of the founder members of the New English Art Club, a painter of the highest natural ability, who has assiduously cultivated his gift for more than a quarter of a century, in the closest and most loving community with nature, is holding an exhibition of pictures at the Leicester Galleries, which must represent the work of several years. Nothing has been alleged against him, so far as I know, except that he is a member of the Royal Academy, and, possibly for that reason—I can think of no other—there has been a tendency to take his whole exhibition as read, and my impression is that it has been dismissed somewhat summarily and grudgingly by the Press. It is almost as if critics had been afraid to express admiration for Mr. La Thangue's work for fear that we of the left wing should not think them up to date.

'Now I would beg these timid ones to ask themselves one question. Supposing, by a mere and quite unimportant accident of lodgings, Mr. La Thangue had remained a member of the New English Art Club, had lodged, that is, with Mr. Sargent in Suffolk Street, instead of with Mr. Sargent in Piccadilly, would the neglect and timidity of criticism have remained the same? We know that it would not. We know that Mr. La Thangue would have been extolled to the skies. And why? Because the critics would have been frightened of being despised by Mr. Tonks, or by Mr. MacColl, or by Mr. Clive Bell, or by Mr. Fry, or by me for the matter of that.

'It is well to remember that the language of paint, like any other language, is kneaded and shaped by *all* the competent workmen labouring at a given moment, that it is, with all its individual variations, a common language, and that not one of us would have been exactly what he is but for the influence and the experience of all the other competent workmen of the period. A just and equable attention to them all would retain for criticism a much more interesting field of action than the present tendency to veer to extremes of partisanship. . . .

'I know enough about colour to know that it is not absolute

but relative. The born painter develops, as he goes, a series of relations in colour, with which he is enabled to convey the sensations about nature that he desires to set up. . . . It suits Mr. La Thangue's talent to develop a series of colour relations, having as a base, a warm colour, something that may be described as grading from russet towards ruby, and his justification for the choice of this base is that he has been able to build on it a series of beautiful and interesting sensations of nature which is what he, and not someone else, has to say. No base in itself is wrong. Greco and Whistler inclined to use black as the spring-board from which they dived into the waters that they made their own. To use black as a spring-board is neither more noble nor less noble than to use blue or red. The only question that is relevant in criticism is how you dive from the spring-board you have elected to use.

'Having undertaken what perhaps amounts to a very discrete defence of Mr. La Thangue, I have no wish to weaken it by appearing to run away from the destructive part of my criticism. To suppress it would weaken any force that may be found in my defence.

'I remember a delightful song which used to thrill the audiences at the old Middlesex Music Hall in Drury Lane, by the concentrated expression it contained of a truth perhaps universal and secular:

> "*When there isn't a girl about, you do feel lonely,*
> *When there isn't a girl about, to call your only,*
> *You're absolutely on the shelf,*
> *Don't know what to do with yourself,*
> *When—there isn't a girl about!*"

Here and there I seem to see a tendency in Mr. La Thangue's compositions to crown too many scenes in nature with a young man's fancy, in the shape of a female soloist, invariably young, and suspiciously pretty. She sometimes justifies her place by being the goatherd, or she may be the milkmaid, and be opening

the gate for the cattle to pass. Still it seems to me that, on the sentimental plane, there is the danger that this excessive proportion of pictorial *bonnes fortunes* may give as exaggerated an idea of the universe as do the narrations of Mr. George Moore on the plane of autobiography. I have not the space to justify my belief that it is in a phrase in the life of Goldoni that there lies a hint of the highest value to the artist. ''*Vi era in questa casa una donna di servizio, ne vecchia ne giovane, ne bella ne brutta,*'' etc. There or thereabouts lies, I believe, the most suitable matter for artistic treatment.'[5]

Pictorial *bonnes fortunes* of the above described variety seldom fell into the lap of Sickert, and when they did, I fear to say that they were not often well received. At any rate they did not find their way to the walls of Burlington House. As a matter of fact his contributions to the summer exhibitions were very uneven in quality. He sent, with apparent unconcern, some of the worst as well as some of the best of his work. Among the latter was the portrait of Admiral Lumsden, whom he had met, while living at Brighton in 1927, at the Hove baths. It was unfinished at sending-in day, but Sickert hopefully put it on board a lorry (it was too big for the ordinary methods of conveyance, and the paint was still wet), and started off with it at 4 a.m. for London. In spite of this zeal, however, it was rejected for that year. He then had it removed to his studio at Highbury and finished it at leisure. It is one of his best portraits, and was accepted and hung in 1928, Orpen remarking: 'Why, Sickert, last year, when you sent it in, it had feet. Now that you've finished it, it has none!'

The un-academic (but not anti-academic) flavour of Sickert's contributions was hailed as a sort of light relief to the weighty seriousness of the average Academy. The volume of comment, both in private and in the press, varied in proportion to the 'noise' of the picture itself. Critics and public affected to be struck all of a heap by the rather doubtful brilliance of the *Raising of Lazarus* in 1932, while entirely ignoring one of his

finest Bath pictures in the same exhibition. How the painter had come to give six fingers to the hand of Christ was the subject of unending discussion. By contrast Mark Oliver's tiny and 'insignificant' Giuseppina in 1927 passed almost without notice, though it is perhaps the loveliest of all his Venetian pictures.

In 1925 he was elected Associate of the Royal Society of Painters, Etchers and Engravers, and in 1926 he was president of the London Group. In the spring of the latter year, which was that of his marriage to Thérèse Lessore, he took his turn at the R.A. Schools; but he was not at all well, and soon afterwards had to give up both painting and teaching altogether (he was still going once a week to his class at Manchester: see Chapter XVIII). In addition to other miseries the Jewish tailors who occupied the floor above him at 15 Fitzroy Street, and with whom he had to share the modest conveniences of the place, were 'disintegrating the house—and his nerves—by their heavy ironing. *C'est que c'est très compliquée la vie d'après-guerre,*' as he wrote to Tonks.

So he and his wife started off in search of quiet and repose. After trying first Margate and then Newbury, they finally settled into a furnished flat at Brighton. There he used to swim every morning at Brill's bath, comb the second-hand booksellers for Victorian journals and the lives of Victorian celebrities, and sleep or read for the rest of the day. By the autumn he had so far recovered as to paint the first of the Echoes. The idea came to him from the renewal of his acquaintance with the *London Journal* and the *Penny Magazine*, and the black-and-white illustrators with whom he had been so familiar in the 70's and 80's. The first was actually done from a pot lid, but all the rest were from wood-blocks in these papers after drawings by Sir John Gilbert, Kenny Meadows, Francesco Sargent, Georgie Bowers, or Adelaide Claxton, and others.

The Echoes have never been popular, even when their beautiful quality is admitted. The reason usually given is that they are not 'pure Sickert'. But surely the mere fact that he painted

them makes them 'Sickert' as much as any other subject. No one else would have had just that particular 'letch', nor have interpreted it in that particular way. The real trouble lies in the demand, by dealers and public, for originality and nothing but originality. All other qualities of painting are made secondary to that unique virtue: a virtue after all which comes unsought to a great painter, and which is useless to one who has nothing else on which to stake his claim.

Early in the following year (1927) he took a studio in Kemp Town, where the portrait of Admiral Lumsden was commenced. And in the summer they moved back to London, having bought a house in Quadrant Road, Islington. Not far away, in Noel Street, he had a studio, overlooking the Regent's Canal, where he painted *The Hanging Gardens of Islington*, *Lilac and Thunderplump* (the landlady's daughter and a friend sewing in the window), and various *Echoes*. Major Lessore, his brother-in-law, had given him a lay-figure which had belonged to Hogarth. It was of solid wood, life size, and very heavy. Its appearance, being carried up to the studio, gave him the first idea for the *Raising of Lazarus*. About this time he received a prize from an exhibition at Pittsburgh, U.S.A., for the best picture of a garden! It was a scene at Versailles, an early picture, painted at Dieppe.

Once again indefatigable, he started a new school at No. 1 Highbury Place (see Chapter XVIII), and, after it had ended, used the room to work in himself. It was here that the portrait of the Admiral was finished and the *Raising of Lazarus* commenced, the first design being painted directly on to the red wall-paper which lined the room. Here, too, he did the portraits of Winston Churchill, Sir Hugh Walpole and Sir Nigel Playfair, *Lazarus Breaks his Fast* and the pictures of Barnet Fair. Sir Nigel Playfair as Tony Lumpkin in *She Stoops to Conquer*, the cynosure of the Academy of 1929, was his contribution to the fund for the rebuilding of Sadler's Wells. But first a word about the picture itself. The execution was loose to the point of care-

lessness, but Sickert would have the details right. Lumpkin is represented in breeches, fresh from the saddle, and muddied by hard riding. Sickert wrote to his colleague A. J. Munnings asking for a sketch to show the proper distribution of mud-splashes on the boots of a postillion!

His interest in the revival of Sadler's Wells Theatre was natural in view of his past associations with it and the fact that he was now living not far away. Some of his earliest recollections were connected with Phelps' acting there, and during his short stage career he was actually on its boards himself as a member of Miss Isabel Bateman's company. He now started to go regularly to the theatre, and soon became friends with some of the actors and actresses, especially Peggy Ashcroft, John Gielgud and Gwen ffrangçon-Davies. This led to a series of theatre pictures spread over a number of years, practically in fact up to the present time. The finest of them, and the best known, is the portrait of Gwen ffrangçon-Davies as Isabella of France in Marlowe's *Edward II*, known as *La Louve* and now in the Tate Gallery, which was painted from an old photograph by Bertram Park. But most were done from photographs taken under his own direction. Like a film producer he brought along his own cameraman, and the shot had to be just right before he would use it. The backgrounds were usually taken from other sources.

In 1932, when the theatre was in financial difficulties, he gave *The Raising of Lazarus* to be sold by auction at Christie's in aid of the fund. Before that, however, there was a ceremonial presentation at the theatre itself. The picture, which was given 'in memory of my perpetual adoration of Sam Phelps and my gratitude to Isabel Bateman, of whose Sadler's Wells Company I was myself a utility member', stood at the back of the stage against black curtains. Sickert wore his scarlet gown. Miss Bayliss advanced and bent to kiss his hand. Sickert drew her up and kissed her on the cheek. A young man read the chapter from the Gospels describing the scene depicted. Then Sickert made an oration celebrating the reunion, in his person, of stage and art.

In such a setting he was in his element. His heart and lungs expanded in sympathy. He said:

'Islington has always been kind to me. My life was saved at the age of five by Duff Cooper's father, Alfred Cooper, the surgeon of St. Mark's Hospital in the City Road. The last time I delivered a speech in this theatre was fifty-two years ago, which I can remember very well—it was in Shakespeare's libretto of Dr. Arne's opera.

'They say that there has been a great deterioration in the modern theatre. I can tell you exactly how great that deterioration is, because we have had, here perhaps more than anywhere, the most perfect and delightful elocution, in the tradition of Phelps, who looked upon the theatre as essentially a place where the masterpieces of literature were recited, and not as a place where producers thought that they would be original by making the bushes behind the seat in a garden look like organ-pipes. . . .

'I am here to-night as a witness, and as a critic. A witness is always valuable because no one has ever seen exactly the same thing as anybody else. I might say I have also been a vicarious witness, for my mother and father, when they were first married, came to this theatre and saw a piece in which Phelps doubled the part of a king of Scotland and a miser; and at that time the waters of the New River passed under the stage where I am standing now, and could be let on or stopped. There was a scene in which the miser would be counting his gold behind a door, and then he would be assassinated and thrown from the door into the New River, making an enormous splash. It was really an extraordinary illusion when the understudy of Mr. Phelps floated past, with the limelights following his body. It is extraordinary how this district has had in it something aloof and poetical. For some reason or other it has not copied the vulgarities of other districts perhaps farther west; it always retains a curious dignity.

'When you speak about "Drama" you cannot possibly draw any distinction between the so-called legitimate drama and the

drama which is supposed to be not legitimate. The music-hall and the theatre are only two slightly differing branches of the same art. We (I retired forty or fifty years ago, but I still remain a member of the theatrical profession: and if I cannot sell my pictures, will come down on the fund for maintenance)—we—I have seen in a theatre opposite a big station in Shoreditch a piece, a *lever de rideau*—(they say that non-stop shows are not taking on now: of course, I can understand that such rot is not attractive: in the old days they used to have three pieces from 7 to 12, and nobody wanted to leave, as long as the theatre was well ventilated. They used to have things like *Our Old Nurse* and *Lend Me Five Shillings* and *Jeremy Diddler*. The Princess was one of the last places like that. My grandmother was a dancer at the Princess.)—I think the play was in North-country dialect. It was a question of a young lady who had been got into trouble and deserted, and the man was supposed to be unattracted—who ever heard of a man being unattracted?—however, he undertook to marry this lady, and he used to say, "Don't look at me, don't look at me," over and over again—just like that. It was a wonderful little drama. . . .

'Now I come to the part where it is rather interesting to have an eye-witness—to an account, extremely clearly remembered, of Phelps. He played Falstaff—one characteristic which I think it would be a useful thing for my colleagues to remember—(my position with regard to my colleagues is rather like that of the boy in buttons to the Lord Chancellor—oh, and talking of the boy in buttons, Johnny Handsome, everybody has some quality which is of special use to him some time, and Johnny Handsome had an enormous barrel of a belly hanging down very low: and he used to complain of his Missus—"I shall cheek her," he used to say—because she had sent him round to the cab stand to pick up oats for her chickens). I was talking about Phelps. Amateurishness was started by actors and actresses who made a certain reputation—you know those advertisements, "Distinctive Trousers for Discerning Men". These actors like to be Distinc-

tive Trousers: but they are no artists unless they form part of a whole. This shows itself in several ways. They seek for fantastic and irrelevant make-ups. It all arises from this, which is very interesting and important, that actors have now a tendency to say, "I must show how good I am in this art by disguising myself so that nobody shall know who I am." Phelps never attempted not to look like Phelps. This is not to say that he was not different in different parts, but there was always that face, and there was no attempt to abolish that face, to make of it something unrecognisable. This can be developed into the vice called "the old favourite", but that was not what Phelps did. . . . His Falstaff was marvellous. He played it as a knight, a fat knight, a boozy knight, a silly knight, but always a knight. . . . The particular defect against him in this theatre was that there were so many people close under the first circle, and he was determined that the furthest person should hear what he said, so that he knew he must slow down. In his Wolsey he used to say, "I . . . shall . . . vanish . . . like a . . . bright . . . exhalation . . . in the . . . evening": which after all is very much like people speak when they are serious. And it has a certain advantage. . . .

'He lived in Canonbury Square. I was there a few months ago. He would have a charming walk from there. He went past the place where Charles Lamb used to get "poopigaffy", a word, I think, not now used. Phelps went to only four public dinners, and no private ones. He was a strong swimmer and a great fisherman. One day he was acting, and a voice from the pit called out, "Damned if it bean't our fisherman!"

'I said I would speak about the art of the theatre and the art of painting. They are closely connected. One of the reasons for the unfortunate state of the modern theatre is the gap between the actors and the scene-painters. The advantage of scene-painting is that if you are not going to use a piano, a very good painter will paint a piano so that you don't spend the whole time looking at it; it will be a "practicable piano". Collet gave a list of things required for a certain scene—ink, pens, blotting-paper, and

"four practicable books with gilt edges". Many people at the present day haven't even got a "practicable" book. I have presented bar-maids with whom I have sympathised with volumes of the classics with gilt edges,—but—oh Lor', no!—what are they to do with them? . . .

'The object of scene-painting is not to make people look at the pictures behind the actors. The other day I saw a play in which there was a man, a composer, whose wife ran away with another gentleman. He leant against the top of her head, and then (she couldn't see it) blubbed—only an instant. If there had been a Turner behind, no one would have seen it. . . .

'Do not listen to the people who say, "What people want nowadays is so-and-so." How the devil do they know? If you sit down and do something no one has ever done before, they can't want it, because they've never seen it.

'We are a country where the language goes by opposites. When we say, "we have the situation well in hand", we mean we are having the trouble of our lives. When we say a man has passed a comfortable night, we know he has suffered the torments of hell.

'Anything popular in art is said to be bad because it is not "high". A great many of the men you are taught to gibe at are very considerable artists, and will be remembered long after some of us are snuffed out. Leader was a very good artist. I am not joking. I am too old to joke. I am here to tell you what I think. Farquharson? You say, "Oh, sheep!" Well, what's the matter with sheep? WHAT IS the matter with sheep? Jean François Millet? "Out of date." The reason is—they *don't know*. As soon as things are not in the market the tendency is to run them down, because there is no money to be made out of them. The pictures are all in America. There's nothing more to be done. But—Distinctive Trousers for Discerning Men—there's money in it. . . .

'Put all your weight behind the demand for opera to be played in the language in which it was written; the big "a's" are

written for those notes; anything else is monstrous. There would be an audience for it. There is an Italian population quite close, a German colony, a French colony. And besides, there is no absolute reason why we shouldn't learn something, although we are grown up. The most valuable things in any language are what they call "tags", because they are formed by natural selection. And the songs embody them; never forget that. I heard a singer whose notes were absolute shrieks of agony, beautiful shrieks, but shrieks. The audience wept. That is what I call Drama.'

Upon hearing of which Max Beerbohm wrote :
'Still a member of the profession.' (*The Times*, 22 Oct. 1932.)

## Richard Sickert, A.R.A.
### Resting

'Open to engagement as juvenile lead, walking gentleman, singing footman, etc., etc. Handy. Experienced. Can do backcloths of Venice, Dieppe, Brighton, Camden Town, etc., etc., if required. General utility. Terms on application.'

&#9733;  &#9733;  &#9733;

Meanwhile in 1927 he had been elected president of the Royal Society of British Artists, invited thereto by a number of the younger members, who wished to infuse new blood into their rather static circulation. The result did not turn out quite according to their expectations. Indeed one would have thought that the lesson of The Master would have warned them against taking another such basilisk to their bosom. But no! They asked for a second bite and they got it. Soon after his election Sickert tried to import the procedure of the Allied Artists into Suffolk Street, and there was trouble. After an association lasting only twenty months the society and their president parted on amicable terms. In answer to a letter on the subject in the *Daily Mail* he wrote: 'Sir, I am afraid Mr. Warren Dow has slightly dramatized the situation at the R.B.A. I have only done what every executive has to do when it fails to get a majority. Far

from being "hurt", I am extremely satisfied to have been able to give twice in a Royal Society an object lesson in what amounts to no-jury hanging.' . . .[6]

The truth is that, now as earlier, there was no professional circle large enough to prevent his escape or small enough to hold only those who agreed with him in everything. He was a law to himself. In everything but his painting he remained fickle to the end. It was his love of change for change's sake, more than anything else, that made him alter his signature, soon after his election to the Academy, to Richard Sickert, in place of the familiar Walter; though the whim to have a telegraphic address of Dicsic may have been an extenuating circumstance. This change was considered to be of enormous import by certain people. It was more written about in the papers than all his paintings put together. It is rather difficult to see what all the pother was about. Most of those who love his pictures prefer the tiny neat 'Sickert' in the corners of the early canvases to an Rd. St. A.R.A., P.R.B.A., sprawled over a fifth of the area of a 15 × 12. But even that is a matter of taste. It is well-known that the custom of signing pictures at all originated with the growing importance of individuality in style. The primitives, whose art was communal, never signed their works. The twentieth century, on the other hand, has witnessed the apotheosis of the signature, when the picture may be little more than a scrawl around the magic name. Imagine a surgeon who signed his appendicectomies in indelible ink on the bellies of his patients, thinking to guarantee thereby the success of the operation!

In 1928 he found time to support the formation of the East London Group by a number of East-end painters who were none the less serious in their approach to art because it was not the main source of their livelihood. He went down to lecture to them on the technique of their craft, and when they held their first exhibition the following year at Reid and Lefèvres, he sent three pictures of his own as a *point d'appui* of the show.

The winter of 1929–1930 was notable for the great exhibition of Italian art at Burlington House. Sickert, who nevertheless made a spectacular entry at the private view in top hat and brown tweed tails, disapproved strongly of pictures being used for national advertising. Their true function being hedonistic, not ambassadorial, they ought to be left in the niches that time and circumstance have allotted them, where they can be enjoyed in tranquillity: not brought together in overpowering galaxies, where they can only be seen through the interstices of a triple row of hats. If it is only the hats that one wants to see, that can be better and more properly accomplished at Ascot and other similar places.

'We are wont to speak of tempting providence,' he wrote. 'So we must assume that providence has been known to succumb to temptation. If providence had elected to sink the good ship Leonardo da Vinci in the gale instead of, as it did the other day, a cargo of modern paintings, Society would certainly have said, "Oh! Hard lines!" and passed on to more congenial preoccupations.

'That the Royal Academy should have succumbed to a sporting stunt is disappointing. The English adoration for taking risks, for the fun of risks, sometimes our own, and always somebody else's, is ineradicable. But the Academy surely exists, one might hope, to say the becoming and scholarly word at the right moment. Private owners will always send their property, properly insured, trapesing over the universe, because their property is of the nature of investment, and because it gains, when authentic, in value in proportion as it is advertised. But national property should be treated differently. Degas used to say, '*Il faut qu'un tableau ait sa place.*' And in its place it should, in a civilised state, remain, with all tremulous precautions, as long as the world holds together.

'Gestures of courtesy between governments are lovely, and of good omen; but the successive deposits of the spirit are sacred, as sacred, or more, as is the hallowed dust of Dr. Valpy, or

that of Mr. Sheepshanks's Mr. Mulready in Kensal Green. Let us by all means send our glad stones to Hellas freely. They enjoy the trip, for which flesh and blood is duly strutted, but not age-old miracles of coloured dust, held together with a breath of perishing glue, on heavy warped and morticed panels. . . .

'The need of experts for facilities of study have been invoked. This is bunkum. . . . It cannot be necessary to vibro-massage an arch-known Titian from Trafalgar Square to Piccadilly for fear it should have escaped Mr. Fry's notice.

'Pleasure, and pleasure alone is the proper purpose of art. Speaking as a convinced hedonist I am inclined to think that the concentration of an enormous rush of Society on one spot at one moment detracts from, rather than adds to the pleasure that art can afford. We were of late congratulated on the fact that there were four, or was it five, simultaneous circuses at Wembley. But five circuses is less, and not more, than one circus. There was a classic, half a century ago, which ran up and down the King's Road:

*There's only one girl in this world for me!*

'If I want to see a Reynolds, little Lady Caroline Montagu Scott is enough at a time. And I want to see her in Edinburgh. . . . Not in London. Every town should keep its attractions at home, and follow the principle of the Christy Minstrels, who never performed out of London.'[7]

During the whole of this period he was writing frequently, not only to the weekly and monthly, but also to the daily press. His letters to *The Times* and other papers covered a wide range of topical subjects, from stone-ground flour to the summit of Snowdon, which he proved to have landed in the centre of a flower-bed belonging to Sir Edward Watkin—who had had it sawn off![8] Of stone-ground flour he wrote, 'I have had white bread made from this flour sent me from Gloucestershire for about nine years. The price of the carriage cannot be set against

the gain in nutriment. Our stomachs are not constructed to digest criminal euphemism.'[9]

I have traced more than a hundred such letters between 1927 and 1935. Some of the subjects are Sea-water baths,[10] Women's dress,[11] Fish as food,[12] Epstein's sculpture,[13] the Haig statue,[14] Art and the gasometer,[15] Waterloo bridge,[16] Conference secrets,[17] Family life on barges,[18] Pylons on the Downs,[19] Flood lighting,[20] the Derby of 1821,[21] Whistler fakes[22] and Tea-tray painting.[23]

Of flood-lighting he says aptly that the object of illumination is to reveal form, while the result of throwing countless equal lights on a body is to create flatness. And of the pylons he wrote, 'Doubly domiciled in Kemp Town may I make a draughtsman's contribution to the question of the pylons on the Downs? When we square a drawing up we are always struck with the added savour of the design. This is because the sense of drawing is merely the sense of the direction of all visible lines compared to the perpendicular. This added beauty the pylons will impart, making the rolling of the ground and the refinements of its recession sharply evident and appreciable. There will of course be also aerial perspective and chiaroscuro, which the pylons will share with the rest of the view. Light and shade fall on what it is the fashionable luxury to call 'the unsightly' the same as on anything else. The potential policing gained by the mere knowledge that the miles in question are liable to inspection at any hour will give a sense of security, and you,

*If Protestant, or sickly, or a woman,*

will feel distinctly more comfortable on dark or stormy nights.'[24]

In the great Holbein controversy (1933), which was fully reported, Sickert sided with Tonks and the painters against Fry and the critics.

In 1931 they moved from Quadrant Road to Barnsbury Park. The studios at Kemp Town and Noel Street were given up, but

Highbury Place was kept on for a while. For some time he used a room in Sylvia Gosse's house in Camden Road. Later there was a studio in Whitcher Place, converted from a garage, and still later two more rooms nearer home. He was still working on the *Echoes*, pictures of Sadler's Wells and various portraits. *La Louve* dates from this period.

In financial matters these were difficult times. The great depression and still more the disappearance of the Savile Gallery which had supported his market for so long (Chapter XIX), struck chilly on a painter never famous for his providence. By 1934 he was in such difficulties that a group of friends and admirers were approached to help him out. This they did to such good effect that he was freed once and for all from the creeping paralysis of debt. He was enabled to get his breath and carry on for another heat.

But Sickert, if he had only the vaguest notions of the value of money to himself, had very definite ones on its possible effects on a painter who gave too much importance to it. In a centenary notice on Sir John Millais he wrote:

'I have never forgotten a lesson that was read me by Monsieur de St. Maurice, who had been equerry to the Khedive and may be supposed to have been at home in theories of finance. It was in the classic restaurant in Dieppe of La Mère Lefèvre, in the Rue de la Halle au Blé, opposite to the three weeks' summer palace of Napoleon III.

'One of the delightful semi-remittance men who wisely pullulate in French ports spoke of his poverty. "What is your rent in Dieppe?" asked M. de St. Maurice. "Twenty pounds a year for an eight-roomed house, a small garden with *peupliers d'Italie*, cellarage, and a cistern of 20,000 litres of rain water," said the clean-shaven remittance man. "And your rates and taxes?" "Two pounds a year." "You are not poor at all! If you had, falling due, at incessant and erratic dates, claims for £400 at a time, which you had to meet or be ruined, you would understand for the first time what poverty is!"

'And in a cumulating form that is what Millais knew from his childhood to the hour of his death. A palace in Princes Gate, fishings and deer forests for the summer, etc., set the pace for his earnings. Millais' anguish was only on a larger scale than the anguish of his noble kinsman across the water in Barbizon and Gréville. But it is not Millet who is to be pitied. *Durand-Ruel était là!* The tragedy of hunting thousands in sterling is more terrible, and above all more dangerous, than that of hunting tens in hundreds of francs.'[25]

Barnsbury Park was near to Pentonville Gaol, a useful landmark for the directing of taxis. Sickert always used taxis with sublime disregard for time or space. Steer tells of one which waited in Cheyne Walk all afternoon while his old friend tried to persuade him of the enormous saving of labour involved in the use of prints and photographs, as documents for painting. 'But', said Steer, 'of course that sort of thing wouldn't suit me.'

Sickert often went to the Garrick Club. There was an evening there when he competed with Leslie Henson and other members as to who could remember the greatest number of old popular songs. Leaving the club with Henry Rushbery he suddenly proposed to drive round London and show him all the houses where he had lodged for the last fifty years. As they crawled into the last taxi, the driver said: 'Pentonville, I suppose, Sir?' . . . and Sickert went happily home.

# CHAPTER XVII

# THE LITTLE SISTER TO THE BRUSH

$\sim\!\!\!\!\sim$

'As I get stronger, I shall occasionally take to my pen again.' This prophecy was fulfilled in a series of articles, contributed between 1924 and 1926 to the *Southport Visitor*, the *Daily Telegraph*, the *Morning Post* and the *Manchester Guardian*. It is of the greatest interest to compare these essays with those of the *New Age* about 1910. Both series were concentrated within periods of a year or two, after which he appears to have temporarily written himself out, although occasional articles, letters to the press, etc., continued to appear in the interval. Both coincided with other educational activities, the earlier with the Westminster School and Rowlandson House; the later with the Manchester class and his lecturing tours. It is certain that Sickert regarded all his writings on art from an educational or reforming point of view, and that for this purpose he was not to spoil the child by sparing the rod. What he says specifically of public art collections applies equally well to any subject in which he was interested. ' "*Si nous avons quitté*", runs a remembered line of Meilhac and Halévy's comedy *La Boule*, "*nos travaux et nos plaisirs, Mister Jonson et moi, ce n'est pas pour des prunes.*" In writing of the principles which should be observed in choosing works of art for public collections, I may presume that what is required of me is not so much roses, roses all the way, but such reasonable compromise as might be described as flower, fruit and thorn-pieces."[1]

To a very large extent the ground covered in the two series of articles is the same. But this was in no way due to a hardening of his critical arteries, nor would he feel at all required to apologise for it. '*Si je dis toujours la même chose, c'est parce que c'est toujours la même chose.*' The new essays were not, however, merely a re-edition of the old. Both arrangement and style show that they were an altogether new and spontaneous outburst of literary energy. In spite of the fact that they were always subservient to his painting, Sickert's writings have a value of their own, both as literature and criticism. With him the pen was the little sister to the brush. She was very well aware of the superior claims of her big brother, and, like most little sisters, she followed his lead, even to the way he swung his cane. In fact, the changes in his later literary style are analogous to those which had occurred in his painting. The construction is looser, the narrative more broken, the 'colour' of the phrases richer. Words are not so much used to outline an unique event, as to throw an unexpected hue or sparkle over an idea. Take for instance these two introductions, one to an exhibition of his own at Major Lessore's Beaux Arts Galleries, the other to that of his old friend Walter Taylor.

> '*J'ai la tête romanesque
> Et j'adore le pittoresque.*'
> Giroflé-Girofla.

'I was sitting, Federico mio, to-day in the beautiful great gallery by the Pavilion at Brighton, dominated by the magnificent portrait of the magnificent George IV ("Is he a gentleman?" "Has he any Greek?")—the gallery which is still *the* example of proper picture hanging—pictures considered as a permanent factor in the architecture of a room, and not as items in a lending library. The life-sized or larger than life portraits or drama-pictures, and the type of landscape Constable loved, and turned out in his dear tiny studio in Charlotte Street, next door to St. John's Church, where Mrs. Beer-

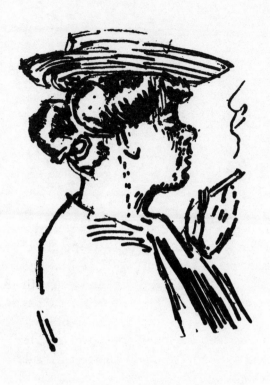

EASTER MONDAY—JEANNE

bohm used to worship, hang on the frieze above the picture rail. . . .

'When a life-sized public portrait, with all due appanage of thunderstorms, curtains, children, favorite chargers, dogs, etc., is destined to hang for ever, irremovable, in a court of justice, a church, a college hall, or the mansion of a nobleman or a public-spirited commoner, running perhaps to a butler with a tray and a glass of sherry in the library at Rutland Gate— you cannot hang such a picture where the side-board is, nor any picture over a mantelpiece. Pictures can only begin where they would be safe from the athletic shoulders, reposing against the wall, of a blown youth, "blasted with ecstasy".

'The consequence of line and centre hanging, apotheosis hanging, has tended to tempt, say, six generations, to ignore the stance of the figure and its whole ambient. It has also kept, say, six generations in a blue funk about what is called the face, and what the patron, if any, will say, when he comes to "look into" the face. I had the exquisite joy of seeing a surgical friend of mine whip a lens out of his pocket; he was not clear as to whether it would have been wise to operate or not.'[2]

And second:

'My friend Walter Taylor, who talks archaic French in his sleep, would be eminently entitled to say with Villon:

' "*Je connais coulourez et blesme*,"

but should he add the envoy:

' "*Je connais tout fors que moi-même*,"

we should have to reply, like the fare to the cabman who said, "Ere you are, sir!" in the wood-cut after W. S. Gilbert, "There you err, sir!"

'Walter Taylor's art is the art of coloured and pale: but he knows himself, that is to say the means at his disposition, exactly. *C'est déjà beau!*

'I forget for the moment how many ways there are of making

tribal lays. I am satisfied to take it from my young friend Ruddy. But there are two ways of painting, and two only. And both are more than right.

'When my sister was five years old she had (and still has) an extraordinary prolific invention of narration. So prolific, that one of her elder brothers said he was sick of her stories, that they were all out of her head. The future feminist retorted with indignation: "They are not out of my head. They are out of my stomach!"

"Well, there is a way of painting out of the stomach, Tintoretto, Max, Turner, Haselden, etc. The nutriment from which this painting results is a form of cribbing. You take the last man's version and turn it from right to left, or from dark to light, or from male to female, or from comedy to tragedy, safely resigned the while, that your spendthrift heir will spaffle what you have hoarded, to other ends than yours.

'Then there is the other painting. Painting from nature, of which an analogy can be found, which, I understand, lies between the late Lord Ripon and his present Majesty. To kill five birds as they fly over you, with two guns, as the guns are handed to you. To pick off the quintessence of a scene while you don't wait is a rare and precious achievement. I am emboldened to add Walter Taylor to the company of the august shots above named.'[3]

As English prose Sickert's style no doubt suffers from the frequent intercalation of tags of foreign languages, particularly French. But it must never be forgotten how long a period of his life had been spent in France, nor how close had been his ties, both cultural and domestic, with that country. He had become so much at home with the literature and the language, that he was constantly finding himself in the dilemma of being unable to express some idea or allusion except by reference to it. And then we must remember that Sickert had never any high-fallutin' notions about his writings. He was not writing books, but articles for an ephemeral press. Like the cartoonists he so

much admired, he wrote for the day, usually, like them, in order to 'chastise our little ways'. Like them too, or the best of them, the discipline of this weekly publicity may have given his style a certain grace of lucidity and economy, but it left him no time for purism. What he had to say must be driven in by the shortest and cleanest means, with a final hammer-stroke to nail it home. It often happened that the hammer was 'made in France'.

Curiously enough, Sickert himself was once of the opinion that 'it is a mistake to drag in snippets of foreign languages, that are not currently known in this country, into English prose compositions. I remember once how, wishing to give it immediate currency, I fathered a humble little *mot* of my own, in dog-Latin, on Whistler. With this sesame-affiliation, my gem had the honours of immediate publication on the front page of the *Westminster Gazette*, under the line that separates the leader, on matters of importance, from the paragraphs of none. The next time I met Whistler he said: "Very nice of you, very proper, to invent *mots* for me. The Whistler *mots* propagation bureau. I know! Charming! Only when they are in languages I don't know, you had better advise me in good time, and send me a translation. Otherwise I am congratulated on them at dinner parties, and it is awkward." '[4]

Sickert had a great respect for the King's English (not to whisper of George Moore's French!). Anything in the nature of a meaningless *cliché* or a badly-constructed sentence grated on his ear like the squeak of a knife on a plate. 'One of the pleasures that a neutral may derive from a heated controversy is that it gives him the opportunity to add to his collection of what we may call "Signatories' English". We all know how difficult it is, in drawing up the simplest communication, not to say the contrary of what we mean. When we sign a Round Robin the problem is multiplied by the number of signatories. Such letters would make an excellent basis for an examination paper in English prose composition. I once had occasion to volunteer a

written apology in the office of a distinguished lawyer, which was to have the effect of a withdrawal, nullifying a critical libel I was alleged to have tumbled into. The distinguished lawyer proceeded to dictate to his shorthand writer the wording of my proposed apology. "I have learnt with surprise"—he began. I begged his pardon for the interruption, and pointed out to him that no one would believe that those four words had been written by me. "You are quite right," he said. "Perhaps you had better write it yourself." '[5]

Sickert's mind bent naturally towards *litterae humaniores*. It was anything but mathematical. As he might have collected examples of signatories' English for examination purposes, so might others gather howlers from his own arithmetic. If he refers to a sentence as containing $x$ words, it is next to certain that it actually numbered $x \pm y$. Nothing, however, quite equals the following, taken from an unpublished manuscript (about 1923). 'The difference between real teaching and cramming is the same in the teaching of drawing and painting as in any other branch of study. A bad teacher will make a student get by heart that four times seven is forty-two.' All right so far! but he goes on: 'A good teacher will cause in the mind of the student a habit of seeing at a glance the following succession of ideas: that, with our decimal notation, 3 out of one 7 make up, with another 7, the ten. And so,

$$7 + 7 = 14$$
$$14 + 7 = 14 + (3 \times 2) + 1 = 21$$
$$21 \times 2 = 42.'[6]$$

*Quod erat demonstrandum!* It is inconceivable that Sickert ever counted his change!

<p style="text-align:center">*       *       *</p>

The field covered by these later articles is mainly, as I have said, that which he had already tilled so effectively fifteen years earlier. There are new emphases on old themes and sometimes an old emphasis applied to a new theme.

Of the former, his abiding love for the work of Millet received an extra fillip from the exhibition and sale at Christie's of that painter's monumental *Coup de Vent*. 'Not only is this a sublime picture by one of the great moderns, but, and this flows from that, it is one of the purest demonstrations that exist of the height to which the art of painting has been lifted. The execution is at the same time lavish and economical, restrained and ecstatic. At a time when the technique of painting has been standardised by pedants into a system of identical and equal touches, and when technical illiteracy assumes almost the character of a series of practical jokes, Millet's erudition-plus-instinctive-impulse is worthy of careful study. In this canvas the meshes of the net-work of the brush in the foreground of the picture are extended and tormented with the excited expression of such things as the storm-lashed ripples of the pond and the ruffled leaves of the vegetation. Millet, differing herein from the less considerable exponents of either method, knows how appropriately to combine the resource that the French call *badigeonner*, that is to say, execution in the manner of a housepainter, with the technique of touches that the Impressionists have exploited to such good effect. There are passages around the falling tree in which the canvas is hardly covered, whereas the bunching bulk of its branches shows all the resources of an eloquent impasto. As the eye picks up the landscape over the dip of the middle distance, and proceeds to the somewhat more serene little oasis of the farm buildings with their road, the meshes of the brush-work draw together until they are hardly perceptible. In this manner a hint is insinuated of distance, repose, and, one might say, a suggestion of the serener illumination of the possible haven.'[7]

In another place he gives a description of the spirit of the subject for which such an execution should be the instrument.

' "In the woman returning from the well I have tried to prevent her being taken either for a water-carrier or a servant. She is supposed to have drawn water for the needs of her house-

hold, water to make soup for her husband and her children. She should look as if she were carrying a weight, neither greater nor less than that of two full pails. And through the kind of grimace, which is, as it were, forced upon her, owing to the weight that is dragging at her arms, and through the blinking of her eyes, owing to the light, one should be able to divine a kind of rustic good nature. I have avoided with a kind of horror, as always, anything that might tend towards the sentimental. I have desired on the contrary, that she should be accomplishing, with simplicity and cheerfulness, without considering it a task, an act which is, with the other actions of housekeeping, a labour of every day and the habit of a life-time. I should like to suggest the coolness of the well, and that its air of antiquity should make clear that many a one before her has come there to draw water.''

'Millet, who was saturated with the Bible, and who read Virgil in Latin, has given, in a letter, the above description of one of his pictures.

'It is not uninteresting to compare with this a description by Eckermann of a Greek gem shown him by Goethe: "I saw a man who had lowered a heavy vessel from his shoulder to let a boy drink from it. But the vessel is not yet convenient for the child. It is not yet level with his mouth. The water still refuses to flow. The boy puts his hands on the rim of the vessel, and, looking up to the man, appears to beg him to tilt it a little.''

'Such descriptions of the aims of two works of art in separate ages and different media are instructive at a moment when fashion wishes to decree that a work of art must, above all, mean nothing.'[8]

They are instructive also in showing, not only Sickert's preferences, but the aims which he set before himself in his own drawing. Indeed it is always necessary to look to his criticism of other men's work in order to divine his ideas about his own. In the whole of his writings there is not even the breath of a hint concerning them directly. No doubt he had learnt a lesson from

the experience of others; and had come to the conclusion that it is a safe rule 'ruthlessly to brush aside all statements of a painter's aims made by himself. A PAINTER MUST BE JUDGED BY HIS CANVASES AND NOT BY HIS PATTER.'[9]

To continue the old themes: as in a cookery-book, equivalent recipes for good drawing and painting are served up again and again, with different sauces or stuffings.

'The artist who elects as his line of business to chastise our little ways with a smile, or a frown for the matter of that, has a way of becoming the best artist of his period, for the same reason that a child of five, pushing her elder sister for a wager in a scissors perambulator on a slippery evening up a Portsmouth *sotto-portico* to the sweet-shop, attains a grace that leaves all but the greatest actresses in the lurch. Neither the child nor the cartoonist are thinking of grace, and that is probably why they attain it. . . .

'And yet we know that the brush is didactic at its peril. A surgeon must neither blub nor preach. Hogarth's moralities are no more true on their side, than are the conjugations of Miss Maude Goodman on the other. Perhaps what we want is something between the two. Is the painter then to be driven abroad to the holiday resorts? The postcards now do that work better and cheaper. For the best artists in that line, after all, remain for ever trippers. There are engravings after Turner of the Bridge of Sighs and the Rialto that must give an architect or a photographer the toothache. The modern French have perhaps shown us the way, not only in present practice, but in understanding of the classics. No previous critic has written with more penetration or more lucidity than Mr. Fry, the pupil of France, last month on Rubens in these columns. He makes it crystal clear that great painting is illustration, illustration, illustration all the time. Let us give the devil his due. . . .[10] We are suffering from too much subservience on the part of the public to what is called expert opinion. That painting must have no subject, must not be literary, has been so dinned into our

ears, that we have forgotten that the choice lies only between an interesting and an uninteresting subject. Can we be surprised that public bodies are not inclined to commission, or even accept, as permanent decoration, such a subject, since subject there must be, as *A Party of Art-students Showing the Proletariat how to Behave with Oddity and Decorum in the Public Parks*? And how long can the plain man be deluded into the belief that a portrait of an empty straw stool conveys to him "profound emotional significance"? To quote from the classics: "Schmidt of London's very nice, but he is go too far!" '[11]

Or this:

' "*Dal vero!*" How many generations have deciphered these two words? How many generations have been satisfied that there was no catch in them? And there isn't; on one condition —that we can agree with Mr. Chadband in our answer to his question, "What is terewth!" . . . There are those who hold, like Lacordaire on the one hand, and the Socialists on the other, and it is not for me to contradict either, that the world is steadily moving towards perfection. What will be the move after seems difficult to conceive. We do know that nothing can stop still. We can only presume that we shall then be able to rush rapidly down hill without a scruple.

'In the beginning the exiguous profits of the daguerrotype, and indeed the very nature of the daguerrotype, did not allow of the professional improver or retoucher. Such as my paternal grandfather has been handed down to me reversed on a sheet of glass, such undoubtedly he was, in repose (*in repose!*) in a dressing-gown and a smoking-cap that are calculated to turn his pious grandson green with envy.

'But when his grandson, at the age of nine, slightly obese from the bread-and-butter and sky-blue of a boarding school in Reading, leant his arm, as instructed (Whistler was done the same way by the stereoscopic society) on a ruby velvet rest, and smiled in obedience to the composite firm in Baker Street, a somewhat puffy smile, the arranger and retoucher had begun to

show what I hesitate whether to call their cloven-hoof or their hydra-head. The era of cotton-wool had invaded photography. . . .

'What is the real test of "*Dal vero*"? That the image should seem probable. Veronese's *Vision of S. Helena* is "*dal vero*". The canvas that is in the National Gallery was, we can be quite sure, not standing on the perpendicular modern easel in front of the sleeping woman. If it had been, it would effectually have blotted out the painter's view of her, to say nothing of waking her up with its creaking. Nor did Veronese see cherubims with wings, flying upside down. But he has made his picture appear probable, and Bastien Lepage, who posed his tormented models for hours out of doors (in grey weather), has not. Stothard's children bear the imprint of truth in every lovely gesture. So do Birket Foster's. The Sweedlepipes are *dal vero*, though they never existed. Busch and Oberlander are truer than true, and lighter than light.'[12]

Of new themes to which he applied those same principles, those same emphases, which had guided him all along, one of the most salient was the question of forgeries, especially Whistler forgeries. Sickert was never averse to an argument, and over this affair of forgeries he embroiled himself more than once with dealers and others. The summing-up was as follows:

'An old lady of my acquaintance said to me a few years before her death: "Since Penelope Noakes of Duppas Hill is gone, there is no one left who will ever call me Nellie again." The passage of some years after the death of a painter places his work in the same sort of isolation from intimate and loving eyes.

'This date is maturing for Whistler. The forgeries are coming, one by one, in extended formation, like the cockchafers in *Max und Moritz* from under the mattress of Uncle Fritz:

> *Schon fast einer der voran*
> *Onkel Fritzen's Nase an.*

'It is on record that at a given moment Charles Dickens, filled with reforming zeal, allowed himself to be nominated on a committee that was to report on the form of slow assassination known as adulteration. He left the committee abruptly, when he found that considerations of "supply and demand" were to be taken into account as a matter of course.

'Now the victims of adulteration are all found in a class, not necessarily poor, but at least abysmally and suicidally ignorant. They are mostly women who have never been told that social status does not depend on wearing furs in summer or on smoking courtesy cigarettes. If arithmetic had taught them to relieve their earnings of these and similar first-charges, they could afford to buy real bread. It can be got, white as well as brown. . . .

'But, you will ask, what can be the mentality of a man who pays, not because he likes them, but as a speculation, four figures for twenty charcoal drawings by Turner on paper of a date subsequent to Turner's death? One can understand why he doesn't prosecute. It takes the courage of a lion to risk leaving a court with the stain for ever on you of having been proved "no connoisseur".

'The procedure is always the same. The forgery is announced as a "find". It is found in the same way as an Easter egg is found in a box border, because it is put there. As the firms are working for the most Innocent of the Innocents, there is very little attempt at imitation of the style of the painter forged—just a cut at what are popularly supposed to be his "subjects". . . .

'Whistler did countless sub-life-sized heads and countless little figure panels of obscure untraceable young women and children. . . . Now in these subjects you may find evidence of a characteristic practice of Whistler. If he fumbled a passage he used, at all periods, to take off the superfluous paint which dissatisfied him by blotting the picture, like a cheque, with a sheet of good stout blotting-paper. This blotting-paper left the raised knots of canvas cleaner than those parts of the thread that were

on a lower level. Here we have a superficial appearance that can be produced by *anybody*. It is natural therefore that the forger should rather parade this trick than attempt more difficult characteristics. *Il en abuse.*

'But you cannot forge the voice of a Duncan Sister or a Sonia Alomis, and that is where the forger immediately becomes "puffickly ridiklus". Helleu once took me up to a Whistler at the Salon, by no means a masterpiece, and challenged me play-fully to defend it, which I rather lamely did by saying: "*C'est la voix du bien-aimé*".

'But I will do it better now. The beauty of Whistler's paint-ing was that he achieved its form purely by relations, con-sidered as opaque, between a restricted number of tones. This is not only extremely difficult, but, odd as it seems, it is so rare that only the great painters can do it.

'For flesh, Whistler's restricted range of tones is exactly the same as you find in the mosaics of Burano. I know because I have mixed them for him. From the same cause, modulation of light on a human head, seventeen and a half feet distant, have, not unnaturally, sprung identical results.

'Now the less a man is a painter the more he is obliged to supplement the theoretically ideal course described in the last paragraph by what painters call "accents", that is to say, emphasised markings, which rather arrest than extend the intimate deployment of form.

'Of course accents can be used with any degree of authority and skill. Lenbach may be cited as an example of great virtuosity in that order. Mr. Sidney Whitman's moustache may almost be said to drip light and shade. But as we are talking about Whistler forgeries, the presence of decidedly ticked accents (e.g. under an eyelid) is a sign of deplorable ignorance of Whistler's most obvious characteristic, which was just the absence of accents. . . .

'But of what avail is it to shut the gates of the park against the rooks? "Over from the country where they do things big"

comes the finished strategy, the barrage under cover of which the duds take up their positions.'¹³

\* \* \*

Lest it may be thought that too much space and importance have been given in this book to the little sister of the brush, the pen, and not enough to the brush itself, the reader is asked to turn back to the title-page.

A man's written philosophy can be presented, condensed, in his own words. His paintings have got to be seen. They cannot be described, or even reproduced, at all satisfactorily. All that is possible in a book is a sort of sublimated advertisement, which will make people go to the source, and in this case that is better obtained from Sickert's witty comments on other men's manners than in any other way. But in the last court 'a painter must be judged by his canvases and not by his patter', or, we may add, BY ANY ONE ELSE'S PATTER.

CHAPTER XVIII

# STRAWS FROM CUMBERLAND MARKET

～✤～

Not long after his return to London, the zeal of the prophet
entered into Sickert. He began again to write, to lecture,
and to teach. The first of his lectures was given in Edinburgh
in January 1923, where he stayed with the Prices. In the
highest spirits he wrote to Mrs. Schweder: 'Such an amusing
success. I am to be made honorary member of the Scottish
Artists. Bathed every day in salt-water swimming bath by the
sea at Portobello. Went to church at St. Giles's where Turner
painted the congregation adoring—George IV. . . . I have been
photographed "by request" for the window in Frederick Street
in a silk hat like a writer to the Signet.' In the lecture he re-
ferred to the Turners (George IV at St. Giles, and George IV
at a banquet) in the National Gallery there, as 'perhaps the
highest point painting has ever reached—so sublimated that it
becomes absolutely magic, and seems to leave the earth, when
the materials are used like sound and hang in the air.'

The next was at the Ashmolean Museum, Oxford, in Novem-
ber of the same year. He had been interested in the proposal to
found a school of art at the university: foreseeing certain advan-
tages in the fact that work there could not be a whole-time
occupation. 'My thirty-two years' experience of teaching in
London', he wrote to the *Morning Post*, 'has led me to the
following conclusion. All study must be composed of the alter-

241

nation of passive and active study. No one is fonder of lectures than I. No sooner do I see the feet of Mr. Roger Fry on the mountains than I scamper, bleating, to sit at them. . . . The atmosphere at the universities, moreover, would not tolerate five days a week painting straight from the shoulder as a complete substitute for thinking. My barber in Camden Town, in reply to my endeavours to wean him from smoking, gave me the following justification: "Well you see sir, it's like this. I am a *heavy* thinker at times. You may believe me or not, I am a *very* heavy thinker. And I find smoking keeps it off me!" '[1]

The following January he gave a series of three lectures at the Royal Institute, which he entitled 'Straws from Cumberland Market': and afterwards repeated them, sometimes condensed into one, at Manchester, Hanley and Southport. They were very briefly reported in the press: but fortunately Mr. Harold Wright took down some notes of the second, which he has allowed me to use. They are so typical of the lecturer's discursive manner and serio-comic matter, wit in the service of common sense, that I have attempted to reconstruct the lecture as follows. The divisions are arbitrary: actually the periods flowed one into another, connected only by a chance word or image, which directed the stream from one tortuous channel to another. Sickert himself was well aware of the disjointed nature of his style. 'I am like a bus-driver', he says elsewhere, 'who is perpetually jumping down to fight some passer-by. I apologize to my fares, climb back on the box, and seize the reins. Bank! Bank! Bank! Charing Cross!'[2]

\*   \*   \*

## Straws from Cumberland Market

He begins by confessing his preference for painters who deal with subjects at the root of existence: and cites as examples, *Morland* (cattle, horses, agriculture): *Keene*, who for a threepenny weekly made drawings that are on a level with the finest in the world. Keene was the first of the moderns. He saw things

EASTER MONDAY—THÉRÈSE

never seen before. He observed the reflected lights in shadows and expressed them by lines drawn in diluted ink. The Impressionist painters were great admirers and students of his work. The painting of trees in sunlight by Monet and Sisley is based on his drawings. Keene's influence on these painters was stronger than Constable's: *Reynolds*, the type of the portrait-painter (Dr. Johnson said, 'Portrait painting is a natural and reasonable consequence of affection'). Such work is not to be ruled out, because it is not produced for solely aesthetic reasons. It also has its origin in a strong purpose. A man that has something to say, something worth the hearing, finds a short way to say it. If one has nothing to say, it is difficult to find an embroidery of words. Pity our so-called refinement, which leads us away from the well of production. 'The proper study of mankind is Man.' '*Quicquid agunt homines*', that is the subject-world of the painter. Refinement, however, has its advantages. Still-life, for instance, arose from the pleasures of the chase and the table. Pictures of the shot pheasant or hare or gathered fruit were conceived to give pleasure to a greedy man, not to prove that the painter belonged to a certain school (they talk of recession, as if every picture has not aimed at recession!). Still-life, like other branches of painting, was interesting when it dealt with things fugitive in nature. The cook was waiting for the pheasant. It becomes dull when the subjects are permanent or arranged, the stuffed bird or the mandolin-cum-journal-cum-pipe.

With Keene he quotes *Rowlandson*'s animated scenes. His people are not ashamed of their surroundings. If you are only to paint 'quite nice' subjects, the field is limited. *Cruikshank*, whose etchings have delicacy, wit and beauty: and *Leech*. The drawings of these men are a living witty commentary on men and manners. There has been an attempt to laugh us out of daring to take any account of wit at all. Then there was *Sullivan*, who drew for *Fun*, not only jokes, but miracles of expression in line. He takes an armchair of American leather and, by a

scribble, produces from it something beautiful. This is one justification for the existence of a realistic draughtsman or painter. Much of the world we live in is becoming hideous. But skill and selection may collocate a part of one ugly thing with a part of another ugly thing and produce a third which is beauty. This beauty, drawn from the seething cauldron of the universe, is of another order. It is found in things that never happened before and will never happen again. It is something new. It is the creative part of the artist's work. . . .

One should have courage to praise people, who do well what one would like to do oneself, especially contemporaries: pointing out what future painting should be, if it is to take hold on the whole world. Such praise is not necessarily fulsome; it may equally well be discriminating. Jack Yeats is doing what I would like to urge young painters to do: painting the life of his own country. Much of our modern landscape has an imported air, and the figures are tucked away in corners. They are seldom DOING SOMETHING in the landscape. Instead, the two elements should be knit together both psychologically and pictorially. The novelists know how to use landscape as part of the things that people feel and do. Yeats' landscapes are solidly constructed and occur behind figures which are active. In his picture *Westerly Wind* there is a jaunting car with a child in it. The centre of focus is the child's inspired little face and golden hair, its eyes full of wonder. Behind it, and seen as though one were looking at the child, is a luminous street scene, an integral part of the whole composition. This is a rare achievement, and represents Yeats' personal conception of the ideal combination of figure and landscape, or landscape with figure as accompaniment. . . .

It is the fashion to sneer at virtuosity. My friend, Mr. Roger Fry, said that it took Degas forty years to get rid of his cleverness: but I think that he himself will take more than forty to get it. Nobody should attempt art, unless he is a virtuoso. There is no place for clumsy people. In these days we no longer believe

in drawing, perspective, architecture. Why? Because we don't wish to believe in them. A horse said, "You can't handicap me." "Why not?" "Because I'm no longer a horse. I'm a hippogriffe!" Barry and Wilson gibed at Reynolds, because he became supple and flexible and polished by his trade. But the medium of oil paint is beautiful in itself. As soon as practitioners make it hideous, the reason for its existence is gone. Every medium has laws and qualities of its own. Ruskin pointed out one, when speaking of economy of means in nature, where vivid colour in one place is withdrawn from another. Economy of means is a sign of the greatest craftsmanship in art. The finest literature is that which expresses most in fewest words, and the greatest paintings express most with the minimum of substance. One of the delights of art is the joy of seeing effect produced with an economy of means. Quality in paint results from a natural gift together with study and practice. These will give a nonchalance, a looseness, a rapidity, which in themselves are of great beauty. A supreme example of this is Hogarth's *Shrimp Girl*, which combines solidity with a tremendous sense of rapidity. Another is Turner's picture of George IV at St. Giles's, which has such beauty as might be suggested by a nosegay of sweet peas. When Cézanne says, "You are only sincere if you did it from nature with sweat and blood from beginning to end on the actual scale", he would abolish nine-tenths of the world's masterpieces. . . .

In one of Kipling's stories there is a painter, or rather an inferior journalist-draughtsman of unsuspected genius. He does one canvas on which his fame rests. That gets burnt, and all evidence of his genius disappears. The story shows a surprising lapse of critical sense. There is no great painter but has given evidence of his genius by innumerable sketches. MASTERPIECES ARE BUT SUMMITS IN A CHAIN OF LOWER ALTITUDES. . . .

There are two ways of painting, both capable of producing beautiful things. The confusion of the two methods, led by Bastien-Lepage and Cézanne, is to be deplored. No doubt it is

hygienic to take pains and brave cold winds. On the other hand, as Sir John Gilbert said to me, 'I like to have my comforts about me.' Certainly a Poussin was not painted in a hurricane. Artists like Velasquez and Rubens painted fragments, which they used later as sketches for larger pictures. The daemonic part of drawing comes in these, not in more deliberate work. The relation of the sketch to the finished picture is this: that if there is not as much life in the picture as in the drawing, there is nothing that will compensate for it. In Tintoretto, where, for instance, the *Miracle of St. Mark* may be compared to the original drawing, the loss is minimised. But there are Pied Pipers among our teachers who are leading the babies of painting over the cliff. Then large *machines* become necessary to expand your want of ideas to a large scale.

The greatest Corots are panels from nature. Constable expressed his real talent in small swift studies. He was the intuitive painter of temperament, not a builder of complicated architectural effects like Gibbon. Another painter who has this gift is Steer. His drawing proceeds from the point of view of a painter. The water colours are a collocation of very precisely felt tones. Drawing arrives from the limits of these tone patches. His superiority is here, that, whenever anything has to be nipped tight, he gets, where it's wanted, the precision of an etcher. That is to be the complete master of a medium. Everything is said that needs to be said; but also, he never opens his mouth, unless he has something to say. . . .

We have no right to ask a painter for an account of his methods. They are made up of three elements, memory, invention and concrete objects. The latter may be merely suggestive. Wilson makes a drawing of a Stilton cheese and a glass of porter. Are they acceptable for a picture? No! Then they become rugged cliffs and a towering castle. The 'object' is used merely for the study of the fall of light. Northcote sneered at Hogarth for his little dolls, but it is a method that has often been used. When it became known that Degas made wax studies for

his horses and dancers, there was a hullabaloo. It is not safe to set up an inquisition and say you mustn't do this or that. . . .

Standing before a picture of a crowd of strikers, containing 100 life-size figures, Degas said to me, '*Oui! je les ai bien comptés. Il y a bien cent. Mais je ne vois pas la foule. On fait une foule avec cinq personnes et pas avec cinquante.*' It is possible to depict the discomfort of a whole row of people by emphasising the discomfort of one. People or things that are in series, like Frith's *Derby Day*, ought to go in portfolios or books. If you are among crowds, you must try to catch the concatenation of movements and so produce the kind of beauty that Indian filigree has. . . .

It is impossible to separate the political economy of painting from art criticism. The question is, whether revival is to be looked for by a struggle to please the *critique d'avant-garde*, or by coming to an understanding with the plain man to furnish some obvious requirements. The *critique d'avant-garde* is rather in the position of the lady who said, '*Je n'aime pas plutôt quelqu'un que je lui préfère un autre.*' Painting should take a lesson from literature where works of art are produced in obedience to ordinary needs. . . .

The tendency of criticism has altered considerably in the last thirty years. In the time of Whistler critics could be divided quite simply, into those who praised you and those who didn't. Painters were indignant if the critic did not accept their own estimate of their qualities. That was not very logical. Criticism is a branch of literature and may be a work of art in itself. It should have the same freedom as the painter claims for himself. The tendency nowadays is towards an overniceness on the part of the critics. It has been said that British criticism is British good nature, and also that we are the most good-natured people in the world. Nowadays the critics approach each picture on the assumption that it is a perfect example of the theory according to which the painter worked. As painters have taken to issuing manifestoes and asserting themselves as holding such and such doctrines, it is not difficult to find out under which flag any one

of them is enrolled. So in each case you get an extremely cour-
teous and well-worded statement of the aesthetics of the par-
ticular exhibit; and, with a slight compliment and a bow, the
critic passes on to the next person, and gives him his sugar
plum wrapped up in the correct doctrine, and everyone is per-
fectly satisfied. This system is a very comfortable one, because
even a large capital is a very small place, and all the people who
are interested in such subjects are liable to meet each other or
each other's wives at dinner: and it is not pleasant to try to eat
soup in the presence of a man whose trade one has crabbed.
But, even from the point of view of log-rolling, the method is
a bad one, because the public is not after all completely idiotic;
and they can see that every picture cannot be a masterpiece, and
that conflicting doctrines cannot all be right at the same
time. . . .

When a man like Sir Charles Holmes, versed in the old
masters and moderns alike, takes to painting himself, on whom
does he found his technique? *Not* on the Bastien-Lepage-
Cézanne method of painting from morning to night in the open
fields on a large canvas. (Our innocents are really being sent to
the slaughter. Why is it imagined that one can learn to paint
only by rushing to Aix, because Cézanne lived there?) *Not* on
Degas, who, though a great draughtsman, was not long enough
in oils to establish methods on which the practice of others
could be founded. Oil paint was indeed to him a mere sport.
The state of his eyes prevented him from continuing the delicate
work he commenced with. So he formed for himself a remark-
able technique. [(*Aside*) I think I should like to keep a school for
forgers!] He used loaded pastel and an enormous spray, and
fixed and refixed over and over again, until he obtained a
quality which has the surface appearance of a cork bath-mat.
The legitimacy of the method must remain an open question,
until time has shown what these pastels are going to do. *Not* on
Monet, who had a very special broken technique, and took for
granted painting from nature. *Not* on Manet, a well-bred

modest gentleman, who discovered, as it were by chance, that there was such a thing as painting, and who was entirely dependent on previous painters, particularly Ribera and Velasquez.

So Holmes chose Millet, learning from him TO REMEMBER IN TRANQUILLITY THE IMPRESSIONS RECEIVED IN EMOTION. . . .

It is wrong to commence a drawing with the 'general idea' of the subject. Is there such a thing as the general idea of anything? Try to imagine the general idea of account-keeping! Begin at a focus which interests you, and work outwards till you bump the edge of the frame. The qualities of the first (tentative) line should be rapidity, decision and freedom from anything that hampers. It should not need 'improving'. This is not the moment to 'show that you can draw'. There is no vice like the vice of rubbing out. That is emetic after good claret! Learn to put down the line and commit yourself to it. You want to SEE your tentative line. A thing you want to correct must at least be there. Put further information around the tentative line, without obliterating it, profiting by what is already there. ACTS OF EXPERIENCE ARE THE RESULT OF BRICK-WALL KNOCKS. . . .

Now concerning the spiritual significance of Greco's legs, this comes from drawing things and following them up. To draw a cobra strangling a tiger, you start from the head and work backwards over the successive coils. Then, will the tail come out right at the end? Being human and fallible, there will be a small coefficient of error at every coil, which in the end becomes enormous. Drawing thus, the greater the number of details which must be searched out on the way, the larger the number of mental operations performed, and thus also of coefficients of error involved. In drawing a map from Shepherd's Bush to the Exchange, if all the small streets must be put in as you go along, the final inaccuracy will be greater than if you are limited to Bayswater Road and Oxford Street. Of course if you start with Shepherd's Bush and the Exchange as accurate fixed points, and work towards the middle from each end, it just

doesn't work at all, when you come to the join. Oxford Circus will have to be left out or become as large as Hyde Park. The truth is, inaccuracy is not a fault in works of art. The handmade Oriental carpet is more beautiful than the correct Birmingham one.

AND SO GRECO'S LEGS GET LONGER AND LONGER. . . .

All these things were inculcated in me when I was twenty-one by Whistler. I have digested them, and believe them to be true, though not because any distinguished man said so. Nevertheless I am very grateful.

<p style="text-align:center">*    *    *</p>

Of the new schools the most important was that which he started in Manchester in January 1925. The idea took shape in the course of conversation with Mr. C. A. Jackson, the picture-dealer, who had already introduced Sickert's work to the North, and who was willing to make the necessary arrangements. Sickert was to travel down on Mondays, take his class in the evening from 6 to 8 and return to London next morning. The membership was limited to thirty. There were models, but, following his well-known prejudice, no nudes. Most of the students had had previous training, but all were keen to learn from their new master. The school continued, with great success, for about a year, only ending with the breakdown in his health in 1926.

Three years later the pupils arranged an exhibition of their work in Manchester, at which Sickert promised to be present. Prevented at the last minute, he sent the following characteristic telegram: 'Sorry I am not well. Very much touched at the kind memories my students have of me. There is something to be said for private enterprise. The dear Jacksons and you and all my pupils are in my grateful thoughts, including the kind man in the lift. Please thank *Manchester Guardian*. I have not forgotten their young art critic who was my pupil.'

The last chapter of the story was the conferring on him, in 1932, of the honorary LL.D. Manchester. Professor J. L.

Stocks, presenting him, said: '. . . His is no abstract art. His studies of popular life in theatre and music-hall, as well as his domestic interiors, show, not merely the vision of the authentic painter, but also the imaginative sympathy that comes only from the deep and loving study of humanity. . . . His breadth and tolerance of mind give to his art criticism a permanent value. His generosity to younger artists and to those less gifted than himself is notorious. . . . His affections are indeed so comprehensive that even picture-dealers are included within its scope. It may be said with confidence that, in all the sea coasts of Bohemia, you will not find so shrewd and adventurous a navigator.'

Again, in London, he had taken a large room, a music-room of Victorian days, in his own neighbourhood, No. 1 Highbury Fields; and the following advertisement appeared in *The Times* of the 13th August 1927.

'Mr. Sickert, A.R.A., will on Oct. 1 open for male students his sixth private SCHOOL OF PAINTING, illustration and engraving, in a studio on the ground floor within the four-mile radius. Division of year into terms will follow existing schools. Fees £20 a year payable in advance. Following the practice of the Paris *ateliers*, Mr. Sickert will draw no fees himself. Vacancies will be filled up in order of application accompanied by fees—Apply by letter only to Southey Villa, 15 Quadrant-road, Essex-road, N. 1. No models will be employed at all.'

With regard to the sex proviso there is a story that one student, evidently from Chelsea, applied in person, not by letter. The door being opened by Sickert himself, the student explained his mission. There was a pause, and another look. Then: 'But . . . excuse me . . . are you a male or a female!'

When the day came it was found that the applicants had been no more than six or seven, in itself a curious commentary on London art, or at least the male half of it. Imagine, if you can, an *atelier* opened in Paris by Degas at the age of sixty-seven! They included Mark Oliver, Lord Methuen, Morland Lewis and myself.

When we arrived we found in progress the demolition of a tree which gave umbrage to the professor and the windows. Sickert was watching the men at work, his head swathed in a bandage. 'My wife says I'm suffering from a swelled head! . . . but really, I'll tell you, it's a boil . . . very annoying . . . I can't have my bathe in the morning. You're not allowed to suppurate into the public baths!'

When the tree-cutters had finished, they were invited in for refreshment, in the shape of a bottle of champagne, hurriedly sent out for at 11 o'clock in the morning. Besides this they received a short humorous lecture on Raphael's *Heliodorus*, a print of which hung on the wall; and went off, highly gratified though a little fogged. The skeleton of the banquet remained for several weeks on a small table by the window and served as the subject for my first still-life. The dust descended on it like snow; flies went to a sweet and drunken death at the bottom of the bottle; but still I painted on. It was a good object lesson on the disadvantages of painting from nature. Sickert contributed the title, the CHIEF CLERK'S BIRTHDAY.

But most of the time we sat in a semi-circle round the fire and listened to the professor talk. It went on for hours. But it was never too much. When everything had been said, we were allowed to work. Drawings had to be done out of school, or we could use *Daily Mirror* photographs. We were taught to square them up and make underpaintings (*camaïeux*) from them in white and two tones of blue. The more canvases we had on the stocks at the same time the better, as they had more time to dry. Sickert came in every morning in a different hat. After going the rounds, he settled down by the fire with a Manilla and the whole of the Metropolitan press. Little by little he came less often. The students drifted away. The school came to an end by a process of evaporation.

# THE CRITIC IN THE DOCK

After the honours which came to Sickert from the Royal Societies and seats of learning, he was conceded another, the real test of an artist's fame, rising prices at Christie's. His own talents cannot be given much of the credit for this, since those had already been long hung out on the line, without much reward. The boom on the Stock-market helped. But without doubt the efficient cause was the faith in him of one dealer, R. E. A. Wilson of the Savile Gallery. So long as Wilson worked alone, this faith was without works, at any rate on a big scale. But he had the gift—no matter if it was only a dealer's gift—of imparting his faith to others: and in particular to Mark Oliver, with whom he went into partnership in 1927. The new Savile Gallery started operations with greatly extended resources, and, besides dealing in old masters, supported the Sickert market, both privately and at auction, to the limit. The result was a minor boom in his work, culminating in the bid of 660 guineas for a portrait of Cicely (Mrs. Tatlock) at the sale of Sir Michael Sadler's pictures at Christie's in December 1928. Exhibitions were held, first in Stratford Place and then in Bruton Street. All his new work, including the *Echoes*, which they at first welcomed, and then, finding the public diffident, discouraged, as well as many of his best early pictures, passed through their hands.

Since the Savile Gallery went out of business at the time of

the great depression, the boom has not been repeated: but several London galleries have kept up the support of his market in a milder degree.

Sickert's personal relations with dealers have always been cordial. He has relied on them almost entirely for the sale of his pictures, holding that it is not the business of the painter to distract himself from his job by private transactions. And they on their side have supported him loyally, often advancing him money in advance of deliveries. The truth is that the English dealers, doing most of their business in modern pictures on commission, have not the *flair* of their French colleagues for large-scale operations or world-wide advertising campaigns.

But Sickert is quite content with his market as it is. His opinions of the international manipulations of the dealers in post-Impressionism, compared, say, with those of Durand-Ruel's support of the Impressionists, and incidentally at one time of himself, show well enough where his sympathies lie. The health of his market has a direct influence on the health of a painter's work. The important thing is to avoid excess in either direction.

<p style="text-align:center">*     *     *</p>

Of the three categories of people, with whom the painter has most to do professionally, the public is the most elusive. What is the public? There is the public to which the artist, being 'different', is just news, the more sensational or scandalous the better. These people do not look at pictures at all. There is the public that goes to the Academy and other galleries as a social or intellectual duty. In England these are very numerous and important. They have great influence on certain branches of painting, such as portraiture. We have seen what Sickert thinks of them. And finally there is the public that buys, though even here we have to distinguish between those who buy for snobbish or speculative reasons and those who buy for love. There are enough of the last, however, to support any painter who knows his job and is willing to do things that people want, not only to

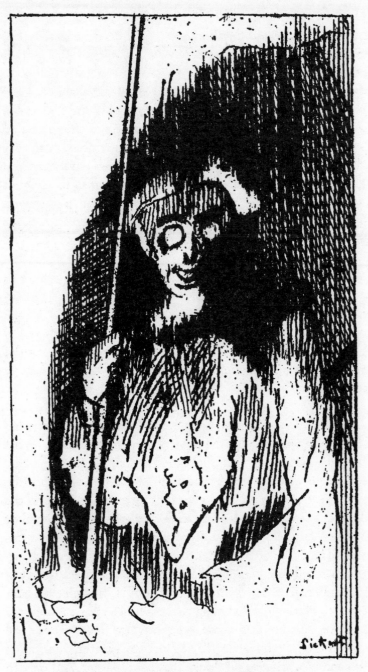

VISION, VOLUMES AND RECESSION—
ROGER FRY LECTURING

express himself or his ideas. This is a string on which he harps again and again. It is the basis of his preference for 'Academic' to 'advanced' art. In a note on the paintings of Mr. Frank Salisbury he says, 'His efficiency and his power of work is important to recognize in a period when the experimental in painting holds the attention of most journalists. I value Mr. Salisbury as one who has done nothing to widen the gap between the painter and the average taste of the public. Mr. Salisbury is doing a real service to all painters, by reminding the public that all painters are, not, truculently, and of set purpose, unemployable.'[1]

Unfortunately the number of real picture-lovers is limited in various ways. It is not to everyone that it is given to learn the language of art. Speaking of those who have and those who have not this power, he says:

'There are persons born with a natural gift for reading this language, persons to whom it speaks clearly, intelligently and profoundly. I am not now speaking of artists. . . . I have noticed that the language of art has a meaning for men and very little for women. This is almost a truism, and only another way of stating the fact that the male mind deals willingly with, and is naturally at home in, abstract ideas, while the female mind, fortunately for the race, is entirely concentrated on positive and personal and immediate considerations. Women are interested in art when it ministers to their vanity, as in the flattering portrait. . . . They are interested in landscape that represents scenes where they would like to be. They are interested in optimistic presentations of life, in which the figures represented are given sympathetic parts; but the language of art is not one they read naturally or willingly, or of themselves. They may be made free of that language, and learn to read it through sympathy with a man who understands it. The marriage of true minds may give a woman the key to some of the mansions of art, just as it may give a man the key to some notions of economy and commonsense, and to the thousand and one short views that it is so vital he should understand in this dangerous and makeshift life.

'Then again I think the language of art is one that is not often legible to young men for two reasons. The one is that life itself is too interesting and absorbing to young men to leave many blank pages on which the artist may write. The other is that the appreciation of art is a matter of long preparation, of many preludes. . . . There is no *coup de foudre* in the understanding of art, no love at first sight. . . .

'The whole of art is one long roll of revelation, and it is revealed only to those whose minds are to some extent what Horace, speaking of a woman whose heart is free, calls vacant. It is not for those whose minds are muddied with the dirt of politics, or heated with the vulgar clatter of society.

'We are fond in England of talking of "refinement", and by refinement we do not at all mean what the French mean when they say *raffinement*. The word refinement, as currently used in England, stands, I believe, for a highly cultivated capacity for suffering acutely from noise, from the smell of inferior tobacco, from inferior clothes, from inferior cooking, worst of all perhaps from inferior service. . . . With this goes, in the region of taste an utter impossibility of living for twenty-four hours in a room with the "wrong" wallpaper, and as a corollary of the wallpaper, a mild liking for inoffensive and slight water-colours in the "right" mounts and framed in the "right" way. For guidance in these matters we rely entirely on *snobisme*, on the hope to secure the tip from the "right" tipster. The refined are perhaps further from art, who is a robust and racy wench, than any class.'[2]

\*      \*      \*

With dealers and public Sickert has dealt only incidentally in his writings. With the critics he has been more or less at loggerheads for the whole of a long life.

'Of painters and critics,' he says, 'my imagination has sometimes vaguely called up a vision. I seemed to see a lumbering, inarticulate, and good-natured tribe of elephants going about their business or their pleasures, with the deliberation we

know. On their heavy heads and narrow backs are seated a voluble tribe of marmosets; I see these dressed in a sort of fancy Zouave costume (probably a reminiscence of a circus I saw in Munich in the early 60's), with little purple caps braided with gold. Some of these little beasts seem clever and alert, while others are either cross or indifferent. But all are voluble, and all are making gestures, which show that they conceive themselves to be directing the movements of the elephants, sometimes with threatening, but more often with gestures of grieved reproach. At a given moment one of the elephants draws the attention of his companions to the existence of their little stowaways. With a heavy gesture each elephant, without stopping in his course, swings his trunk aloft, and picking each little dead-head gently up by the ample seat of his baggy breeches, deposits him, ever so gently, on the ground, and, trumpeting loudly, gallops away. It has always been with me, as the Germans say, a long-in-silence-cherished wish to be that elephant.

'There was a delicious fellow in the music halls some years ago, whose mature and sympathetic figure was tightly encased in the classic uniform of the page-boy in buttons. He was wont to complain to the audience of the stinginess and cruelty of his mistress. "One of these days, I shall cheek her, I know I shall! I shall say . . . I shall say . . . Oh! is it indeed, mum?!" He would go on to relate how she would send him round the cab-stands to pick up oats for her chickens. "Let her do her own oating!" he would rap out, in a terrified aside.

'*Réflexion faite*, why should not we all do our own oating? I have in the press at present a work, which will shortly appear, on the lines of "Every man his own Lawyer", to be entitled "Every man his own Berenson." '[3]

The critics for their part must feel that he has been really rather ungrateful, because, on the whole, they have been very kind and indulgent, even when he was most provoking. But he never complained of what they said or did not say about his own

work. There was the lady critic who once asked him what he would like her to say about his work in the papers for which she was writing. 'Say, madam,' he replied, 'for once, what you yourself think.'[4] On the other hand, there was the honest critic who apologised, 'I had to say what I thought, you know'; to whom Sickert: 'It wasn't your saying what you thought that anyone would complain of, but of your thinking what you said.' They have been kind, but it has been of that kindness that does little more than damn with faint praise. The truth is that they have never quite known how to deal with him. They have to acknowledge him as a painter, but they cannot fit him into the main pattern of twentieth-century art, as they have conceived it. For the critic, the revolutionary, the 'some new thing', is the best copy. The past, and especially the recent past is thrown aside. It is out of fashion, dreadful crime, and chiefly useful for invidious comparisons with the urgent now. In answer to which habit of theirs Sickert would beg 'the superficial persons, to whom the art columns of the newspapers are generally entrusted, to revise their attitude as follows: you are not to consider that every new and personal beauty in art abrogates past achievement like an act of Parliament does preceding ones, or that it is hostile to the past. You are to consider these beauties, these innovations, as enrichments, as variations, as additions to an existing family. How barbarous you would seem if you were unable to bestow your admiration and affection on a fascinating child in the nursery, without at once finding yourself compelled to rush down-stairs and cut its mother's throat and stifle its grandmother! These ladies may still have their uses. You are much too officious and hasty.'[5]

In the early days of the New English Art Club and Camden Town Group Sickert had no lack of notice. Since then, unable to classify him as either academic or revolutionary, there has been no alternative but to treat him as a minor old master, a relic of the past, revered—but superseded. The post-Fry criticism has so compromised itself with the fashion of Cézanne

and post-Impressionism that all other modern painting whatever seems slightly irrelevant. Subject interest, *a fortiori* story-telling, in pictures is considered not only unimportant but impertinent. The fact that Sickert obstinately insists in being literary is another reason for dating him; when his pictures are obviously distinct from anything in the past, it is put down to eccentricity or mere naughtiness.

Sickert lays his finger on the true relation of subject to treatment in one of the most profound and illuminating passages in his writings.

'Since the "night of time" criticism has set in opposition the words "subject" and "treatment". Is it not possible that this antithesis is meaningless, that the two things are one, and that an idea does not exist apart from its exact expression! Pictures, like streets and persons, have to have names to distinguish them. But their names are not definitions of them. . . . If the names we give pictures were indeed their subjects, there would have been need of but one picture in the world entitled "Madonna and Child". The subject is something much more precise and much more intimate than the loose title that is equally applicable to a thousand different canvases. The real subject of a picture or a drawing is the plastic facts it succeeds in expressing; and all the world of pathos, of poetry, of sentiment that it succeeds in conveying, is conveyed by means of the plastic facts expressed, by the suggestion of the three dimensions of space, the suggestion of weight, the prelude or the refrain of movement, the promise of movement to come, or the echo of movement past. IF THE SUBJECT OF A PICTURE COULD BE STATED IN WORDS, THERE HAD BEEN NO NEED TO PAINT IT.'[6]

Sickert's whole contention is that the subjects of too many modern pictures *can* be stated in words, and *are* so stated. The picture itself adds but little to them. This is the core of his quarrel with Fry and his followers, that they have so gone to bed with Theory, that the poor pictures don't stand a chance except they please the mistress. 'Subject', he says, 'is the

lynch-pin of the picture, and if the subject remains the secret of
the artist, or of the chosen interviewer he slaps on the back, the
apple-cart is upset.'[7]

Sickert and Fry were friends from the early days and struggles
of the New English Art Club. They remained so later, when
their critical ways had parted. At home they waved to each
other cheerily from opposite sides of the fence. Only on the
hustings were they at daggers drawn. Each had praise from the
other for his own painting. Fry particularly, as we have seen
already, wrote a review of the Stafford Gallery exhibition in
1911, which is remarkable for its generous breadth of apprecia-
tion from an opponent (see Chapter XI). It is true that he later
abated some of the warmth of his enthusiasm, for in the course
of a review of an exhibition of Sickert's etchings in 1925 he
wrote: 'On the whole this exhibition makes me wish that with
all those years spent in France Sickert had picked up a little of
French seriousness to correct the frivolity of the English tradi-
tion as Whistler professed it. I wish he were not so anxious to
pretend that this business of art is all a joke. . . . But every-
thing about Walter Sickert has to have the same air of paradox.
He is so ingrainedly *frondeur* that, since his wit, his talent
and, above all, his taste, makes him the natural associate of the
"libertarians", he has by sheer cussedness been driven to be-
come the advocate of Prussian discipline, of meaningless dex-
terity and of Victorian sentimentality, and is thereby eternally
condemned to practise no single one of the virtues he preaches.'
Which only shows what muddled thinking may arise when he
is looked at through the age-old spectacles of English puritan-
ism.

On his part Sickert wrote encouragingly of Fry's own pic-
tures; and, since these were dearer to him than his critical
works, this must have taken some of the sting from Sickert's
attacks on the latter. Fry did not underrate his adversary even
on his own ground. 'What an art critic he could be!' he once
said to Blanche. But to Sickert criticism meant something

different than it did to Fry, who found himself bound to the chariot-wheels, which he himself had set in motion. The scientific element in Fry's outlook was repugnant to him. He held no theories of art, to which pictures must accommodate themselves—or be damned. A painting was judged by the pleasure it gave to the eye, not to the understanding. He remained fixed in the belief that it should tell a story, and that its success as a picture depended on how good the story and how well it was told.

In those days (in these also for that matter) there were others, as well as Fry, who combined the functions of painter and critic: D. S. MacColl for instance, Maurice Denis—and himself.

'It is sometimes necessary', he wrote, 'to separate clearly the two personalities of that strange occasional compound, the writer-painter, or painter-writer. In Venice a soup of rice and green peas is called *risi-bisi* or *bisi-risi* according as the rice or the peas predominate. If this soup has stood, and is thick, the compound is described as *massa fissa*, "very stodgy" shall we translate it? Mr. Steer, who has the rare faculty of putting a witty and silent finger, like the advertisement, on the spot, with deadly certainty, none the less deadly for that he, wise man, elects to diagnose *in camera*, is suggesting the instant formation of a society of writer-painters, or painter-writers, in which no one shall be allowed to exhibit but journalists. I once heard a prudent Norman give, as a reason for not interfering between two dogs who were fighting on the route d'Eu: *"Qué que vous voulez? Ils s'entre-déchireront: puis l'affaire sera faite."* '8

D. S. MacColl had been a keen soldier in the battles of the 90's, and his influence on English painting, or at least on the appreciation of English painters, had been considerable, especially after his appointment to the Tate Gallery. He took sides openly and strongly against Fry and the post-Impressionists, and so might have been expected to support Sickert in later, as he had in earlier, years. That he did not do so seems to have been

due to a personal bias for the poetry rather than the prose of painting. For MacColl, Steer remained supreme among contemporary English painters. He was always faithful to the New English Art Club, and could not forgive Sickert for his desertion to other standards. He justified his criticism of the other's work by holding, rather strangely, that he could not draw. On the other hand the two men kept a strong mutual regard for each other, both as individuals and critics. MacColl has confessed so much to me personally, and on his part Sickert wrote to his friend from Dieppe:

*March* 1922.

MY DEAR MacCOLL,

You are certainly an awkward opponent. I shall be careful of rattling a stick against the bars of your cage any time. . . . Since I saw you I came across a number of your articles which Miss Gosse had cut out of the *Saturday Review* and kept. They seemed to me extraordinarily good criticism. Not only because they over and over again took exactly the line I should wish to have taken. You must have been amused to hear me express several opinions which you had already printed. The line about the Luxembourg, etc. and of course the Maris was nuts to me. . . . Yrs. W. S.

There were other subjects on which they had to agree to differ. Sickert for instance could have no sympathy for the other's interest in the Chantrey bequest or any other public subsidy to living artists. Under the heading of 'Soup-kitchens or Trade' he says:

'Painters being, on the whole, more childish than other men, show a more than usual simplicity when they think the future of the art of a country depends on the administration of a certain tiny fund which is able to buy—is it half-a-dozen pictures at the utmost a year? This fund, moreover, is so conceived and so administered that the purchases made by means of it tend to be exhibition pictures; that is to say, works produced for that

special purpose and entirely divorced from the main intentions of artistic utility, which is the decoration of rooms. These pictures must, moreover, be bought, as it were, still-born, before time and the market have had their winnowing say in sifting vital from dead work.'

After describing certain pictures (none larger than 24 × 20) which had come up for sale and made good prices at Christie's, he goes on:

'That is where all the soup-kitchen schemes for the encouragement of art are amiss. None of these pictures would have been bought by any trustee of Chantrey bequests or anything of the kind. No modern expert would recommend works of a similar character by living painters to a committee or a private patron. He would not be considered to have earned his money or done justice to his reputation for perspicacity with any canvas under five or six feet. The pictures I have named are great pictures but would hardly lend themselves to inflated journalistic comment as noble works. . . .

'The winners of the lucky-bag prize competitions awarded by the experts are often in the long run the most to be pitied. They have only learnt to produce an article of which they may perhaps sell one in a lifetime. They have learnt to value it at ten times what it would fetch at Christie's, and to build their existence on that valuation. They have meanwhile not learnt to paint pictures for rooms, and time is going on. Nor have they, as the Impressionists did, formed a little connection of ten-pound customers who believe in them and come again.'[9]

Sickert was almost as shy of curators as he was of critics: but it was no pleasure to him to have to oppose old friends. On one occasion, when he felt bound to do so, he ended the letter to Tonks in which he explained his position with the post-script, 'the nuisance is I am fond of MacColl'.

In the same spirit, defending himself against the imputation of unfriendliness, this time to Tonks himself, he wrote:

'My dear Tonks,

'Among the many recollections I have of you one will always stand out in my memory. I can see you standing in Augustus Street looking up at the window of Grimbles factory, where you had come to find me, under the impression that a very amusing caricature (one of my most treasured possessions —*La main noire*) you had done might have offended me.

'Exactly in the same spirit you would always find me looking up at your window. . . .

'I am much touched by your letter. The kind things you say in it about our intellectual relations will remain, with things of the same kind you have said in past years, among achievements I really value. But all that has been give and take. Contemporary friends and colleagues serve each other, as we used to learn in the Latin Grammar, in the function of whetstones. One hand washes the other, as the Germans say, and I am all against amputations, were it only from motives of intellectual selfishness. But with you, as you know, that is not all. . . .

'I know I have a certain German quality, which is called in German *sächlich*—devoted to things, ideas, etc.—to the possible disadvantage of people. When I see my article—my thread of argument—I certainly do not mitigate it by thinking that my best friends may not like it, may not agree with it. When you are drawing from a model you couldn't possibly be hampered by any thought as to whether the model would like the drawing. Something of the kind is perhaps a fault of mine. . . .'

But if there was one category of writers on art that roused his venom even more than the critics, it was the experts, of whom he took as his scapegoat Mr. Bernard Berenson: Mr. Berenson who, 'after making us feel small and breaking our heads for years with his 'inis and 'iccios, has come down heavily and imprudently into the field of modern art, and plumped for Matisse, carrying with him deeply-moved spinsters, who had never heard of Monet, and breathless dowagers to whom Degas was as nought! None of them knew, I'll bet, how relieved were

those of us, including the present writer, who had hitherto cherished modest and chilly doubts as to the sufficient length and weight of our kilt of culture, when we saw Berenson prone and bare on the field of modern art, revealing deficiencies we had long suspected, but dared not hint at! Ouf! There is one at least whose works I shall not have to read!'[10] . . .

Stendhal, in his life of Rossini, quotes a modern citizen, who felt himself obliged to ask an expert: 'Monsieur, est-ce que j'éprouve du plaisir?' And it was an expert who moved Sickert to one of his few flights of verse:

*To* P. W. STEER        1 5 *Fitzroy St. W.* 1.

### LINES TO AN EXPERT

*If he proves a simple codger,*
*Unload Steer, and load up Roger!*
*And he'll like you all the better if you do!*
*For Rogers you may trust in,*
*Though the Cézanne boom be bustin',*
*And he'll like you all the better if you do!*

W. S.

\*         \*         \*

Since Sickert has himself wielded a critical pen to so much purpose in the daily, weekly and monthly press, it is natural to enquire how his criticism differs from that which he at times lambasts so unmercifully. Why indeed write at all, if the critic is always such a parasite? The answer is that he couldn't help it. He did not write regularly, nor about everyone. But when he saw beauty neglected or nonsense praised, his fingers began to itch and could not rest till they had had their scratch. He had a fluent and telling style and he liked to use it. Writing, like speaking, was a natural function of his mind, and the free use of all its functions is a matter of enjoyment to any animal. It was never allowed to interfere with his painting, but his experience and great knowledge give authority to whatever he writes. An incurable flippancy, which he advocated as a virtue to his more

269

serious students, constantly peeps forth, making his essays easy
to read, as a pretty woman is said to be easy to look at. Only
occasionally does it lead him into real naughtiness.

As I have said before, and shall say again, Sickert held no *parti-
pris* which admitted certain artists within the charmed circle
and denied others. He flung wide the net of his affections over
all times and schools. He was accustomed to derive as much
pleasure from paintings by anonymous or little-known authors
as from those of the greatest masters. He shared with Keene
a certain relish for *bad* pictures. At the same time his criticism
was not just a matter of 'that's your meat, this is mine'. The
qualities which he sought for and loved in others were those
which he applied in his own work. All his training, all his
native wit, taught him that there was nothing abstruse about
the art of painting. Instead of abracadabra, it was just plain
A.B.C. and the plainer the better. Pictures were painted for
the enjoyment of ordinary people; so, as a spectator, Sickert
put himself behind the spectacles of the ordinary man. Indeed he
was the ordinary man, with just that extra grip of self-confi-
dence, which real knowledge gives. The chief difficulty which
confronts the lay picture-lover to-day is that he is required to
understand a painting before he can enjoy it. Usually, and
rightly, he does not get beyond the premise. So many pictures
are painted to prove what so-and-so has written about such-and-
such, and not because someone might like to hang them on their
walls. Sickert, on the other hand, held that pictures should
explain themselves, leaving the spectator free to enjoy the
qualities of artistry and craftsmanship employed. 'Art', he said
in the 90's, 'is produced for lay consumption, and if it fails to
be lucid, it fails of its first function.'[11] And twenty years later,
'Painting, like speaking, is a form of expression, and a speaker
who is incomprehensible cannot be said to speak at all.'[12] After
thirty more years he is still saying the same.

Lucidity itself can be given added force, by economy. The
last quotation continues:

THE CRITIC IN THE DOCK

'I was standing with a Frenchman on the sea-front at Dieppe when we witnessed the meeting and parting of two early-Edwardian grass-widows that we both knew. We also knew that it was the first time that they had met that season, and that they were fast friends. They passed each other hurriedly. The bells at the hotels had rung for luncheon. They nodded cordially, and their dialogue was compact, but, to me, quite lucid. "Going strong?" said one. "Full of beans" was the reply, and the incident closed. My friend asked me to translate. *"Madame X"*, I said, *"a dit, ça va fortement?" et Madame Y a répondu, "remplie de haricots"*. *"Mais quoi? comment? Remplie de haricots!"*

'I gave my friend the necessary explanation, which the reader can imagine. That Mrs. X, having suppressed, as we wisely do in England, what Casanova calls *"les compliments d'usage"*, had meant to convey that she was glad to see that Mrs. Y had arrived for the season. That she hoped Mrs. Y and family were well. That she hoped to see something of her. That she supposed she had been playing at the Casino. That she hoped that she had not lost much. Mrs. Y, I further explained, by "full of beans" meant to convey that she and her family were quite well. That they were staying at the Bains. That she was in a hurry, as the luncheon bell had just rung and she had to change. That she had been, as Mrs. X supposed, playing *petits chevaux*. That, though she had lost a few francs she was playing on an infallible system. That she supposed she would see Mrs. X at the Gymkhana on the links that afternoon. . . . Each held the clue to the other's code, and I, lucky man, to that of both. If any of us three had needed a pamphlet to explain the conversation we should have to consider the symbolism of these ladies a failure.'[13]

But Sickert's chief contribution to the literature of art is his remarks on technique, written from the point of view of the craftsman.

'The draughtsman has not yet been found', he says, 'to formulate the canons of art, but they exist for all that, and from time to time one facet or the other has been comprehended and

expressed in words. A jobbing painter has naturally not the time to study much of what has been written on his craft. I have formed the impression, so far as my very limited opportunities for study have gone, that nothing of any value has been written on our art by writers not themselves craftsmen. I am convinced that it is impossible to approach art-criticism except from the core, from the material and its nature, outwards to its resulting message and to a consideration of the aims and effects moral, social, political, aesthetic or sentimental, of the work. . . . When I am writing on these subjects I believe my only claim to utility is that I know myself to be quite incapable, by want of training as a student and a writer, of authoritative synthesis. I therefore limit myself to a rôle that may be defined as the craftsman as witness.'[14]

Oil paint is a medium having its own laws, which depend on qualities inherent in it and which cannot be altered to suit the fancy of the painter. To know these laws and obey them is his first duty, failure in which will wreck his whole subsequent practice. Thus Sickert's first judgment on any artist is a judgment of his technique. Only then will he pass on to the larger question of whether the man has anything to say worth saying.

He has a large measure of sympathy with the man who 'knows what he likes'. By experience, and with an occasional help of the hand, he may come to a better and better appreciation of the qualities of the great painters: as he, who likes only what the books allow him to, will never do. When Sickert writes about a picture that he loves, he does not ask himself why he loves it. The form of his words is rather a song of victory or a shout of pleasure: as if to say, 'Come and see what *I* have found!'

Such was his essay on:

### THE POLISH RIDER.

'London! Like the evening star, you bring me everything. From the other end of nowhere Rembrandt's son rides for a few

weeks through the West End, on the white horse, debonair, to an early death, one of the perfect masterpieces of the world.

'I remember an illustration in the *Fliegende Blätter* in the early sixties in which was depicted a little girl guiding her blind grandmother. Finding the road rather even, and therefore tedious, the child from time to time feigned an obstacle, a brick or a stone, and said, "Granny, jump," which the old lady obediently did. When someone remonstrated with the child, she answered, "My grandmother is mine; I may do what I choose with her."

'And this, gentlemen of the press, curators, critics, experts, and others, is the claim we painters make in regard to the old masters. They are ours, not yours. We have their blood in our veins. We are their heirs, executors, assigns, trustees. We are pious sons, but henceforth it is we who are the interpreters of their wishes, with full power to set them aside and substitute our own, whenever and wherever it seems fit for us to do so. . . .

'The painter generally likes pictures *quâ* pictures. Charles Keene, sitting over one of the last little fires that warmed him in the Hammersmith Road, confided to me, with one of his immortal winks, "Ye know, I like bad pictures. But don't tell Jimmy." And if we like bad pictures, sometimes, we know the faults of the great pictures quite well, intimately. But we love them none the less for that, rather the more, as a man might a mistress for her freckles. But if we may say she is freckled, you mustn't, or we shall call you out.

'In skill and power this painting reaches backward to the primitives for severity and purity, and forward to certain modern developments in colour, to a certain *bravura* and *furia* of fluent and spirited execution. How all good painters speak the same language! Turner in his Calais Pier, Delacroix, Décamps, Géricault, Courbet speak this same language of paint. The whole landscape is full of Courbet. Look at the execution of the horse's head, the exquisite looseness of touch and firm-

ness of intention. Look at the amazing welding, in one fluent impasto with the low-toned cool white, of touches, mere flicks of porphyry and moss-green, here a hint of black and there a touch—a touch like a spark that is come and is gone—of red. . . .

'To revert to the subject of flaws in the beloved. No Rembrandt is quite Rembrandt without, somewhere, an unexpected bit of drawing that is a little stumpy, and squarer than one expects. A personal note shown to excess in his worst etching— a man in a felt hat by the bottom banister of a stair-case with a knob. I see this trait in the knee of the Polish Rider—just enough to be, not a flaw, but an added emphasis on the signature.'[15]

'London, like the evening star, you bring me everything.' How many readers know why the evening star? I for one certainly would not have done, had I not found an early picture of Sickert's, a little girl playing with a goat in a field, painted about 1904, with a Greek inscription:

$$\text{Έσπερε, πάντα φέρων . . .}$$
$$\text{φέρεις οἶν, φέρεις αἶγα, φέρεις ματέρι παῖδα.}$$

which proved to be a fragment from Sappho and is translated:

'Evening Star, you bring everything, you bring the wine, you bring the goat home, you bring the child to its mother'; a lovely thing, which must have impressed itself deeply on his imagination and memory.

Or take this on Turner:

'The rising generation of students knows very well that the drawing of landscapes or inanimate objects, by artists who are not accomplished draughtsmen of the figure, must always remain on an inferior plane. A paling or a post is drawn quite differently by a man who can draw the figure, than by one who is obliged to limit his representations to posts and palings. It cannot be too often remembered that Turner was an accomplished draughtsman and painter of the figure. His portrait as a young man was sufficient to prove it, if we had not as well the

magnificent *dramatis personae* in the picture of *Calais Harbour*. His figure drawing is not merely correct; it is vividly and eloquently dramatic and expressive. Look at the parallel sturdy backs of the two fishermen in night-caps, retaining a perpendicular seat while their boat is at an angle of $45°$; at the lady in the thin white empire dress that the wind is moulding to her plump figure; at the officer in the cocked hat; and at the old sailor furiously gesticulating in the Frenchest of French gestures his request, made inaudible by the wind, for the filling of the bottle he has got on board with Calvados or *fil à quatre* . . .[16]

'Imagine Turner living in these days. Can we see him swopping horses once a month at the bidding of Mr. Fry or Mr. Clive Bell or Mr. Rutter or myself? The born artist is, providentially, a thick-skinned and sturdy brute. . . . We all know the story of Turner's leaving a hospitable house, where a band of colleagues had passed a delightful evening in aesthetic discussion, distinguishing themselves by the subtlety, the ingenuity and the eloquence of their contentions. Turner alone had remained dumb. Stepping out into the night, he sniffed the air and produced this, his tardy and only contribution to the symposium, "Rummy thing, painting!" '[17]

Or this on Ingres:

'In Ingres we come to the modern who proves the oneness of past and present. I might have seen him, for he died within my lifetime, so near is he, and yet he ranks in achievement with the great masters of all time. For we have now come to the modern who was not the sketcher, but the painter of pictures. At the age of twenty-five he had painted the portrait of Madame Rivière, one of the great paintings of the world. So slack, so sentimental, so impatient have we become that the mere momentary contemplation of such intellectual wealth, such patience, such ingenuity is to us a greater fatigue than were to him their constant exercise. He humiliates and crushes us, and drives us to a defence consisting of theories of negation. "We have got past that", we say, holding out empty hands. We are

embarrassed and annihilated in such noble company, and long for the comparative flattery of mediocrity. . . .

'For all this the path of classic effort is neither a hidden nor mysterious one. It moves from careful step to careful step, and cumulates by what is little more than sublimated common-sense. Since a suave and beautiful execution must needs be slow, careful and laborious, and since the life to be suggested by the work is in its essence fleeting, it is clear that the execution of a picture and the impression received from nature must be separated. The part that is played in the work of Ingres by painting from nature is a small one. Some painted studies we have, but few. He must have felt how heavy-handed was the brush charged with its sticky burden, compared to the point. And the point has this above the brush. Since nature is essentially alive, the pulsation of two or more variants is legible through the openness of a drawing, where one version of a painted study must needs efface the other. . . .

'What is the secret of a great painting? A great painting happens when a master of the craft is talking to you about something that interests him. In the case of Ingres the thing that interests him is sometimes divinely lovely in itself, and sometimes it is fustian. But the quality of art is such that it transmutes whatever it touches to favour and to prettiness. Let us imagine that the scene depicted in the Odalisque did ever in its total reality exist, as Madame Rivière did, in her shawl, most certainly twist and wreathe her adorable person; in what does the painting by Ingres differ from a plate of colour photography? First in this, that all dross, external to what has interested the painter, has been fired out. Then that each line and each volume has been subtly and unconsciously extended here and contracted there, as the narrator is swayed by his passion, his rhetoric. The drawing has become a living thing with a life, with a debit and credit of its own. What it has borrowed here, it may, or may not, as it pleases, pay back there. And further, the following compromise has, from the necessity of the case, to be

set up, and it, the very compromise itself, is the creation of the beauty of colour in a picture. Nature having the range of all colours, plus the range from light to shade, can set this double range against the painter's single range of colours in a uniform light. So the great painters of the world have in their traditional cunning hit upon the plan of attenuating, as they cannot but do, the light and shade of their pictures, and paying us back by drenching each tone with as much of the wine of colour as it will hold, without contradicting the light and shade.

'The light in the *Odalisque* is a light that never was on land or sea, but a kind of sublimated illumination, where nothing is dark and nothing glitters, but all is saturated with colour to the $n^{th}$ degree.

'The story of the angry Delacroix enthusiast is a chestnut, but a French chestnut. It cannot too often be told. In the *Entry*, I think, some *Entry*, one of his numerous and generally prancing *Entries* of either Sardanapalus, or the plague, or Caracalla, or Severus, or Commodus, or Incommodus, there is an old man at the side, I can see him now, around whose haggard and bistred trunk has raged, and will ever rage, to the end of time, what is called a controversy. Some maintain that the pest-stricken, triumphant, conquered, converted or convicted (as the case may be) old man shows to the spectators his back, and some his front. The battle raged, of shoulder blades versus pectorals, until they called in one of those epileptic and uncompromising enthusiasts, to whom the head of Charles I is not only meat and drink, but board and lodging and reach-me-down in one. "Which is it, you who are the greatest and most faithful of the master's admirers; back or front?" To which the enthusiast: "*Monsieur, ce n'est ni l'un ni l'autre. C'est de la PEINTURE!*" '[18]

## CHAPTER XX

# LIFE IN THE COUNTRY

❧

In the summer of 1934 Sickert and his wife went to Margate for the holidays. But all days are holidays for the painter who loves his trade; so it was not long before he had taken a studio there and begun to work. He also gave lectures on art at Margate College, and for about eight weeks went every Friday to teach at the Thanet School of Art.

They liked the district so much that they decided to leave London and make their home there. At Christmas of the same year they moved down to a pleasant house at St. Peter's-in-Thanet near Broadstairs. It had a charming garden and out-buildings, once stables, but now used as a studio. The only light came from a small window high up near the ceiling, which might have been considered a disadvantage. But Sickert had been accustomed all his life to work by artificial light after the end of the day (in our climate it is almost a necessity); and a two hundred candle-power sun in the room has the advantage of not going in and out, nor round the corner of the building opposite just when it is most needed.

At first he was working chiefly on portraits. Sir James Dunn had commissioned no less than five, some of which had been started in London. Then there were those of Lord Beaverbrook, Lord Castlerosse, Miss Marie Tempest, and many others. He was also continuing the series of Echoes and theatre subjects, as well as views of his garden and Broadstairs and domestic in-

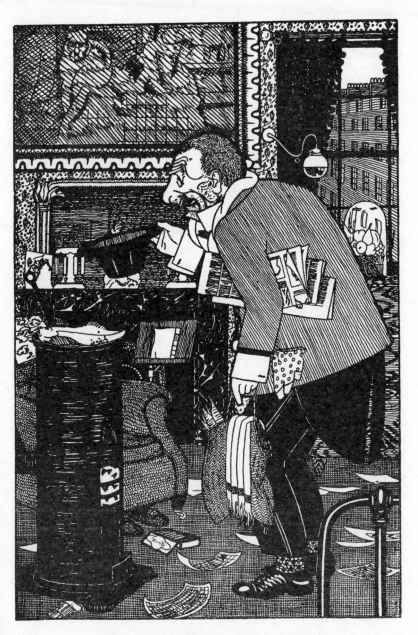

WALTER SICKERT, ESQ., A.R.A.
by 'Quiz'
*Saturday Review*, 22 November 1924

teriors, in some of which his own burly tweeded figure appears. Though now an old man beyond gainsay, the best of these pictures show no slackening in the power of draughtsmanship or control of colour. The juggler was still juggling with his plates. He only reduced their weight a little from time to time.

At St. Peter's they led a quiet country life, broken only by infrequent visits to London for a reception or a private view. It was not long before he started another school, renting a studio in the town for the purpose. As before at Highbury, when the school ended, the room was kept on for his own work. Instead, he taught drawing at a boys' school next door. In 1938 he received the degree of D.Litt. from Reading University.

The following letters to his old friend Jacques Blanche give a picture of his life at this time.

<div style="text-align: right">

*Hauteville,*
*St. Peter's-in-Thanet.*
*March 5, 1935.*

</div>

Mon vieux Jacques,

*Comme j'ai été content de voir sur la cheminée ta bonne écriture. Quand le printemps deviendra un peu plus clément il faut que vous veniez nous voir.*

*Nous sommes à vingt minutes de la ville de Margate. Il y a dans l'été des paquebots du Havre, de Dieppe, du Tréport, etc.*

*Nous avons eu la chance de trouver une espèce de petit gentilhommière avec orchard, grand jardin, écurie etc. pour £80 l'an. Nous avons loué notre maison de Londres à mon beau-frère Frédérick Lessore, du Beaux Arts Gallery pour la même somme. Sur notre maison ici il y a, taillé dans une pierre sous le toit le chiffre 1827. Ma femme m'a dit aujourd'hui que son grand-père Lessore avait une maison à Martin ou Martigny Marlotte, près de Fontainebleau, où Millet est souvent venu le voir. Il dessinait sur tous les murs. Je lis et relis le livre de ton ami Moreau-Nélaton qui doit être le grand prix du mauvais style. Il appelle un collectionneur 'le personnage', 'le particulier' etc. Tout son monde est 'friand' du régal de tableaux. Il appelle les pastels des 'perles'. Je*

*parie qu'il dira que la reine portait autour de son cou un collier de 'pastels'.*

*Je donne des conférences piquantes à Margate sur l'École Française. Le vicar de Margate et sa dame m'honorent de leur présence. . . .*

When Queen Victoria was a little girl she was donkey-riding at Broadstairs and her donkey ran away with her into the gate and the fields *of this house*.

Our bedroom has nineteen framed drawings by H B for which I paid 2d. each. Lithography. We have six monochromes by Tintoretto. I paid £5 for the 6, on canvas in raw umber etc. tempera.

Our chief pride here are six little plasters by Danton *le jeune*. Can you tell me if there is a standard French work on this splendid sculptor. I would translate it and publish it in England *with photographs*. Give my love to Elie and Daniel [Halévy].

I compared the painting by Ingres of Monsieur Cavé with the pastel of Degas in our group. Curiously enough it is the same view, and the same lighting as in your pastel group.

Love to your dear wife. A *bientôt*.

Your affectionate and grateful

R. S.

Hauteville,
St. Peter's-in-Thanet.

MON VIEUX JACQUES,

You are the most *helpful* person that ever was.

You not only answer at once, but you are as 'thorough' as the sort of cookery book that gives 'one hundred ways of making a Welsh rabbit'.

Thank you for your interesting pamphlet. What a splendid portrait by L'hôte! He has caught the 'primeur' on your right temple expressing the anxiety with which life inspires us all!

I am going to send you drawings of my six statuettes. . . .

Your

R. S.

. . . I have just finished reading Stendhal's *Le rouge et le noir*. I find an average of six paragraphs to the page. How different from M. d'Attaly . . .!

The mention of the pictures and statuettes which adorned his home is interesting. Sickert was never, like Degas, a collector. It is true that he never had enough money to indulge very deeply in that mania; but, apart from that, he had not the collector's temperament, which, when present, may be fully exercised at any price-level. He liked to possess beautiful things, but they were seldom of the so-called collector's-piece class. He once owned a fine Degas and a valuable collection of Whistler's etchings, but they were sold some time when he was hard up, and the loss did not rankle long. His more permanent possessions were prized solely for their beauty, not for their value or rarity. A good reproduction of a drawing gave him as much pleasure as the original. With his bound copies of *Le Rire* he felt as rich as Mr. Courtauld. Though he could not have the masterpieces of Rubens or Raphael, he could and did extract an equal amount of pleasure from the fine seventeenth- and eighteenth-century engravings after them. In fact Sickert had many reasons for his liking for engravings. In the first place he regarded them as truer reproductions than photographs: quoting, for example, with great approval Sir Charles Holmes, who had written, 'No photograph known to me of Titian's *Madonna in Glory* at Serravalle suggests anything but a dark and obscure painting. Mr. Gilbert's engraving of the centre portion is so broad and cool and airy that it resembles a sketch by Corot, after Raphael.'

Also he valued them as safeguards of permanence. 'The old masters had the instinct of self-preservation. It is true they had something to preserve. I picked up the other day in a very neatly classified rag, bone, and bottle warehouse (such a lesson in classification to us all!) not fifty yards from the Tottenham-Court-road wash-houses, for the sum of 3d. sterling, an excel-

lent proof of an engraving by Paulus Pontius, dated 1630, after Rubens, that is to say, a translation into a relatively permanent medium, by a contemporary, as who should say a J. Pye, after, and above all during, Turner. I find a *dettaglio* reproduced in Kristeller's standard, if uncritical, work on engraving.

Not being a proper Kunstforscher, I have no means of knowing where, and in what state, the Rubens of which this engraving is an intelligent translation hangs at the present moment of grace. It may be, I hope it is—the subject is sanguinary—in a state of perfect preservation, in the safe care of some Bode or Cantalamessa, to whom herewith my grateful, if somewhat ignorant, homage. But, on the other hand, there is the possibility that the canvas may have been burnt. Or worse, it may have been scraped down and entirely repainted by successive reach-me-down restorers in vogue. On these hypotheses, and they are only, in the case of this particular picture, the merest hypotheses, "Where's your Rubens the noo?" Why, safe, at any rate, in the pigeon-holes of the rag, bone, and bottle merchant behind the Tottenham Court-road baths! . . .

'Now I am a "business man", as the poem says. If I nag, I nag constructively. Let some intelligent print-seller ferret out the best copper-plate line-engraver living, and commission him to translate, say Sargent's *Carmencita*, or any one of the luminous and mysterious landscapes of Steer's, or the marvellous *Mail-coach Road* in the recent exhibition of paintings by Yeats at Mr. Tooth's gallery. Let him steel the plates. I will guarantee large editions, and subscribe for a print of each. The print-seller, instead of talking himself hoarse persuading people to buy paintings they cannot afford, will live hereafter in clover, and one engraver, to begin with, will be taken off the contemporary dole. *Un passo alla volta*.'

And lastly he valued them for purposes of education. In the course of three letters to the *Morning Post* on the subject he said:

'No one will dispute the statement in your leading article that much of the modern poster-work is highly artistic. But it is

artistic in proportion as it does or does not fulfil its purpose, which is to catch the attention of a driver in the Euston-road who is trying to exceed the speed-limit. We must remember that the children in their schools are indoors and sedentary.

'I have said before, and I hope to say again and again, that I suggest for school-rooms reproductions of such works as Guido Reni's *Dawn*, *The Vision of S. Helena* by Veronese, Raphael's *Heliodorus*, *St. George and the Dragon* by Tintoretto, Leighton's *Summer Moon* and Frith's *Derby Day*. . . .

'The cinema has enlightened us on the capabilities of enlargement. Cotton printers could print enlargements of line-engravings of the classics, which could be hung on rollers *without glass*. I have a map of London in 1832, printed on a handkerchief, on which people have blown their noses for a hundred years. The small bold print is as clear as to-day's copy of the *Morning Post*.

It will be the historical and romantic elements in these works that will appeal to the young, as they do to the old. . . . The gravity of the child is our most eloquent and precious guide. The finest art alone is good enough for it.'

To return to the collector, Sickert always looked at the work, never the signature. Drawings or paintings by unknown artists often gave him as much pleasure as those by well-known names. The following article gives his philosophy of collecting on a sixpence.

'The unintelligent collection is one that contains minor specimens of everybody who is to the fore at the moment. The unintelligent collection will tend, therefore, to defeat its own end. First, financially because one important example—and importance has no reference to area—of even a relatively unimportant master will tend to keep up its value, while the small change of the same artist will tend to depreciate. Secondly (and I make no apology for seeking these things second), because the educational, exhilarating, and consoling elements in such collections is nil. They are like the middling rings that are worn

for ostentation, and only succeed in marking with precision the extreme limit, upwards, of the wearer's means, where silence as to that limit might have left it in a, perhaps, more prudent penumbra.

'I have always in my mind, when I think of collections, the collection of a friend of mine. My friend is an aristocrat, and therefore entirely free. He is untouched by the opinions of others. He collects, or rather he retains, what he loves. He can read of fluctuations in art values, as he brushes the morning's coffee from his beard, without a tremor. He is never impelled to those periodical vomits at Christie's that constitute the agonies of the contemporary painter, and the well earned *beanos* of the dealer. "That has been a lucky picture for me," said their Napoleon the other day to me, "I have had it back six times."

'And what is my friend's collection? His uncle was an extremely able pastellist in Queen Victoria's Pimlico, who had the ability and the good fortune to be acceptable to the court of her Majesty, as the painter of all the beauties of the reign at their best. My friend has a collection of his uncle's pastel heads of these adorable ladies, and, what is more to the point, his fine staircase is hung, to the third floor at least, with a complete collection of engravings, by competent engravers, of all his uncle's pastels. The pastels, having been done by a painter who was an Academician and respected his medium, are in excellent condition. And as they are so now, they will probably remain so for another couple of hundred years. The engravings constitute a multiple second line of defence against time and accident, and are in themselves beautiful *bibelots*. They undeniably stand the best decorative test, which is to be legible, or audible, if you like, at a distance. . . .

'Let us give the word "Art" a moratorium for a hundred years! We shall be nearer to achieving the thing. Variety is the essence of life. Whatever they are, do not let me see the *same* things inside as well as outside *all* the houses! *Chacun son goût*; *et les vaches seront bien gardées*.'

Such being his tastes, what do we find hanging on the walls of Sickert's own home? First, there is little or none of his own work. To live with one's own pictures he regarded as a form of incest; in any case most of them are soon taken off his hands. There is a cartoon by Max, some prints of old Venice, paintings and water-colours by his father and grandfather, as well as the drawings and statuettes mentioned in his letter to Blanche.

He has a large library of books, many of them devoted to the arts, especially the art of illustration. He has always been a great reader, in many languages. During and soon after the last war, it was Proust and other modern books. For the last ten years it has been chiefly the older classics, Sainte-Beuve, the Journals of Delacroix, books about French history from the Revolution to the war of 1870, the Tichborne case, and English, French, and German novels. Goldoni has been read and re-read. I remember once, at the time of the Abyssinian war, when his beloved Italy was pitted against the whole of Europe, or rather against Mr. Anthony Eden and the Archbishop of Canterbury, finding him deep in his arm-chair and Goldoni.

'They expect me to be sorry for those black men,' he said. 'What do I know about them? Have they got any literature like this? But *these* people,' shaking the book, 'I can understand. They are our race. They speak our own language in art, in everything that makes our European life. Abyssinia indeed!'

<p style="text-align:center">*      *      *</p>

The letters to Blanche were followed by others, including the promised pen drawings of the Danton statuettes. It has been as pleasant to me now, as it was then to him, to bring these two old friends together in the later as in the earlier chapters of their lives. No one has been more courteous and helpful to me in the making of this book than M. Blanche. No one has agreed more closely with me in their estimate of Sickert's character and the forces which directed the development of his genius. In his book, *More Portraits of a Lifetime*, he says:

'It so happened that during this long lapse of time I had only

seen reproductions of the pictures wherein the art critics praised his amazing youthfulness. M. and Mme de Fleuriau told us how he had gone to lunch at the Embassy, how brilliantly witty he had been with all his captivating charm of old; his dress had, however, been formal and ceremonial. This description formed a contrast with the photograph which shows him as a man in his seventies wearing a cap like the old sea-dogs of Dieppe; and still more so with his *Lazarus Raised*, exhibited at Burlington House, for in this painting Lazarus-Sickert bears the features of a Biblical patriarch. . . .

'As I have said before, legend and truth must be disentangled by his future biographers; it is the duty of contemporaries to state facts; the sequence of his output will explain itself and his work will establish the chronology for his biographer. But the legend? He himself has taken pleasure in blackening certain aspects of his character, in endorsing others with a romanticism and an anachronistic dandyism which he has evolved and which covers other artists of our day with ridicule when they venture to follow in his footsteps. Where the ordinary man would be blamed, genius goes far to absolve an artist. Yet as a man of surpassing intelligence, of far-reaching culture and infallible taste, he does not fall into so ridiculous an error. Sickert's need for utter privacy should offer an explanation, an excuse for his moods, his alibis, his extravaganzas. His smiles and friendliness, his intimacy followed by estrangements, are all like a screen that veils, with amusing images, his proud progress through life. The artist rejects all manner of compromise in his insistence on following the course he has set for himself. The man well-beloved of women can be saved like a swimmer whose breath threatens to fail. He is ready to suffer the hand that is stretched out to rescue him. He makes no demands, he merely accepts, supported by the consciousness of his true worth. "My friends, witnesses of my former existences, you may stand aside," he seems to say when the curtain rises on a new sentimental episode.

'Sickert knows that he will always give more than he receives; his princely generosity—a quality which is so rare amongst great artists and which reminds one of Corot—which dealers and suppliers have experienced wherever they have had dealings with him, together with his indifference about his work, have been a source of profit to those to whom he has entrusted it. . . .

'Why did he condescend to be elected as an A.R.A.—an honour which entitled the widow of an academician to a pension? Did he not resign suddenly when the jury committed an injustice? Was not the wag's insolent letter of resignation from the Academy posted at the station after he had seen the President into his train—the President who had just spent the day with him at St. Peter's-in-Thanet at his invitation—the serpent in the basket of figs; Boreas after Zephyr? Not in vain had he been trained by Henry Irving the tragi-comedian. If an actor cannot get under the skin of his character—the costume is not enough—the actor is a poor player. The true artist is sincere in his acting, whether he laughs or weeps. Sickert was always straightforward, either looked one in the face or turned his back—a sharp witticism often finished the matter. In his jests, on the whole, he was utterly loyal to himself. He never lost his temper nor his manners in anyone's presence. Once the irascible baronet, Sir William Eden, set ablaze by one of George Moore's aggravating and ill-humoured retorts, peevishly shouted, stamping his foot: "Sickert boasts of being middle class, but he behaves like a gentleman," a rude remark that infuriated the son of the squire of Moore Hall—which quickly brought him to his senses.

'Sometimes at Ebury Street, when no outsider was present, we used to amuse ourselves by imitating Sickert's tone of voice in imaginary conversations with such people as his charwoman, his colourman, the postman, a peer or an ambassador. Henry Tonks, acting on the suggestion that Walter had been commanded to paint Queen Mary's portrait, invented the dialogue

between the A.R.A. and his model at Buckingham Palace during a sitting. It was plausible and ridiculous, for the improbability of such an absurd circumstance gave rise to all sorts of foolery. The shades of phraseology seemed like a verbal transcription of one of Max Beerbohm's caricatures. . . . Or again, it was I who invented Sickert's morning greeting to the seafolk in the dialect of the Pollet fishermen when he came down to Dieppe from his house at Neuville. Always smiling, brotherly, and paying compliments, as if he were addressing women of great charm. But he kept his distance, there was an impenetrable zone created by his politeness—the serpent lay dormant in the basket of figs.'

<p align="center">*     *     *</p>

In December 1938 the Sickerts moved from Broadstairs to Bath, to the fine old Georgian house outside the city where they now reside. At the age of eighty he is still painting: and, up to the outbreak of a new war, he taught regularly once a week at the Bath School of Art. There is a picture of him standing on the edge of his terrace and looking out across the sun-filled valley to the beautiful city he has loved and served so well. When I last saw him, he was talking of going back to Dieppe!

# CHAPTER XXI

# A PORTRAIT FINISHED

And now the portrait, outlined so many chapters since, is nearly finished. There remain but a few touches, highlights on the parts that are to come forward, a little colour in the shadows, and the picture will be ready for the frame-maker, and then the jury of the exhibiting society, and then the public.

The evidence having been assembled and heard, the correct procedure, no doubt, would be to sum up and pass judgment. But who is going to sum up a man in a chapter of words? and who is going to pass judgment on paintings still wet from the brush, when there is no unanimity on those that have been looked at and written about for centuries?

To classify is the modern craze—or curse. Starting from science, it has spilt over into art. The method is this. First you take a number of animals (and is not the painter also an animal, God bless him?) with a common characteristic. Having chosen a word for it, you apply it to all of them like a surname. This process is repeated for other sets with other characteristics and so on. Then, when you find a new animal, you search him for his most obvious distinguishing mark, the length of his nose may-be, and docket him away in the museum with the other long-noses; and once in the museum, as we all know, he is dead and dust-enfolded and of no more interest. His work is done. He is worse than ossified. He is classified.

Where this system goes wrong, apart from the mouldy

grave-yard-like odour which it imparts to everything it touches, is that, in the excitement over its nose, all the rest of the animal's body is passed over in silence, almost as though it did not exist. The worst example of this conspiracy is furnished by the greatest of all living things, no less than mighty Leviathan himself. I am an uneducated dunce, a very heathen, if I do not know that the whale is an animal and not a fish: not even consider, mind you, but KNOW. And why is he an animal? Because he has warm blood and his lady suckles her little ones. I admit the warm blood on the word of a Cuvier: but I can see the whale for myself beating the waves with his flukes, and who shall tell me to KNOW that he is not a fish? He is as much a fish, if I call him so on the evidence of his living habits, as he is an animal on the grounds of his dead bones and deader ancestors. Are we not all descended from the worm?

And in art it has been the same story. Classify! Classify! and you may be dispensed from looking or enjoying. Idealist, Realist: Classical, Romantic: Pre-Raphael, post-Impression: 'ism after 'ism; hoist your pennant and let your painter go! But here a worse evil still arises. Painters, bred in the fashion of the day, begin to paint to the order of their chosen label: as if a bird should grow webs to its feet, not to swim with, but in order to be called a duck!

Against such a background Sickert stands four-square, both feet planted firmly on earth, or, like Leviathan, sounding to the depths of the sea. Fish, flesh or fowl? He refuses equally to be caught by a hook or snared in a net. His comparative anatomy would have puzzled the great Cuvier himself. Alike in his preferences and his practices he conforms to no set of rules. He holds, quite simply, that the rôle of the painter is to see, and then to record what he has seen for the pleasure of others. The fact that the natural world is seen differently through different eyes, or, as has been said, through different temperaments, is what gives to art its infinite variety. What we require from a draughtsman is that he allow us to see natural objects (and 'a

EASTER WEDNESDAY

silk hat is as much nature as a silk worm') in a way, which, by association, arouses our kinship with his humanity, and at the same time gives us a new pleasure and a new surprise at beauty unperceived. Translated into practice this means, first the impact of familiar scenes on a rare intelligence, and second the simplification of a craftsman, who can turn the raw material of his medium into a miracle of loveliness revealed.

\* \* \*

Drawings, and the part played by drawing in paintings, were given by Sickert a special pre-eminence in the hierarchy of the Arts. 'The sculptor', he says somewhere, 'is of course a nobler beast than the painter, and the draughtsman than either.'[1] Colour, which by nature is a decorator's element, was superimposed on drawing, and also on sculpture, to give an added realism. A painting is no more than a tinted drawing: or, as Ingres said, 'drawing includes everything but the tint'.

Fine drawing is apt to crop up in unexpected places, and Sickert took his nourishment where he found it, not waiting for it to be served up on silver or fine porcelain. Some of his preferences may appear somewhat shocking to more delicate feeders, but that is because these gentry do not appreciate drawings with their eyes but with their ears, or through the tips of their sensitive fingers. One of the places where he found it most often was in the pages of the illustrated press, especially the comic press. He had always a particular affection for the black-and-whites. He had grown up with them. His father had been one of them. Whose name is so often or so reverently on his lips as Keene? He recognised the essential fitness of their supply to the demand. Illustrated papers were themselves a product of his own century, the nineteenth. New methods of reproduction had created a new opportunity. The pleasure given by drawings was for the first time within the reach of anyone. The new client was the public, the man in the street, the ordinary citizen. This new patron was not interested in Art. He demanded that a drawing should be easy to understand, with

plenty of movement, simply expressed with a minimum of means. He liked his humour to be racy, and his sentiment homely. What a godsend to draughtsmen in an age in which the quality of the demand for higher art left so much to be desired! The black-and-white artists were illustrators, and the word has become derogatory; but Sickert never found it so, claiming it openly for himself, and for all the greatest painters from Tintoretto to Turner. In his old age he turned back the pages of time, proving his continued affection and admiration for the English wood-blocks of the 60's in the delightful series of *Echoes*. He was very proud that the *doyen* of those artists, Sir John Gilbert, had sat to him in his house in Blackheath. 'To my great delight, he was even kind enough to retouch the drawing, which was published in the *Pall Mall Gazette*. This gives me a right to boast that I have once collaborated with Gilbert.' In his writings he often speaks with approval of the German illustrators, and in 1922 he wrote for the *Morning Post* an article on 'Some French Cartoonists', which not only expresses his admiration for them individually, but explains the reasons for his delight in all such drawing.

'When we see our more rigidly straight-tipped friends doddering portentously over a third-rate scribble by Daumier, that he himself would, on his way to an idea, have thrown into the waste-paper basket, while they bestow at most a patronising smile on the best Haselden, Métivet or Genty, we recognise the terrible servitude of the straight-tip.

'If Daumier were now, let us say, forty, he would be congratulating himself daily on two things. Firstly, on the invention of photo-zinc printing, and, secondly, on the enormous demand for pictorial thought, undiminished by the multiplication of photography.

'This demand is greater in France than in England. Nearly all the daily papers publish, several times a week, embodied in the text, cartoons in which events or fancies are treated with more or less wit by master-draughtsmen, several of whom are at least

the equals of Daumier. The very art of drawing for photo-zinc reproduction is a progress on the art of the lithographer, by as much as line is an instrument at once more delicate, more obedient, and more abstract than tone. The print from a photo-zinc block has set up, for the million, a harmony that was denied to the combination of type with prints, either of steel plates, etchings, or the lithographic stone. . . .

'Métivet seems to stand naturally at the head of the French draughtsmen. The grace of his pen line as it swells and contracts with his thought, accompanied as it is by its granular reinforcement, is incredible in its felicity. I have a recollection of a drawing which is little more than the outline of two dressmakers' dummies, as it were setting to partners, seen in *enfilade* through the bow of a shop-window. Métivet is really a supreme example of the anodyne nature of pictorial art. A thing that, said in words, would often be intolerable, is transformed in drawing into something so rich and strange that, having its origin in propaganda of a temporary interest, it has become, in the garden of fancy, a pergola, wreathed for ever in festoons of trailing beauty. Added to which, and embodied in it, is the profound and incurable philosophic good nature of every individual Frenchman.

'From Abel Faivre, as from all the French cartoonists, we get drawings in which the comic force, as in Haselden, is inherent in every line, and not merely illustrations of two figures, who are supposed to be reciting a subter-imposed legend. Abel Faivre is the most enviable of artists. Endowed from his beginnings (how many years ago?) with power at once plastic and comic, he has developed incessantly in the direction of elegance, beauty and simplicity. How many paintings that change hands at large figures at Christie's have the intrinsic artistic worth of the front pages of the *Rire* of the 16th of October 1920, the 19th of November, and the 31st of December 1921?

'I am inclined to think that, with Genty, drawing has arrived at something hitherto untouched. His subjects, being of a

jocular nature, might easily cause the artistic excellence of his work to be overlooked. His compositions are often of a shape known to frame-makers as "marine", that is to say, a narrow horizontal strip. I have in my mind, and in my most valued possession, a composition representing part of a scene in a sort of little Parisian Caledonian market. The ground is littered with humble and appropriate still-life, and such still-life! Every pot and brush and stool is a concise translation into line, a formula that seems to make the drawing of each separate object hence-forth an impertinence or a plagiarism. I seem to remember a plane tree that raises its weary bachelor trunk from a thirsty gap in the pavement. A young "intellectual", costumed as such, stands embarrassed under the indignant denunciation of a stout saleswoman. "He's a German. He's a German. I named my price, and he has made me a counter-proposition!"

'Then there is Laborde, whose use of an attenuated half-tone thrown in places, like a veil, over a line drawing done with the brush, is a marvel of feeling and ingenuity. And Falke, with his sense of the packets that compose the back of a big man's neck and shoulders, and the ham-like hang of a hand. Vallée is techni-cally perhaps less pure. His qualities need the stimulus of some uncanny sexual implication to achieve a certain monstrous charm he sometimes captures. And Kern, who has epitomised the universe in terms of a crushed tyre!

'No political cartoon has ever made a convert. We are born believers in or doubters of Sir Roger Charles Doughty Tich-borne's identity. But the way the propaganda works is this. I buy every paper in which there is a chance of a drawing by Métivet, for their beauty as drawings and their wit. Now, let us suppose, for the sake of argument, that I do not entirely share the political views of Métivet, it is Métivet, all the same, who compels me to buy and, incidentally, to read everything that can be said on that side. A poor man will buy an expensive paper every day on the mere chance of an occasional drawing he desires to possess. Let editors take note.

'One paradox of illustration is worth recording at the present moment. *Clarté*, for instance, is a paper with a high literary and moral standard. What interests me at present is that *Clarté* is illustrated, and that the illustrations are a dead weight. No one can say that they constitute an attraction, and such deductions as can be made from their intellectual quality are a terrible let-down. We all know that, in a wood-cut that aims at being other than a facsimile of a drawing on paper, there is a certain logic in the procession from black to white. A quality is obtained like that of a drawing in white chalk on a black ground. But an "advanced" magazine in these days, whose aim must be the greatest possible diffusion, cannot rely on wood-cuts. Photo-zinc from every possible point of view, practical and artistic (and this is a tautology) is the superior of wood-cut. But many of these drawings, head-pieces, and so on, in *Clarté* are done in a style whose only reason for existing was that it was suitable to the nature of a wood-cut. And they call this modern! Is it possible to imagine a more chuckle-headed error in reasoning in a paper with the title of Clarity? What, furthermore, are the illustrations? Chiefly still-lifes, books, inkstands, stools, and such-like odds and ends. How is it that the scholarly writers, and, presumably, scholarly editors of such a paper do not know that a work of art in drawing is the extraction, from such groups of objects, of line and light and shade, in themselves beautiful, delicate, and precious. Imagine the propaganda of *Clarté* served by a pencil like that of Métivet!'[2]

I have given this article at length, because it contains the very pith and core of Sickert's aesthetic creed. The question he asks of the editors of *Clarté*, he asks in fact of all the purveyors of art and all the people for whom it is purveyed. 'How is it that you do not know that a work of art is the extraction from natural objects of line and light and shade (and colour), in themselves beautiful and delicate and precious?'

And the objects themselves may be *any* object. 'While the snobs of the brush labour to render the most expensive women

and the richest fabrics cheap, the master-draughtsman shows us the wealth of beauty and consolation there is in perceiving and following out the form of anything. Anything! This is the subject matter of modern art. There is the quarry, inexhaustible for ever, from which the draughtsmen and painters of the future will draw the endless line of masterpieces still to come.'[3]

Of course there is an understood proviso to this 'anything', as important as the principle itself: namely, that the objects, whether men and women or still-life or landscape, shall be about their natural business in the world. Not the forms only but the life within them must be 'significant'; in other words the mind must be drawn to sympathy with a life which is familiar, a life that never stands still, but which may sometimes hover tremblingly for a space just long enough for the draughts-man to pin his game.

<p style="text-align:center">*       *       *</p>

One of the most amazing questions ever asked about Sickert's work (it must have come originally from the Elephant's Child) was, 'Is he a modern?' The answer, I suppose, is, 'ask his in-come-tax collector!' For how else than as a riddle can such imbecility be treated. If to be 'modern' means anything at all, it means to be alive to-day. The most 'modern' painters of all are the pavement artists, who start all over again each morning. What the questioner really means of course, though she does not like to put it quite so crudely is, 'Does he belong to my clique?': in which case the answer can be amended to, 'No, Madam, Mr. Sickert is *not* a modern.'

Time was when a fair measure of uniformity might be found between all the artists working at the same moment, in the same country. The cause is well known. It began with the dis-covery of certain French dealers that pure aesthetic could be sold. It was simply a matter of advertisement. Quack art was no different from quack medicine. The credulity of the public could be relied on to absorb anything under the seal of the

printed word. It was only necessary that, just as no one knew what was really in the bottle, so the new art should be so completely different from anything that had gone before it as to escape all possible comparison. All the paraphernalia of a stupendous advertising campaign were set in motion. Reproductions, books, newspaper articles, expensive magazines devoted solely to the new painting, flowed unceasingly from the press and were distributed over the whole world. The public, remembering the mistake they had made over the Impressionists, were ready to accept anything. They asked only for authority. The dealers took care that they had it. The immediate result was a riot of originality. All that was demanded of an artist was that he go one better than his predecessor and that his output should be large. The ideal painter, the 'greatest of the Masters', invented a completely new style every few years.

The state of mind of the average picture-lover can be described, mildly, as bewildered. Many, including the speculators and the snobs, were stampeded into the chase of the wild-goose that promised such golden eggs. Others joined small cliques, with or without a distinguishing 'ism. The rest fell back on the Academy, where at least they could be pleasantly reminded of their favourite country-side or their favourite rose. Sickert thus fell between two stools. He belonged to no clique, and he did not paint roses but pictures.

Originality! As if any painter can escape his own proper originality, will he but follow the old advice, 'to thine own self be true'. 'Is it not true that to be well-dressed you must first have learnt to dress like anybody else? Good dressing might be defined as an almost imperceptible adjustment of variation on a uniform. And so in painting is there among the work of the masters more uniformity than there is variation. It is probable that in the intentional seeking for variation lies the fallacy of such modern art as has gone badly astray.'[4]

Originality is not the same thing as imaginative invention,

which is the highest gift of the artist. But even invention cannot grow upside down in a vacuum. It can only come to fruition when budded on to tradition, and pruned by discipline. The example of Picasso will show how rank the growth may become under faulty culture. Without brakes, without stabilizer, he has plunged headlong down the path of experiment, till the dream of beauty is become the nightmare of madness. THE GREAT INVENTOR IS NOT TO BE FOUND AMONG THE SEARCHERS FOR PERPETUAL MOTION.

Strange as it may appear, there has probably never been so little true inventiveness in art as to-day. Sickert himself is not an inventor. To begin with he inherited the slice-of-life type of composition from the Impressionists. His drawings are made from nature, and the paintings which are based on them are not permitted to deviate from the original design. On the few occasions that he has attempted a purely imaginative theme, such as *The Raising of Lazarus*, the result, considered as invention, was not very successful. The *Echoes* show the intense admiration he had for a form of composition, for which there was no place in his own artistic capacity.

There is another sense in which Sickert is not an inventor. His importance to modern painting does not depend on the development, under his name, of a new school. It did not lie with his particular genius to be the blazer of a trail. In a world in which new trails, albeit drawn by red herrings, stretch out in every direction, he kept his way undeviatingly along the main road: that road, onto which he was directed by his master Degas, the latest traveller on it. Sickert is in the line of the great masters because he has been wise enough to keep his art traditional. He has avoided by-paths. The line of evolution is ever through the least specialised forms; and what is true of the macrocosm nature, is true of the microcosm art. Man's brain has given him the mastery of the earth, because it enabled him to deal effectively with the most varied and variable emergencies. For the race is not to the swiftest runner, but to him

that can overcome the greatest diversity of obstacles. And for this purpose the runner must be unencumbered by eccentric overgrowths. In the same way eccentricity in art carries its own nemesis. It is sterile. The crank is a vacuum. Nature abhors him. Separated from their special hosts, the parasitic 'isms would soon dry up and wither away. They have no roots in natural soil, but only in the hot air of the greenhouse.

*          *          *

Sickert himself is a realist. But what exactly was his method of composing a picture? What is the genesis of a Sickert? I am thinking of his interiors with figures. The first thing is that there is *no* special arrangement. The room is an ordinary living room, not a studio got up, more or less, to look like one. If there is a bed in it, it is a real bed-room. People sleep in it. They go to bed tired and get up bleary-eyed. When the model, whether a friend or a professional, arrives, he is treated like a visitor. There is talk. He looks at the pictures. They make tea. There is the fire to be poked, or the blinds drawn. At some moment of this time, not immediately, a composition arranges itself to suit the painter's eye. 'Stay like that,' he calls out and begins to draw. When the subject is a nude on a bed, there should be just that atmosphere of intimacy which is suggested, for instance, by the disarray of the bed-clothes. The titles were added afterwards, and were suggested by some quirk in the relationship of the figure or figures, as they appeared in the drawing.

Fortunately Sickert himself has left a description of his method which could not be bettered, under the heading of:

### A STONE GINGER

'Not only are words not the painter's medium, but the very nature of his medium, and the kind of preoccupation that his medium imposes on him, renders him, of all men, the least apt at expression in words. Cumulative and silent observation, what

the Germans call *ablauschen*, a manner of breathless listening, as it were, with the eyes, a listening extending over a long series of years, make of him, in so far as he is a painter, rather a silent than a resonant being. The game he pursues must not be startled, must even, as much as possible, be kept unaware of his presence. "Don't speak," is what he generally says or wishes to say. "Do not disturb the spell." A stillness like the sleeping of a top may describe, as near as words can describe it, the operations of a painter's activity. "Do not ruffle me. Do not ruffle me disagreeably. Still less ruffle me agreeably. Ignore me. Suppose me not present."

*Scheuch nicht den holden Traum.*

'The painter is consumed with envy of the racecourse thief, and the welsher. If he could organise it, he would carry with him the "minder", who keeps watch for him. He would carry with him, if he could, all exes paid, his band of "wraughters" or "rorters", whose duty it is to jostle the "mug", if the "mug" is only a "mug". If the "mug" should be a "tradesman" as well, the course of procedure is different, and somewhat out-side the scope of this article. He would carry with him the "jollier", whose duty it is to keep the "mug" amused, and rouse him to acts of folly. All these he would carry with him so that he, the "worker", or the "tool", might have his mind and his hands freed for the master-stroke. Luxury would be carried to its highest point, if the "fence" could not be too far away, to advance him a professional proportion of the value of his haul.

'If it is an outdoor landscape that he is studying, the ray of sun-light that pierces the clerestory of the forest is on that bough, his bough, at that point in time only. Those beech leaves are a cold shower of new silver pieces, perhaps for the last time this summer. He is as anxious as the harvester. The weather may change to-morrow. A fortnight hence the inclination of the sun at this same hour will be different. That bough on which all

depends, that bough, the protagonist in his ineffable little drama, will never be quite the same again. Miracles of concentration, made possible by an inherited aptitude, sedulously cultivated for years, must be done in twenty-five minutes.

'If he lives in a northern climate and has no hankering for physical martyrdom, he, with the rest of his countrymen, will work indoors. The house, where man is born, and married, and dies, becomes his theatre, and the sun shines as well, if sometimes more indirectly, on the indoor as on the outdoor man. It may be that the windows, framing and limiting the light, act on the indoor landscape as the frame of the sonnet-form acts on a stream of poetic light, not always to its detriment. We all know that picture of Moritz von Schwind of the little German girl in plaits, who throws open the casement of her bedroom to greet the sounds and scents of the morning. The everlasting matutinal is enshrined in it once for all and for ever. . . .

'Or take the afternoon. The torpors of digestion are over. Tea has clarified the brain, and set tongues wagging again. The afternoon light flows in through the open folding doors, from the small back-room in the classic uniform English first floor, into the bigger front room. The sympathetic personality of the man who is standing talking, saying almost anything, some of those nothings that we willingly listen to, just because they are not important, and so do not stir, but amuse us, has become transfigured by the light. The light has carved him like a gem. For the moment his mood, his pose, and the lighting conspire to make of his image the quintessential embodiment of life. He is not so much Tom Smith as he is Every-man in No-man's-land. He is the painter's America, his new-found land. These things being things of the spirit, phantom sensations built of dust and sunbeams, of personal sympathy and a light play of mood, can we approach to an analysis of the instrument with which they shall be concentrated by the painter into a permanent record?

'If he be only a painter, and not a draughtsman, he will be able to give you something, something beautiful, something with a certain charm of execution and colour, something to which will even cling a faint scent of the magic moment, but it will be a faint sensation only to which he will give a degree of permanence. The work will be wanting in bite, in bulk, in depth, in resonance, and in uniqueness. But if the painter is doubled with the draughtsman, we get the supreme work. . . .

'The man, then, whom I have left standing with a cheroot in one hand, looking out towards the light with his head slightly raised, half in pleasure at the sunshine, and half in a certain inspiration he gets from the memory of a quite trivial incident he is recalling, with an emphasis that makes it important to him, has got to be drawn. HE HAS GOT TO BE DRAWN. It is a few minutes to five, and the Ides of March. He has got to be drawn, not only before the sun sets behind the houses of Stanhope Street and puts a cold extinguisher of lead on the whole scene, but long before that. He has got to be drawn before the fizziness in his momentary mood has become still and flat. If the painter is tactful, and behaves to the man as if the man were a sparrow, if the painter can throw his crumb of appreciation and his monosyllabic assent gently enough not to frighten the model, and yet sharply enough to keep him alert, I give him twenty to twenty-five minutes. So have I seen a wave that Whistler was painting, hang, dog's-eared for him, for an incredible duration of seconds, while the foam curled and creamed under his brush for Mr. Freer of Detroit. . . .

'All this is so important that we had better have an adjournment to allow you to consider it. It is not what I once heard my old friend the sub-editor of the "New York Herald" describe as "A daisy story", but it is what the sporting touts call "A stone ginger".'[5]

There you have Sickert, whimsical, concentrated, flippant, detached. And here is his interpretation of one of his favourite drawings, *L'Armoire à glace*: from a letter to W. H. Stephenson,

who had bought the painting in 1924. 'It is a sort of study *à la* Balzac. The little lower middle-class woman in the stays that will make her a client for the surgeon and the boots for a chiropodist, fed probably largely on "*Ersatz*" or "improved" flour, salt-substitutes, dyed drinks, prolonged fish, tinned things, etc., sitting by the wardrobe which is her idol and bank, so devised that the overweight of the mirror-door would bring the whole structure down on her if it were not temporarily held back by a wire hitched on an insecure nail in insecure plaster. But a devoted, unselfish, uncomplaining wife and mother, inefficient shopper and atrocious cook.'

It was said a few pages ago that two things went to the making of a great painter, the impact of familiar scenes on a rare intelligence, and the craftsmanship which can use the raw materials of the art in such a way as to bring out their own intrinsic beauty. How Sickert's mind reacted to the human comedy, we have seen. But it is perhaps even more as the craftsman of genius that he will be remembered, when most of our other modern canvases are stopping up the cracks in our modern houses. In other parts of this book the actual technique by which his paint is applied has been discussed. But it is impossible to describe the exquisite quality which he obtains thereby, just as it is impossible to imitate it by merely following the directions in the receipt. If you look at one of his pictures closely, the later ones, after 1900, in which the paint is drier and the canvas coarser, and if it is clean and properly varnished, you will get an effect as of looking down through a clear sea, in which, at different levels, coloured fronds, corals and stretches of bright sand alternate, and reflect, and gleam, and seem to move. In the last period of all, after 1922, glazes of pure colour appear for the first time. They are of an extreme thinness, obtained by scrubbing on the paint over a bone-dry underpainting, and they are often broken up later by small patches of opaque paint dotted over them.

But it is useless to describe these things. They must be seen.

Only to be seen they must be looked for. They would seem to be due to an inspired combination of two qualities, looseness of touch and firmness of intention. This last is one to which Sickert attached the greatest importance. He always forbade his students to rub out their drawings, but even that was only the symptom of a deeper error. In effect, each line of the pencil, each stroke of the brush must be put down with the intention of adding something to what is already there, not of subtracting or covering up. Correction is possible by both means. But in one it is attained by cumulation of effort, in the other by dissipation.

<p style="text-align:center">*  *  *</p>

Yet, in spite of all this wealth, it has to be admitted that Sickert is not a popular painter. While he has many admirers, especially among his fellow artists, the true value of his work is still largely unrecognised. Nor is it difficult to understand why this should be. The higher criticism is mainly occupied with the higher art; while, for the more modest-minded, who go to the Academy and like to know what it is all about, he is both too foreign and too uncompromising. And there are other reasons for his unpopularity with an English public. He is not a society painter. Neither reigning beauty nor Derby favourite are his meat. The drawing-room and all its appurtenances are anathema to him. Neither do his pictures point a moral, dear to the English heart; it is enough for him that they should adorn a tale. Again, he does not paint enough large, 'important' pictures. The most characteristic of them are 24" × 20" or smaller. And finally, Sickert will not paint to order. Every picture means a lesson learnt anew. The public, on the other hand, likes to know what to expect. There is also an objection which is more reasonable than these, and that is an occasional ugliness and brutality which appears in some of his pictures of women.

But none of these things should weigh with us, when we come to a final assessment of a painter's worth. That depends, at long last, on the value of the man behind the brush. When the art

attracts to its practice an active and vital mind, a great artist will result. Bad painting, on the other hand, is the outcome of poor-quality man. For every picture is a mirror of the painter himself. It is more personal than a signature, even than a thumb-print: for the thumb-print shadows the body only, but a picture the soul. Let the painter beware then. He is about to expose himself naked in the market-place. Sometimes a single trait will so dominate all others as to communicate itself directly to the spectator. Such were the gaiety of Hals and the disillusion of the later Rembrandt. IN PORTRAITS IT IS THE PAINTER, NOT THE SITTER, WHO IS BETRAYED.

No such single and immediate revelation is apparent in the case of Sickert. I have often (perhaps too often) had to speak of his charm, which is incommunicable, but to which everyone who has known him bears witness. He was ever kind and thoughtful of others, especially of the younger members of the profession. Like most men who are conscious of their own power, he was incapable of jealousy. 'I think an artist is seldom jealous of another man's income,' he says. 'We are jealous of the quality of his work. And, especially if we are a trifle sterile ourselves, do we suffer agonies at the facility of a more pro-ductive painter.'[6] His own production of course was always large, to match his great facility. He was eager, inquisitive, argumentative, and inconsistent. He was a *savant* and an aristo-crat, *un homme du monde* ('*comme si nous n'étions pas tous du monde*', as he was fond of quoting Degas).

Painting remained always the dominant passion of his life. When young he had a tremendous capacity for work, forgetting appointments, meal times, everything, in his absorption. Out-side of the studio he was inconstant and undependable, entirely neglectful of friends and relations in normal times, though capable of the utmost generosity and resourcefulness in crises. His indifference to money left him free to live. Or rather he used money to live, in contrast to so many to-day who only live to make money. Safety first has become the national motto.

Social legislation, old age pensions, compensation and insurance have given a security to men and women hitherto unknown; but in taking the risk, they have also taken the spirit of adventure from life. To Sickert life was very much of an adventure, out of which he was bound to get as much amusement as possible. That he got it out of simple situations and simple people did not detract from its essential quality. Perhaps human personality is never quite as complicated as it seems to be, or as we make it out to be: and least of all the great artist's. In order to attain to that ideal vision, a direct and simple approach is a first necessity. Sickert's perception of the material world was a perception of light and shade, quiet, subtle and sensuous. So also his vision of the inner world of character was calm and unexacting. He liked unpretentious people, whose opinions were truly their own, not somebody else's. He could not get on with people who were always pretending, above all with those whose tastes in art were borrowed ones. So he avoided them as much as he could. Moreover he refused to believe that natural taste varies very much from person to person or from age to age. The great masters are great and will always be great, because they appeal to this natural taste, which does not change. Only fashion changes, and fashion is imposed taste, imposed most often by someone who has an axe to grind. Sickert's own foibles and oddities were a protection against intrusion into the privacy of his inner life. They served as red herrings to draw off the pack from the scent; but all the time the true scent is there for those who have noses for it, or, in this case, eyes to see.

How is all this, or any of it, made apparent in his art? There is a small painting of eggs in an earthenware dish, which he called *Take five eggs*. It was evidently a favourite, for there are two versions of it. So simple a theme, in different hands, may take as many different meanings. Here they are light refreshment for a duchess, there faery eggs forlorn; here again an exercise in non-Euclidean geometry, there a symphony in Eggs-flat; here they will attain the weight of folios, and there they

will have the lightness of vacuity, mere shells of eggs. With Sickert they are good fresh-laid house-wife's eggs, to which the sun, stealing through the larder shutters, lends for a moment the colours of a Venetian morning, but which nevertheless awaken mundane visions and an appetite for breakfast.

# POSTSCRIPT

⟨❦⟩

The writing of this book has had three objects.

First, in order of importance, to present to a wider audience in a more permanent form Sickert's random contributions to the literature of criticism.

Second, to outline the main events of his life, while yet as many as possible of the chief witnesses were still able to testify thereto.

And third, to supply the kind of text-book of drawing and painting which might be inferred from his teaching and his own practice.

Of criticism of Sickert's own work there is, intentionally, as little as possible, compatible with the telling of a straight story.

The first two of the above objects might have been separated, the life into one part, and a selection from his writings into another. It seemed better, however, to attempt the more hazardous method of interweaving the two, in the belief that each one will illuminate, and to some extent explain, the other.

Mr. Sickert himself has given me neither help nor hindrance (*c'est déjà quelque chose!*). He has read the manuscript, and made no more damaging criticism of it than 'Sentimental tosh!'

Mrs. Sickert has followed him more realistically, and her control over fact and legend has been invaluable.

Without the help of Miss Sylvia Gosse this book could never have been written. She has put at my disposal not only her unique collection of Sickert's articles and letters to the press, but her long and intimate acquaintance with his movements and activities.

# POSTSCRIPT

All his old friends, with one or two notable abstentions, have been most cordial and helpful. M. Jacques Blanche in particular, though the war prevented our meeting, has spared neither time nor trouble to write me his reminiscences of Sickert's early life in Dieppe.

To Mrs. Schweder I owe much of the history of her sister Christine, as well as the letters that Sickert wrote to her in 1920–22.

There are many others, Mrs. Swinton, Mrs. Clifton and Mrs. Bristow among them, to whom I am indebted for one or more of those small details which go to make up the larger whole. If I cannot mention them all by name, I am none the less grateful.

The warmest thanks are due to Miss Margery Oliver for her tireless tracking down of elusive illustrations.

I must also thank collectively all those who have permitted me to use material, either writings, photographs or pictures, of which they held either the possession or the copyright. Most of them have been acknowledged separately in the text.

# INDEX

## To Quotations from Letters and Articles by
## W. R. SICKERT

# INDEX TO QUOTATIONS

8. *The Art News*, April 7, 1910. Fathers and Sons.
9. See Chapter I, 5.
10. *The New Age*, June 16, 1910. The Study of Drawing.
11. *The New Age*, May 5, 1910. Fashionable Portraiture.
12. See 11.
13. See Chapter IV, 8.

### CHAPTER XI

1. *The New Age*, July 14, 1910. The Allied Artists' Association.
2. *The Art News*, March 4, 1910. The Allied Artists' Association.
3. *The Art News*, April 14, 1910. All we like Sheep.
4. See 2.
5. *Pall Mall Gazette*, March 11, 1914.
6. *The New Age*, June 25, 1914. Democracy in Ease at Holland Park.
7. *The Fortnightly Review*, January, 1911. Post-Impressionists.
8. See 7.
9. See 7.
10. See Chapter IV, 8.
11. *Burlington Magazine*, March, 1916. The True Futurism.

### CHAPTER XII

1. *The New Age*, March 5, 1914. Mesopotamia Cézanne.
2. *The Fortnightly Review*, January, 1911. Post-Impressionists; and *The New Age*, March 5, 1914. Mesopotamia Cézanne.
3. *The Cambridge Magazine*, June 8, 1918. Preface to Catalogue of Pictures by Nina Hamnett.
4. *The Nation* and *Athenaeum*, February 16, 1929. Duncan Grant.
5. See Chapter VI, 2.

### CHAPTER XIII

1. See Chapter II, 2.
2. *Morning Post*, June 9, 1923.
3. See Chapter II, 2.
4. *The New Age*, June 11, 1914. On the Conduct of a Talent.
5. See Chapter II, 2.
6. See Chapter II, 2.
7. *The New Age*, May 12, 1910. Goosocracy.
8. See Chapter II, 2.
9. See Chapter I, 4.
10. See Chapter I, 4.

11. *The Times*, July 3, 1913.

12. *The Art News*, March 10, 1910. Solomon J. Solomon.

13. See Chapter XI, 7.

## CHAPTER XIV

1. *Straws from Cumberland Market*, January 17, 1924. First of Three Lectures at the Royal Institute.

2. See Chapter IV, 3.

## CHAPTER XV

1. See Chapter VI, 4.

2. *The Times*, August 15, 1929.

3. See Chapter IV, 8.

## CHAPTER XVI

1. *Eldar Gallery*, November, 1918. Preface to Catalogue of Pictures by Thérèse Lessore.

2. See Chapter X, 5.

3. *The Art News*, January 20, 1910. Straws from Cumberland Market.

4. *The Art News*, February 3, 1910. Abjuro.

5. *The New Age*, May 7, 1914. Mr. La Thangue's Paintings.

6. *Daily Mail*, December 30, 1929.

7. *The Fortnightly Review*, February, 1930. Italia! Italia!

8. *Daily Telegraph*, May 4, 1929.

9. *The Times*, September 3, 1929.

10. *The Times*, January 15, 1929.

11. *Morning Post*, January 22, 1929.

12. *The Times*, April 20 and May 10, 1929;
and *Daily Herald*, November 28, 1929.

13. *Daily Telegraph*, January 26, 1931.

14. *The Times*, July 29 and August 15, 1929;
and *Daily Telegraph*, January 26, 1931.

15. *Daily Telegraph*, August 29, 1930.

16. *Morning Post*, June 20, 1930;
and *The Times*, January 23 and March 11, 1932.

17. *The Times*, January 30, 1930.

18. *The Times*, January 24, 1930.

19. *The Times*, October 5 and November 2, 1929.

20. *Daily Telegraph*, September 11, 1931.

21. *The Times*, January 12, 1932.

22. *Daily Herald*, November 23, 1932.
23. *The Times*, July 10, 1931.
24. *The Times*, October 5, 1929.
25. See Chapter IV, 11.

### CHAPTER XVII

1. *Manchester Guardian*, March 6, 1926. On the Choice of Pictures.
2. *The Beaux Arts Gallery*, July, 1935. Preface to Catalogue of his own Paintings.
3. *R. E. A. Wilson. Ryder Street*, November, 1932. Preface to Catalogue of Water-colour Drawings by Walter Taylor.
4. *The Art News*, April 21, 1910. Painting and Criticism.
5. *Daily Telegraph*, December 2, 1925. Artist and Public.
6. From an unpublished Manuscript. About 1923.
7. *Southport Visitor*, May 17, 1924. A Morning at Christie's.
8. *Daily Telegraph*, March 3, 1926. The Great Modern.
9. *Southport Visitor*, May 6, 1924. Mr. Finburg and Turner.
10. *Daily Telegraph*, November 4, 1925. Fairy Food.
11. *Daily Telegraph*, February 3, 1926. Playing at Work.
12. *Morning Post*, May 18, 1925. From the Life.
13. *Evening News*, March 7, 1927. Impressionist Forgeries.

### CHAPTER XVIII

1. *Morning Post*, June 9, 1923.
2. See Chapter X, 8.

### CHAPTER XIX

1. *Liverpool Post and Mercury*, October 1, 1929.
2. *The New Age*, July 28, 1910. The Language of Art.
3. See Chapter XIII, 12.
4. *The Art News*, April 28, 1910. The No-Jury System.
5. See Chapter X, 7.
6. See 2.
7. See Chapter IV, 11.
8. See Chapter I, 5.
9. *The New Age*, July 7, 1910. Soup-Kitchens or Trade.
10. See Chapter X, 1.
11. *Whirlwind*, 1890. Page 22.
12. *The English Review*, April, 1912. The Futurist Devil-among-the-tailors.
13. See 12.

# INDEX TO QUOTATIONS

14. See Chapter X, 7.
15. *The New Age*, June 23, 1910. The Polish Rider.
16. See Chapter IV, 8.
17. See Chapter XI, 11.
18. See Chapter VI, 9.

### CHAPTER XXI

1. See Chapter XVI, 7.
2. *Morning Post*, June 6, 1922. Some French Cartoonists.
3. See Chapter X, 10.
4. *Winter.* 1914–15. Preface to Catalogue of the Third National Loan Collection.
5. *The New Age*, March 19, 1914. A Stone Ginger.
6. See Chapter XI, 3.

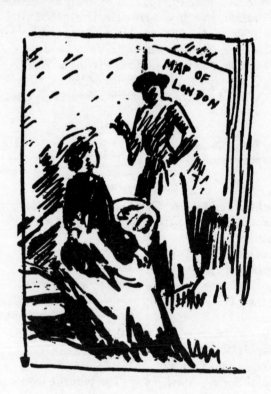

# INDEX

# INDEX

# INDEX

323

# INDEX

# INDEX

# INDEX

# INDEX